C000008797

THE ROYAL BALLET

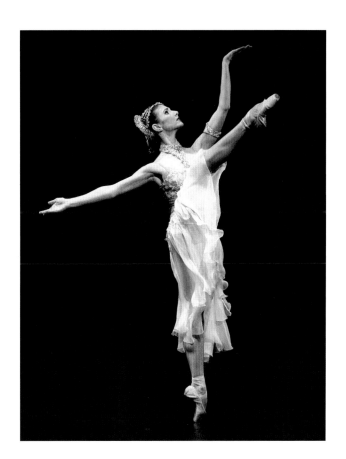

in HOUSE

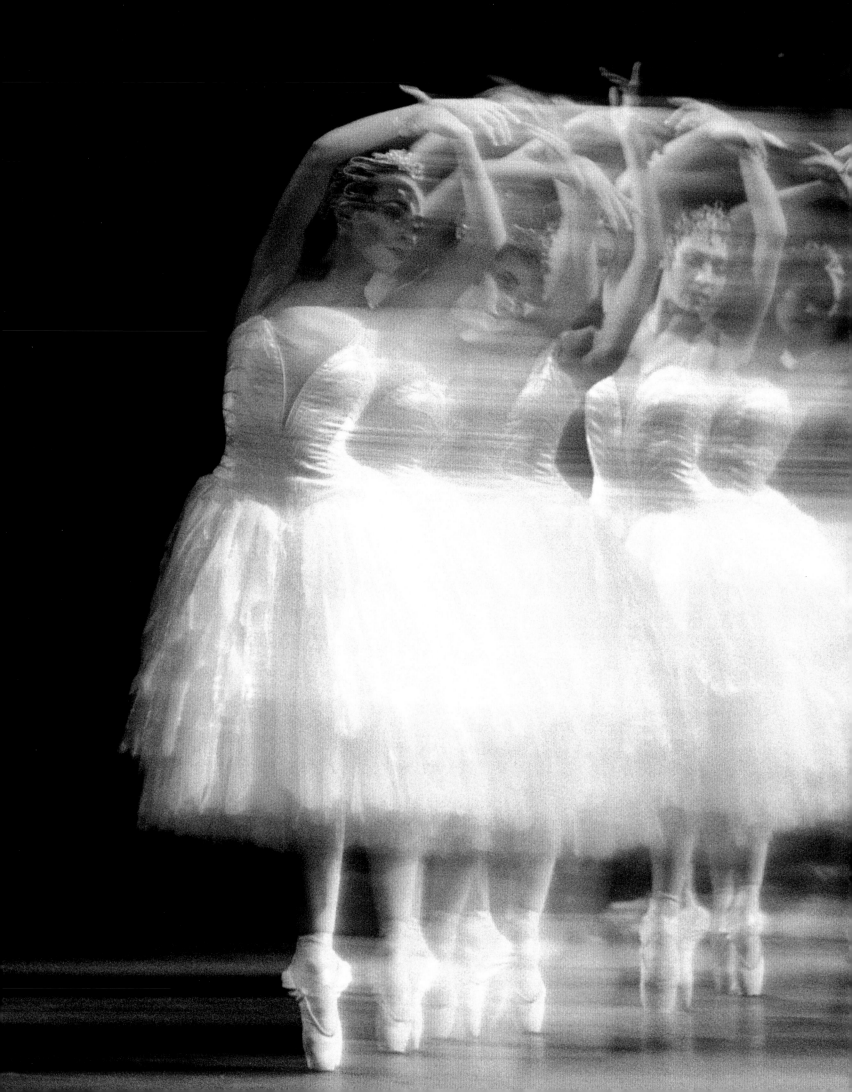

THE ROYAL BALLET

in HOUSE

Photographs by

Bill Cooper

OBERON BOOKS

First published in 2002 by the The Royal Opera House
in association with Oberon Books Ltd.

Oberon Books
(Incorporating Absolute Classics)
521 Caledonian Road, London N7 9RH
Tel: 020 7607 3637 / Fax: 020 7607 3629
e-mail: oberon.books@btinternet.com
www.oberonbooks.com

Copyright this collection © Royal Opera House 2002

Copyright Foreword and text © Royal Opera House

Copyright Photographs © Bill Cooper 1999 - 2002

Agon choreography by George Balanchine © The George Balanchine Trust.

The Concert choreography © Jerome Robbins

All rights whatsoever in this book and these photographs are strictly reserved.

The Royal Opera House and Bill Cooper are hereby identified as authors of this book
in accordance with section 77 of the Copyright, Designs and Patents Act 1988. The
authors have asserted their moral rights.

This book is sold subject to the condition that it shall not by way of trade
or otherwise be circulated without the publisher's consent in any form of binding or
cover or circulated electronically other than that in which it is published and without a
similar condition including this condition being imposed on any subsequent purchaser.

A catalogue record for this book is available from the British Library.

ISBN: 1 84002 350 3

Designed by Leslie Gerry

Printed in the UK by G&B Printers Ltd, Hanworth

Half-title: Alina Cojocaru in *La Bayadère*
Title page: Corps de Ballet in *Swan Lake*

Contents

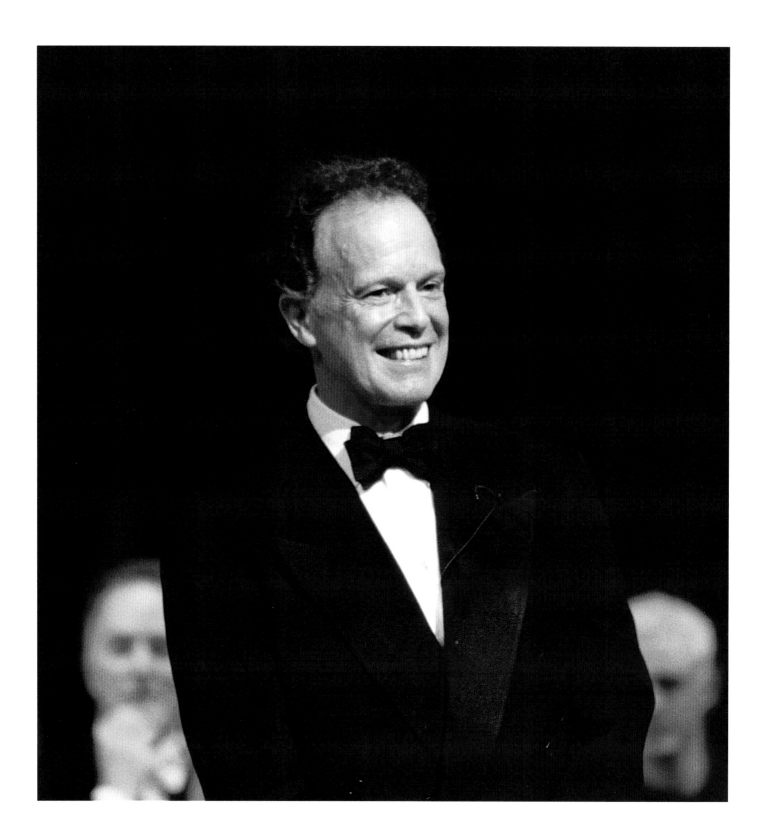

Foreword

By Sir Anthony Dowell

Seventy years after the company was founded *The Royal Ballet In House* records an important period in the history of British Ballet. Our founder Ninette de Valois' dream of the Company being resident in the Royal Opera House has been fulfilled.

Until the rebuilding of the House was complete, one of 'Madam's' aspirations had been missing. Lack of adequate rehearsal space meant that we spent most of our time in rented studios at the Royal Ballet School's premises in West London and the House was never quite our home. Now, after an unsettled time during closure, we rehearse and perform in this fantastic building and our new facilities are the best in the world. The whole House is alive with activity and its doors are open to the public, not only for performances but also for all kinds of events, exhibitions, open classes and rehearsals, giving us and the Royal Opera House new life. The evidence is in this book which, through Bill Cooper's photographs, focuses on the productions staged since the re-opening of the House in 1999.

During part of my fifteen years as Director of the Company, I was blessed to be able to work alongside two great choreographers, Frederick Ashton and Kenneth MacMillan, who were instrumental in moulding our heritage repertory. Both were stars of the Company in their own right. They cast their ballets with dancers from all ranks often discovering new talent and creating new stars. New work is at the heart of the Company and the search for new choreographers is continual. The addition of the Linbury Studio Theatre and the Clore Studio Upstairs to the new House means there are now two further spaces in which to mount smaller-scale new and experimental work.

Watching new talent emerge is one of the most rewarding aspects of being a director. The corps de ballet consists of much more than a group of clone mirror images and its members have the opportunity to shine as individual artists in many of the smaller works in the repertoire. There will always be those who fondly, and rightly, remember great dancers from The Royal Ballet's early years. But, no doubt, one day we will recall just as fondly the great dancers we see today. Indeed, one of the great strengths of the Company is that so many roles that seemed to belong to dancers on whom they were created can be danced by others with outstanding success. The photographs in this book record this for us. One has only to look at the dancers immersed in their roles and performing at the peak of their abilities to know that The Royal Ballet is happy in its new House and on top form.

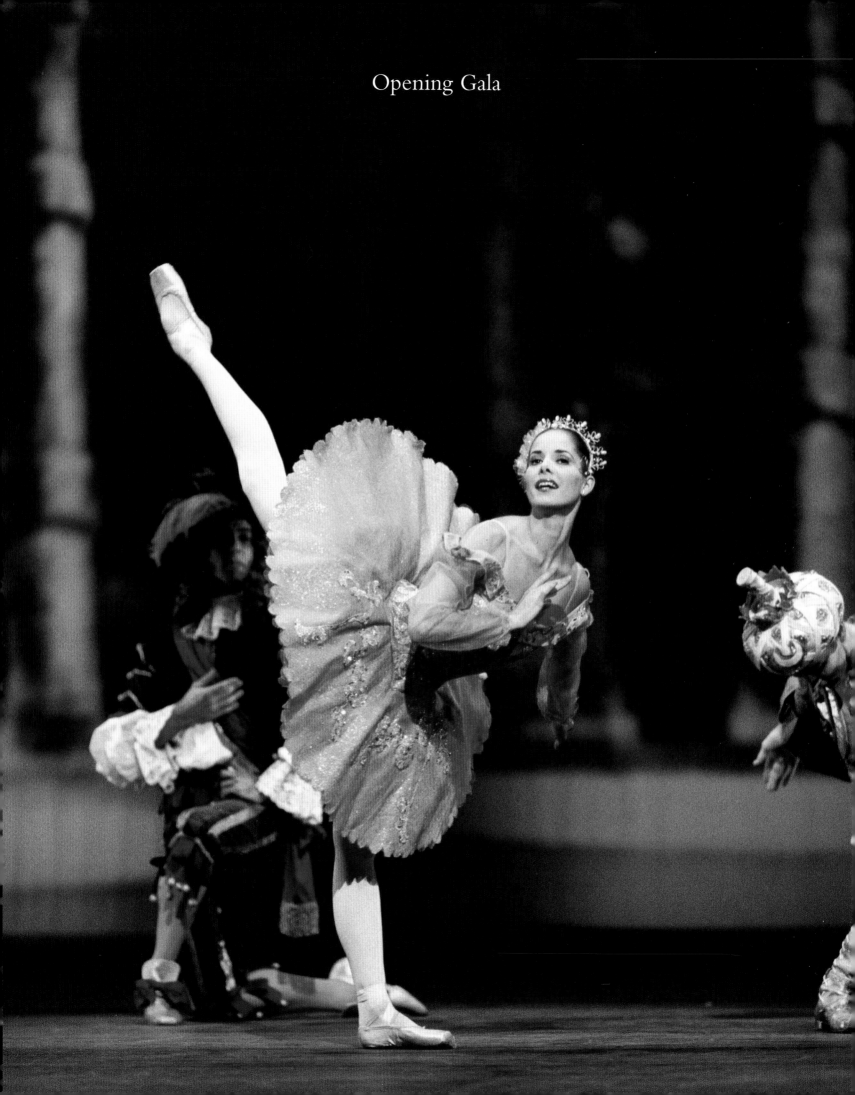

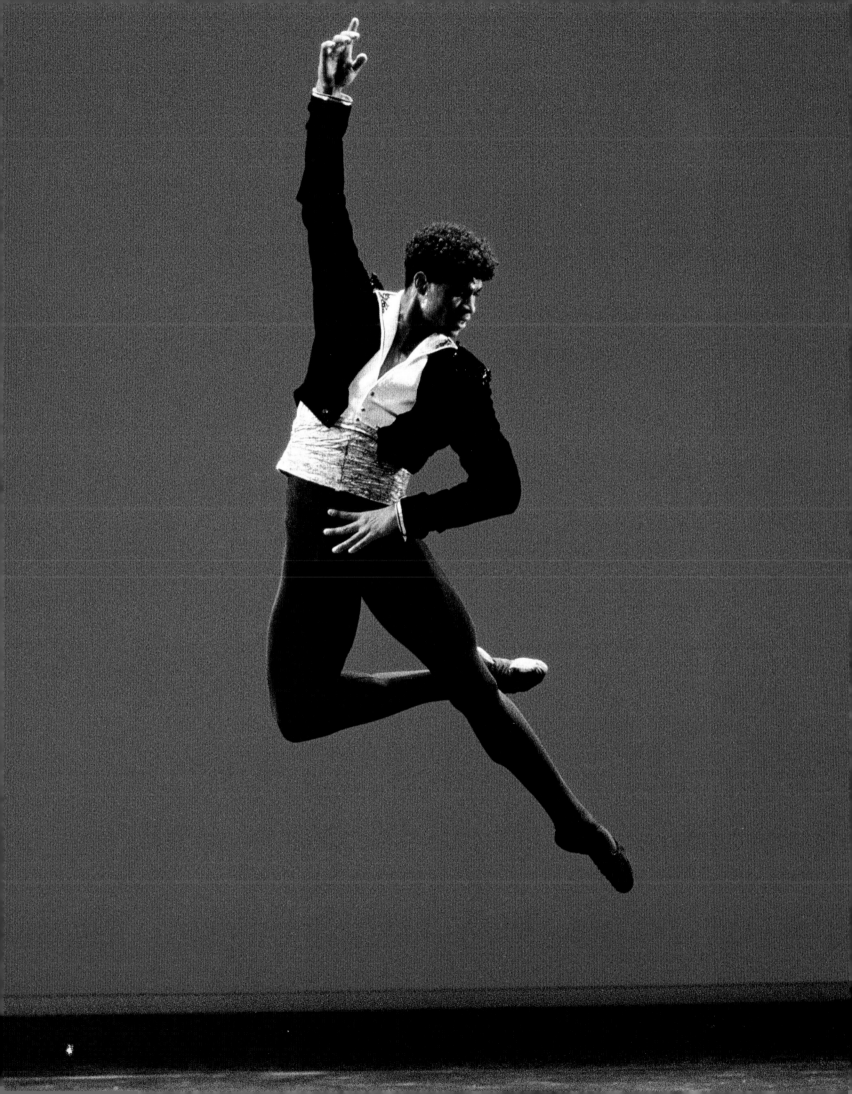

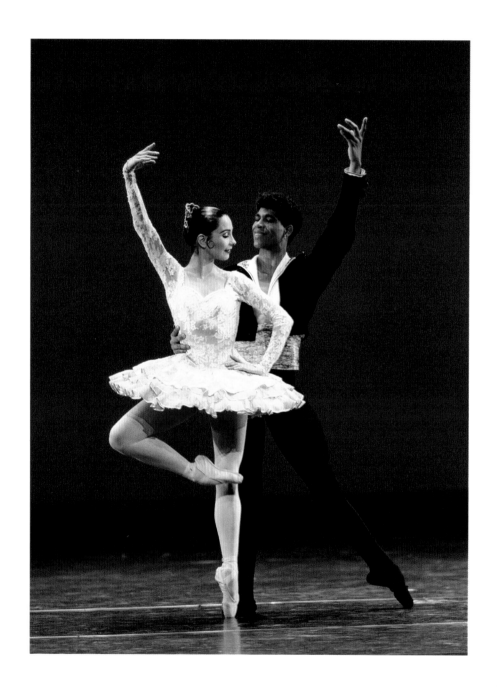

Previous pages, left:
Darcey Bussell as Princess Aurora in
the Rose Adage from *The Sleeping
Beauty:* Act I (1946 Production),
right: Carlos Acosta in *Don Quixote*

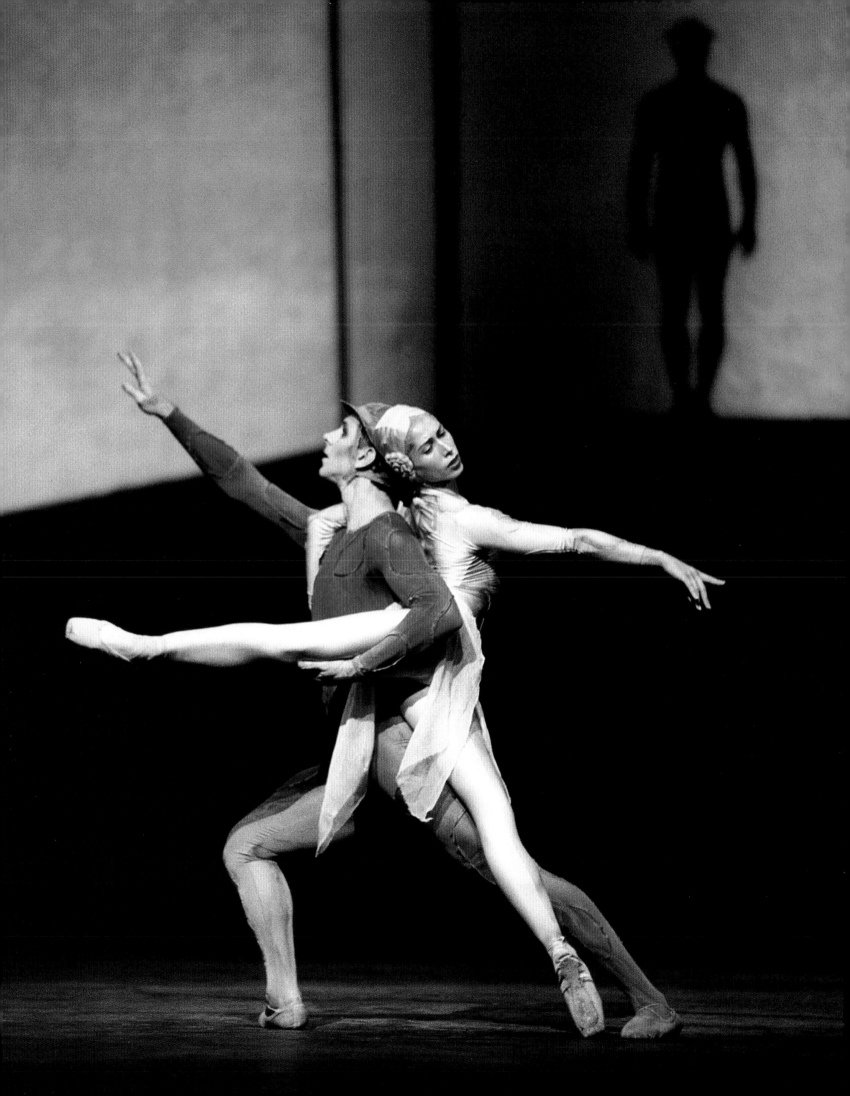

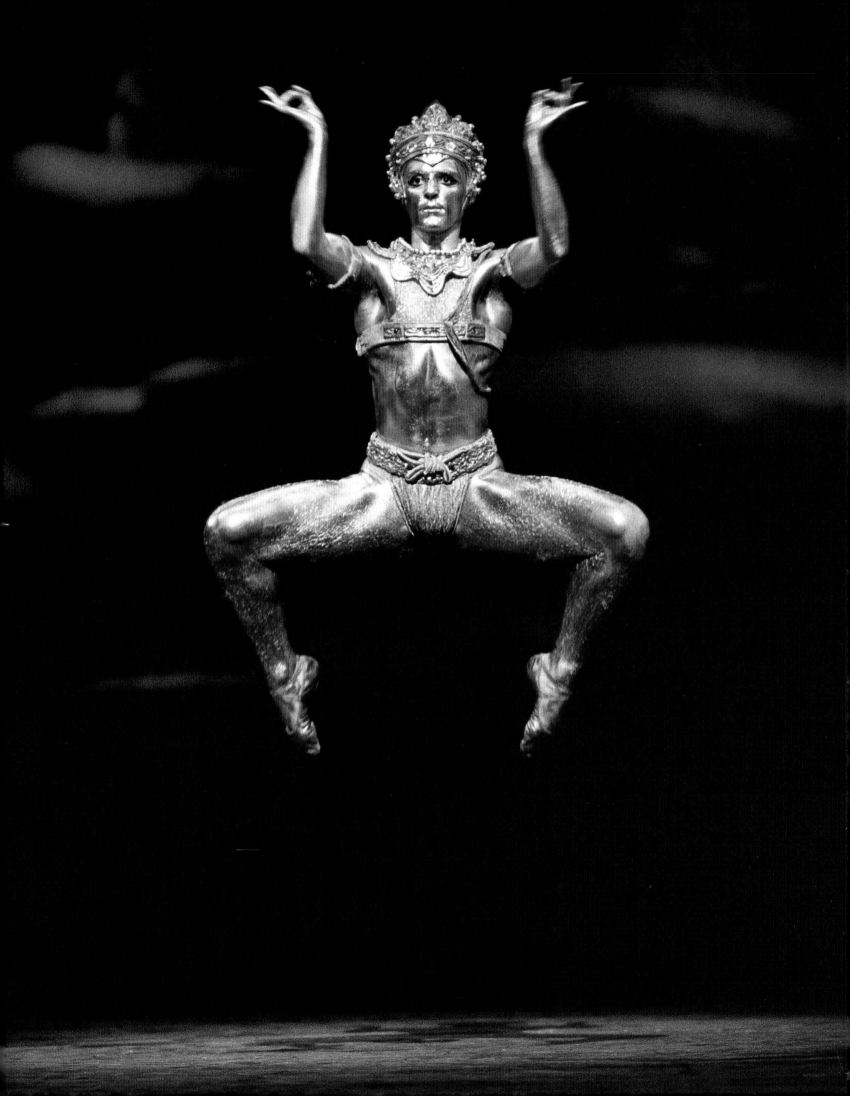

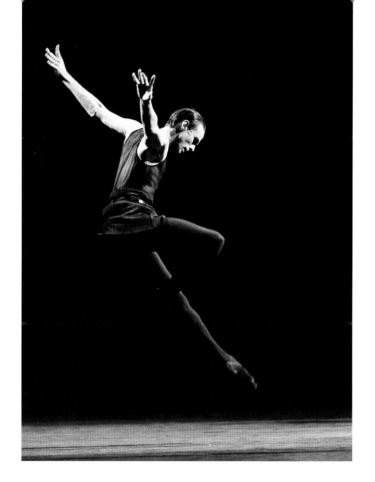

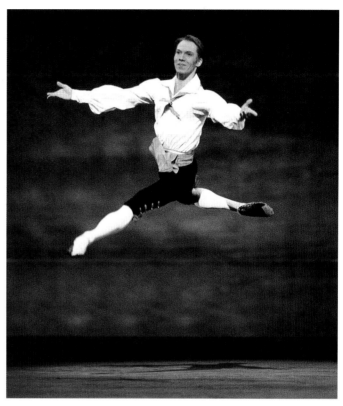

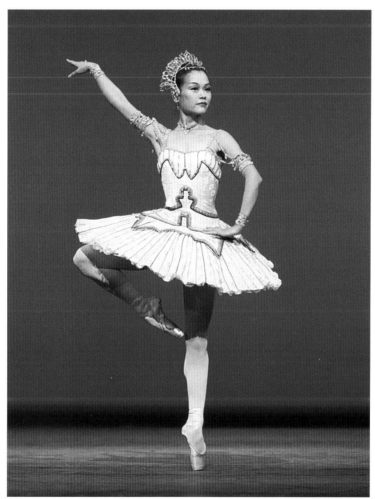

Left: Angel Corella as the
Bronze Idol in *La Bayadère* Act III

Above left: Edward Watson in
Fearful Symmetries

Above right: Johan Kobborg in
Napoli, Act III

Right: Miyako Yoshida in *Raymonda*

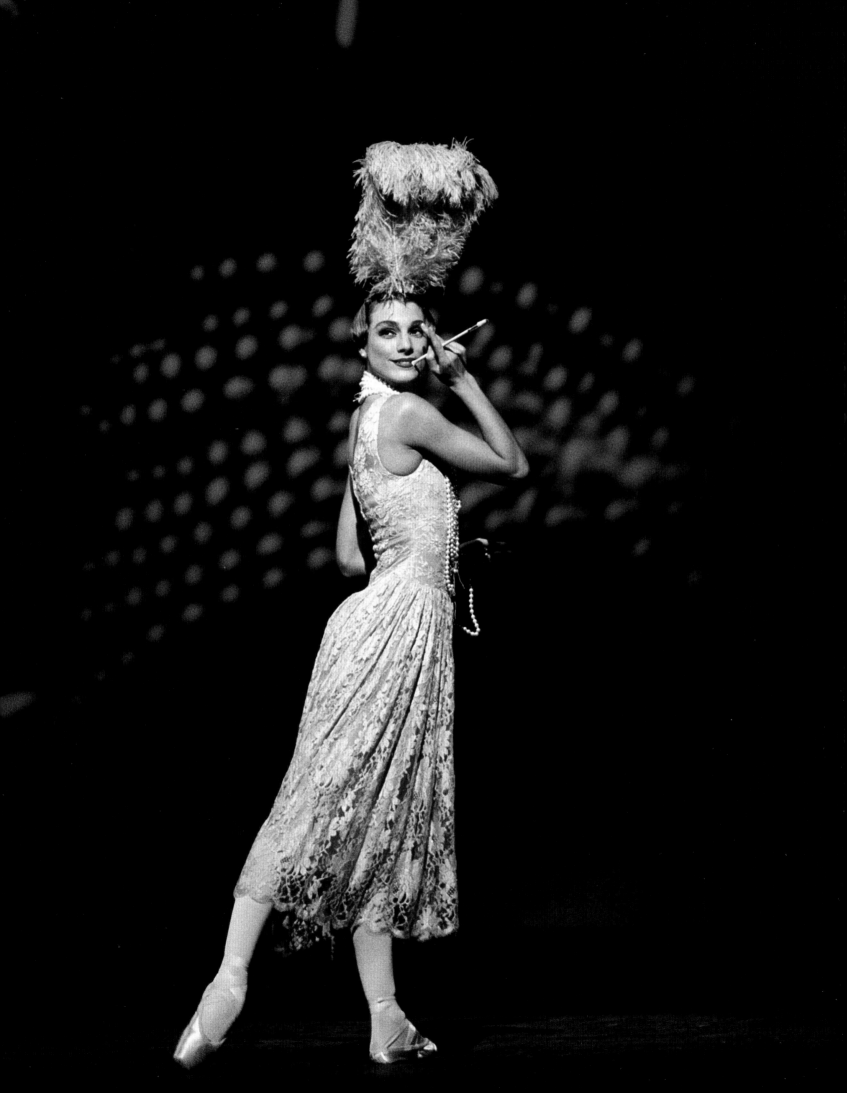

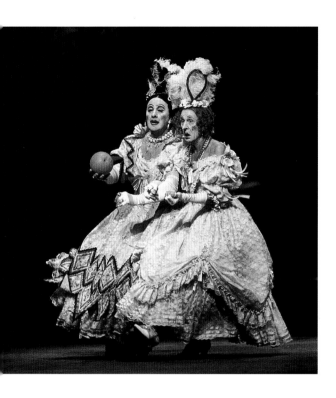

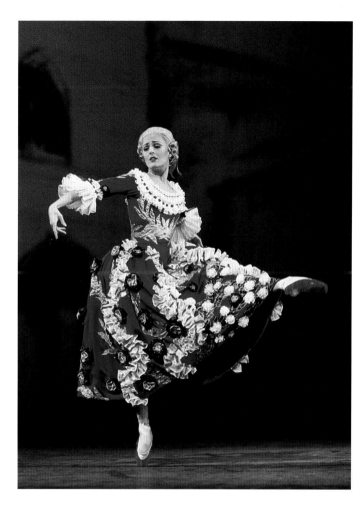

Above: Oliver Symons and David Drew in *Cinderella*

Right: Christina McDermott in *The Good Humoured Ladies*

Below: Jane Burn, Nicola Tranah and Gillian Revie in *Elite Syncopations*

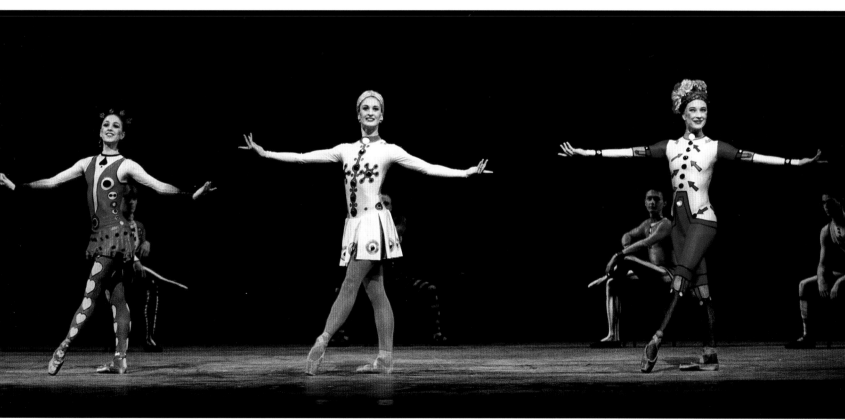

Left: Zenaida Yanowsky as the Hostess in *Les Biches*

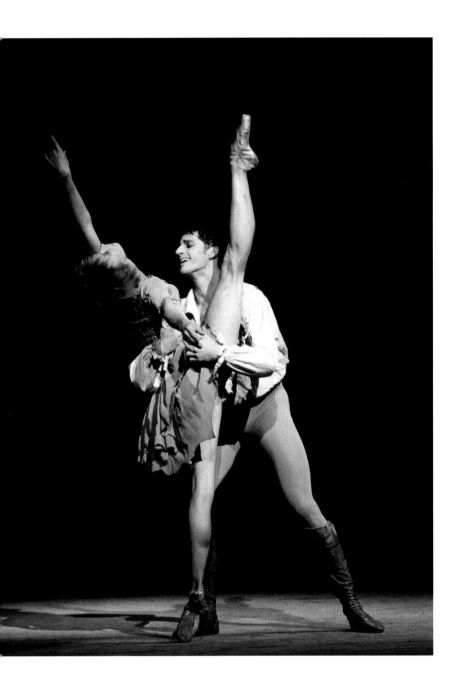

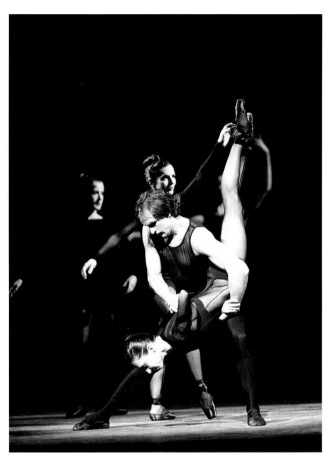

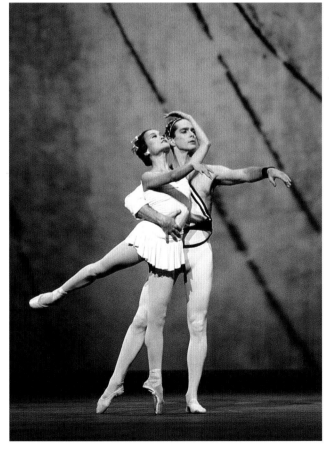

Above: Sylvie Guillem and
Jonathan Cope in *Manon*

Top right: Mara Galeazzi, Irek
Mukhamedov and Nicola Roberts
in *Fearful Symmetries*

Right: Miyako Yoshida and Bruce
Sansom in *Symphonic Variations*

Right: Deborah Bull and
Adam Cooper in *Steptext*

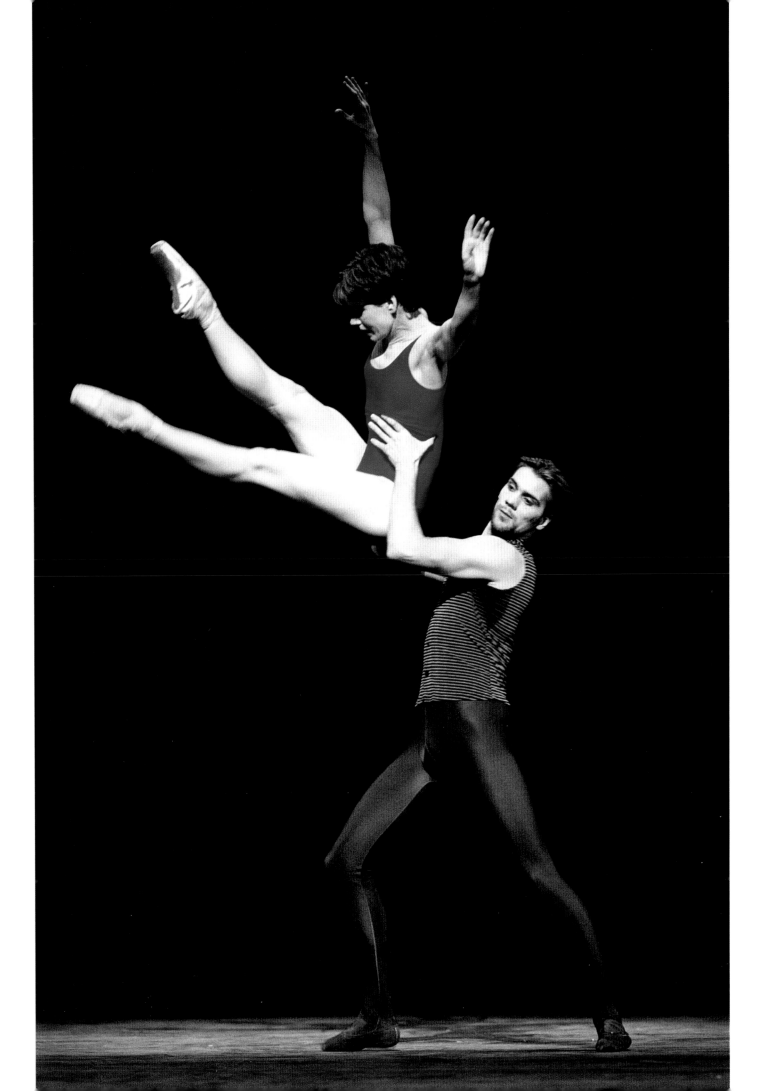

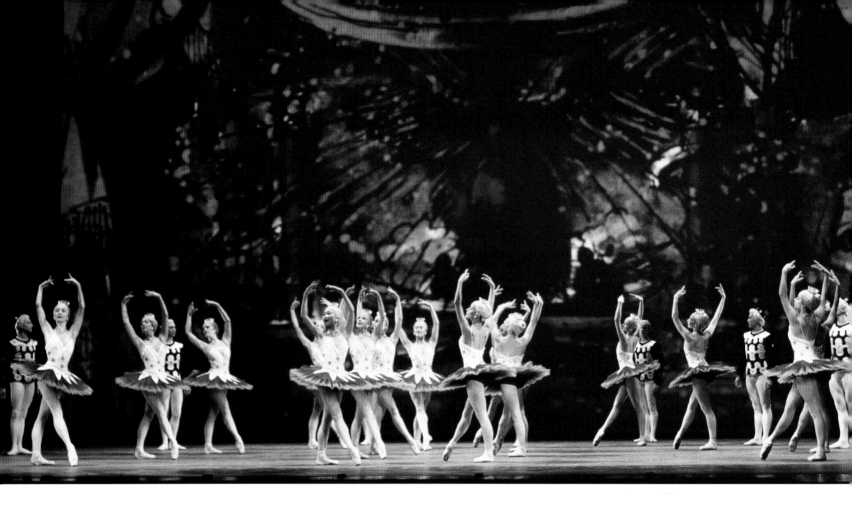

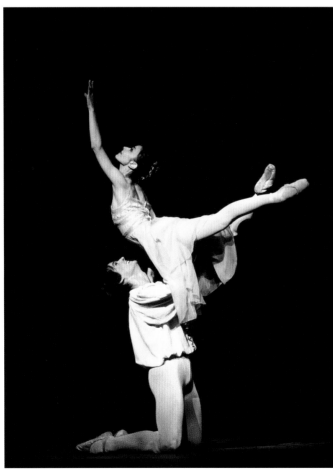

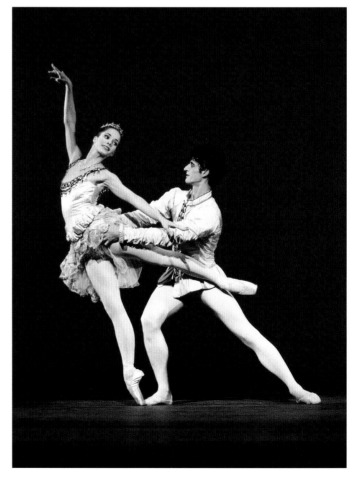

Above: Angel Corella and Viviana Durante in *Romeo and Juliet*

Above: Darcey Bussell and Jonathan Cope in *The Prince of the Pagodas*

Top: Ballet Imperial – Corps de ballet

Right: Jonathan Cope

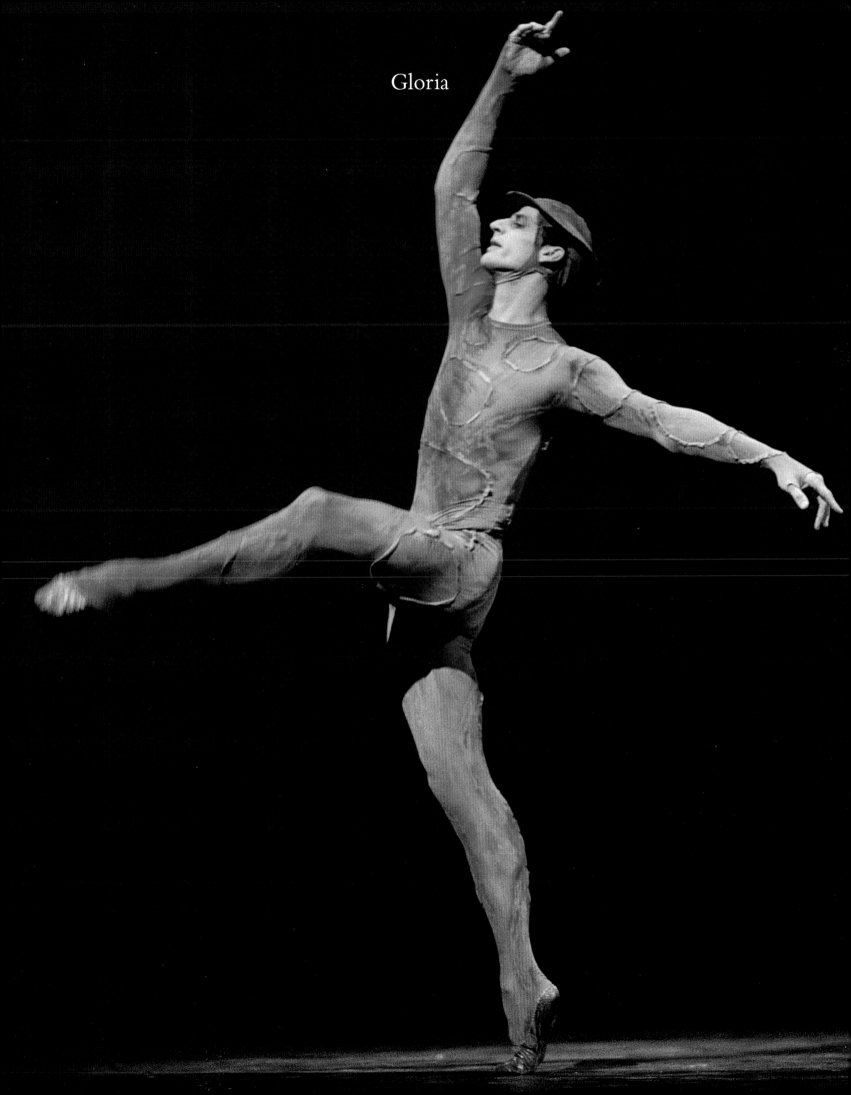

Gloria

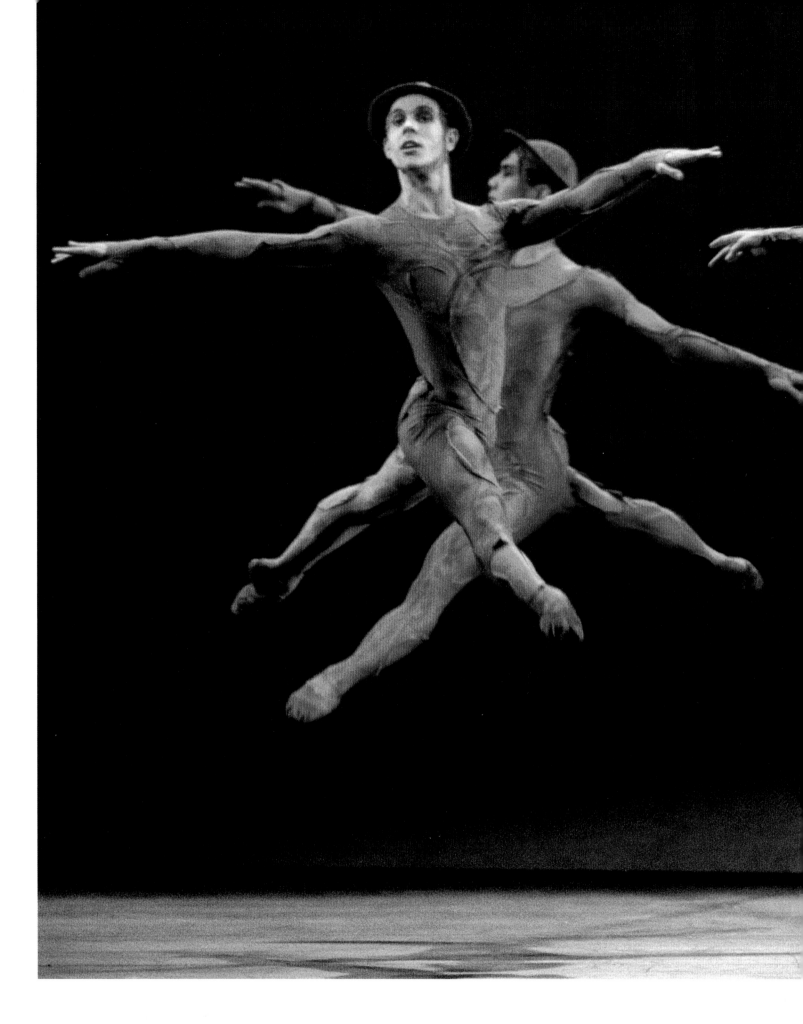

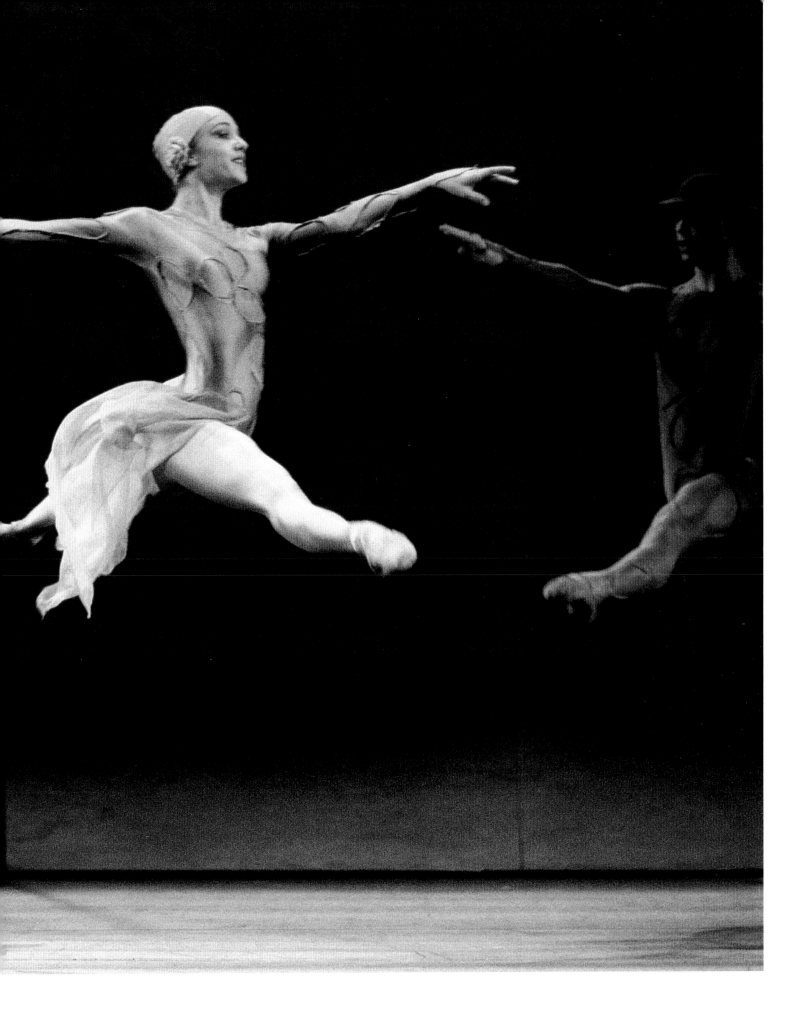

Hubert Essakow and Jane Burn

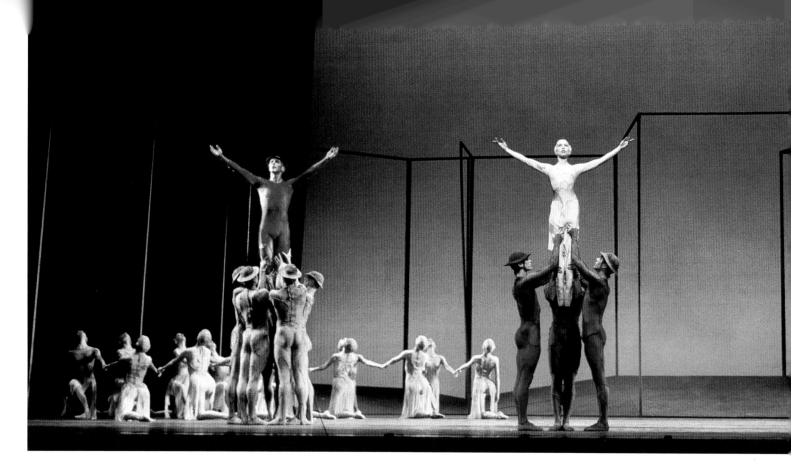

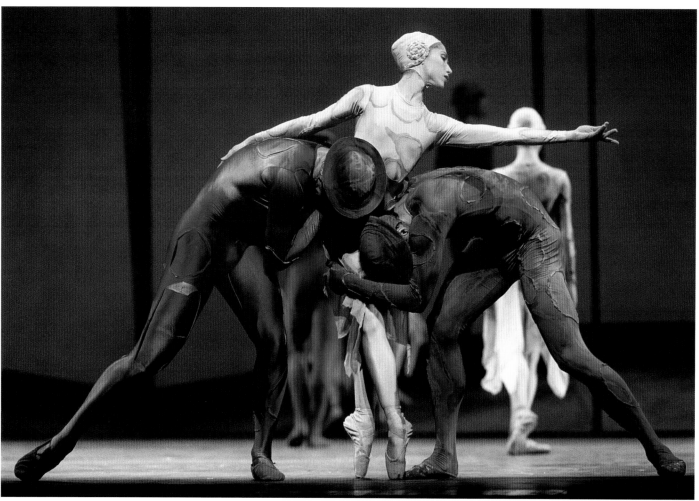

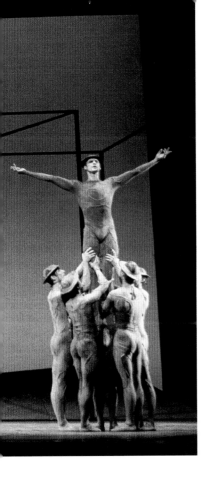

Opposite and overleaf: Christopher Saunders,
Leanne Benjamin and Jonathan Cope

Below: Jonathan Cope

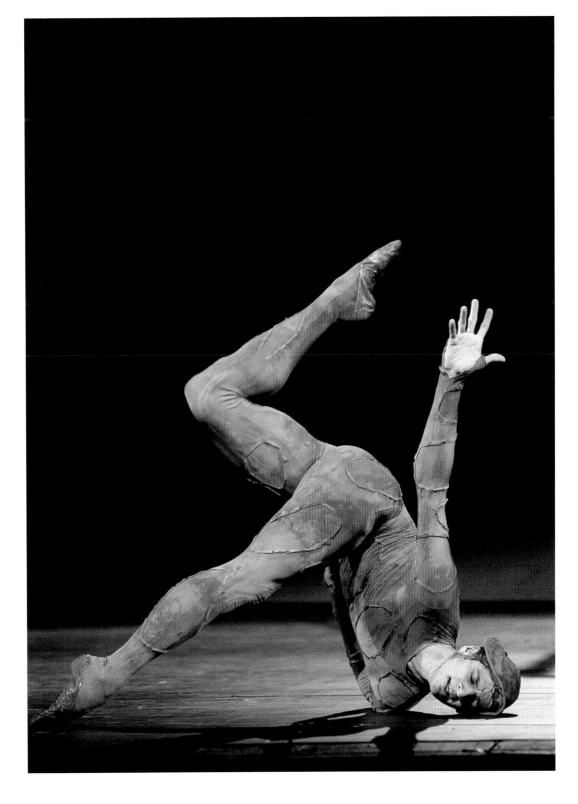

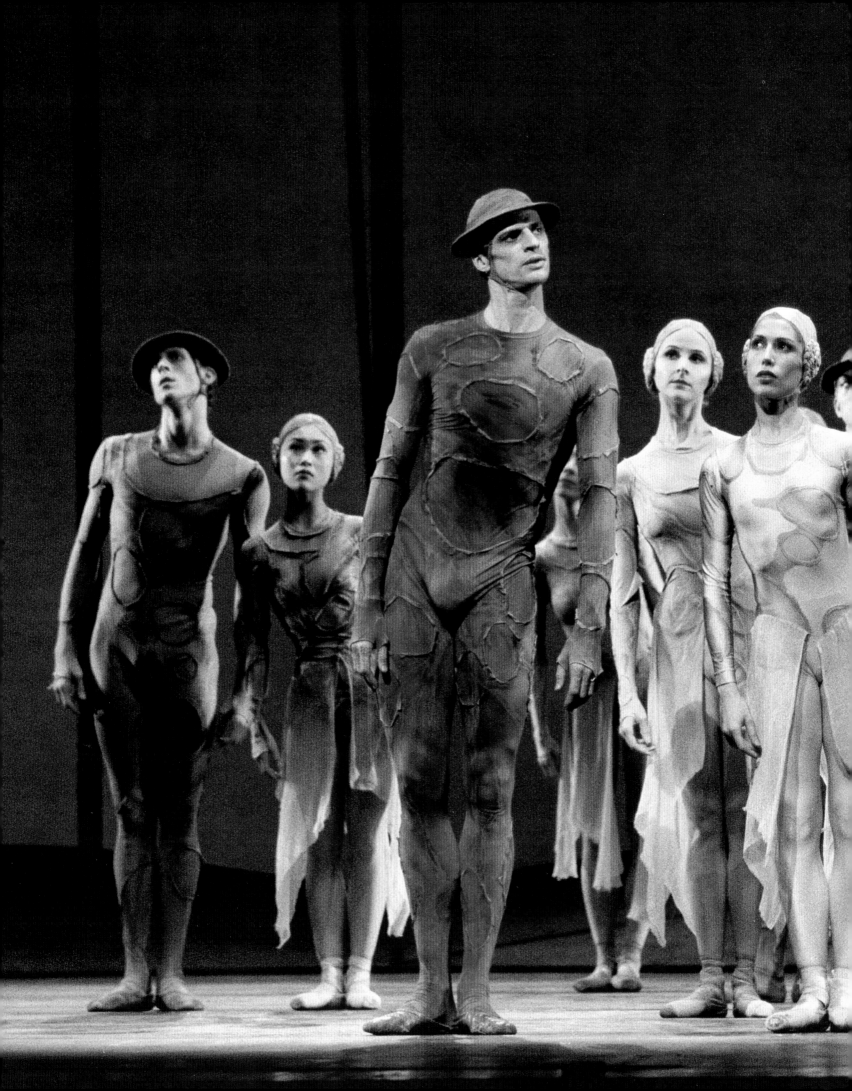

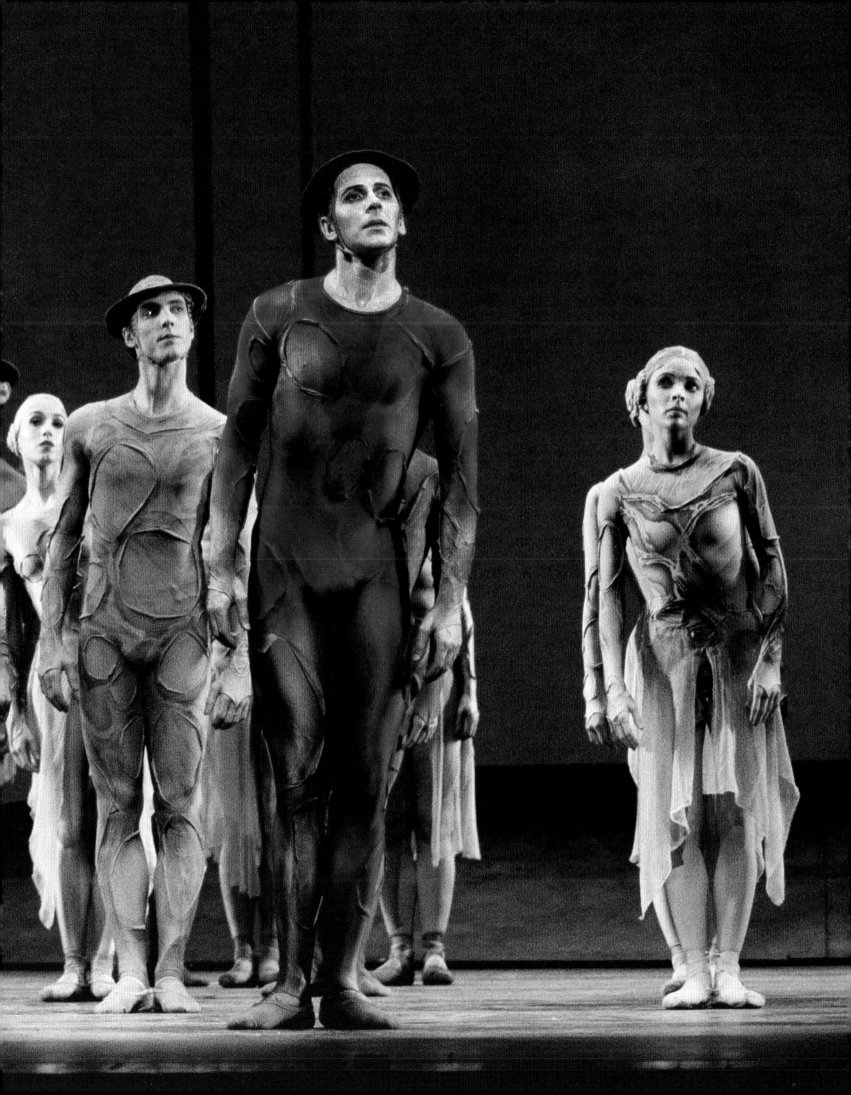

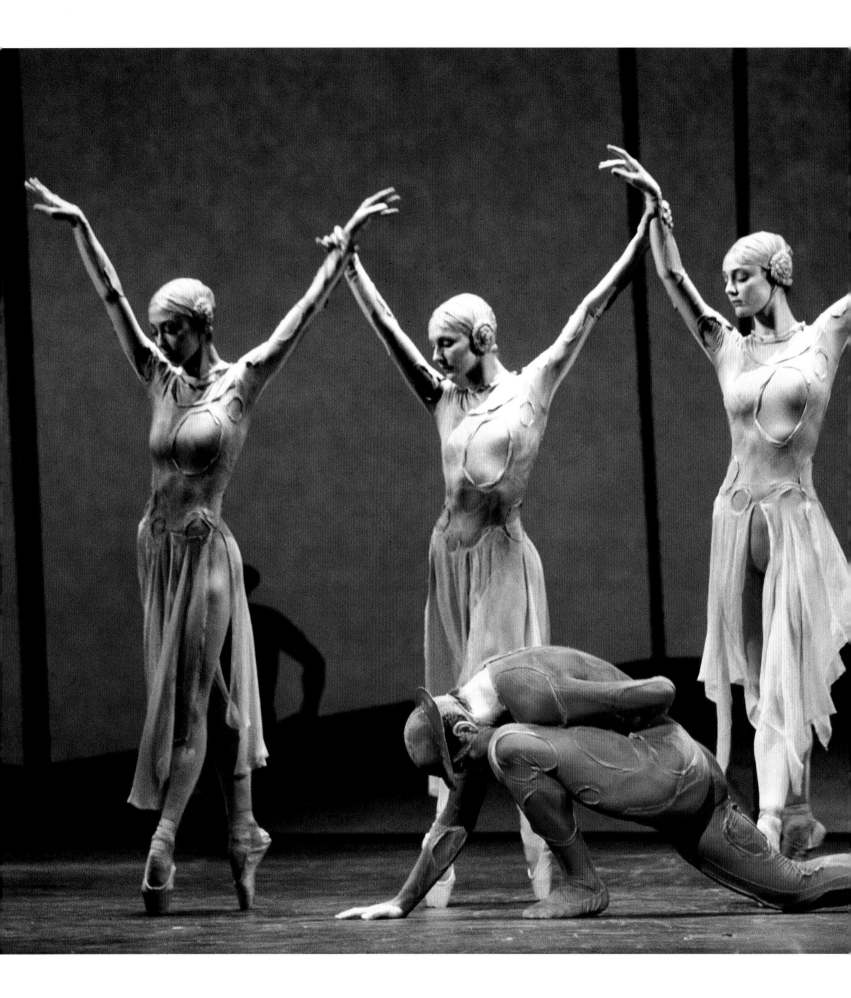

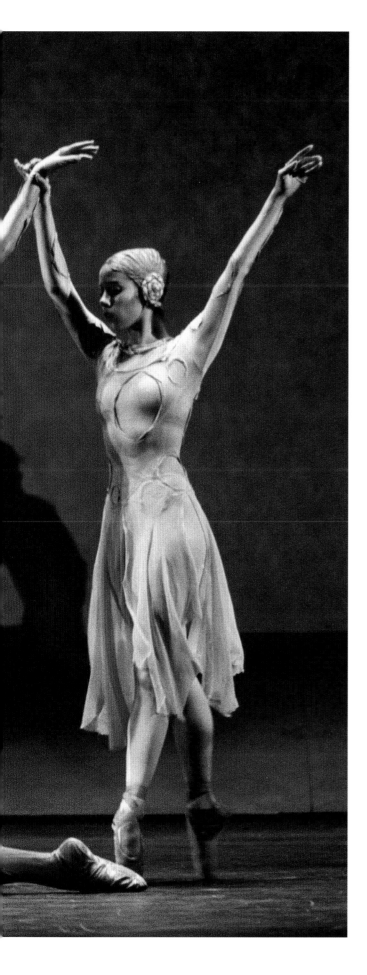

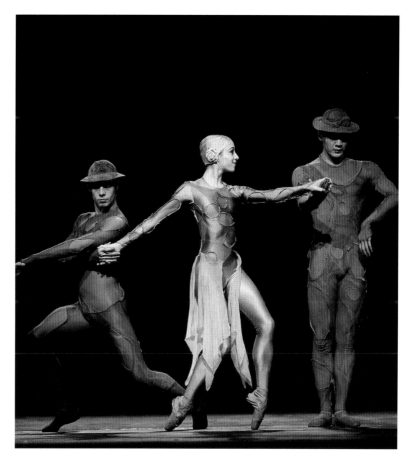

Hubert Essakow, Jane Burn,
Yohei Sasaki

Chloe Davies, Rachel Rawlings,
Nicole Ransley, Jaimie Tapper,
Christopher Saunders

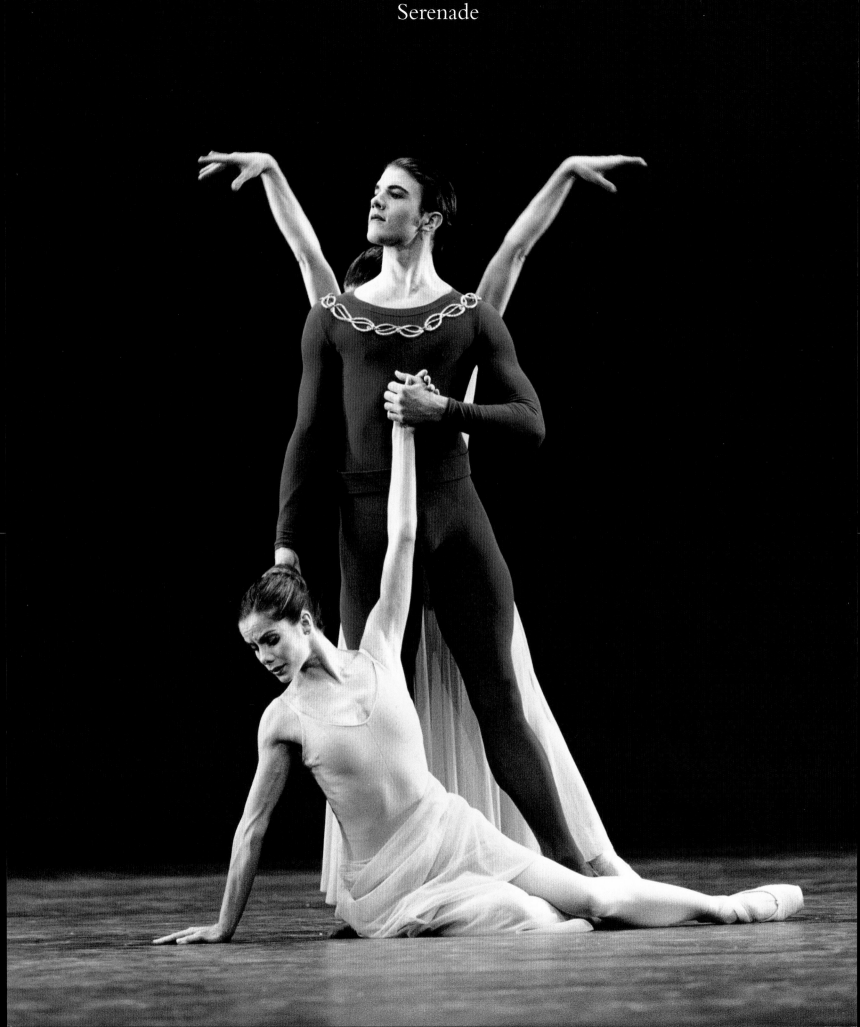

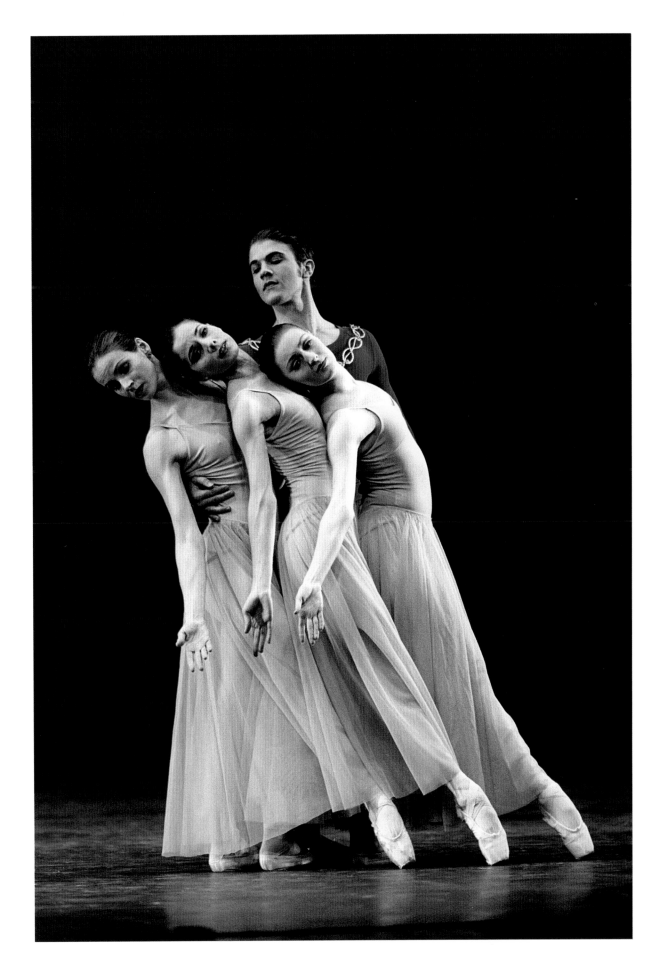

Left: Darcey Bussell and Nigel Burley *Above*: Deborah Bull, Darcey Bussell,
Christina McDermott and Nigel Burley

29

The Firebird

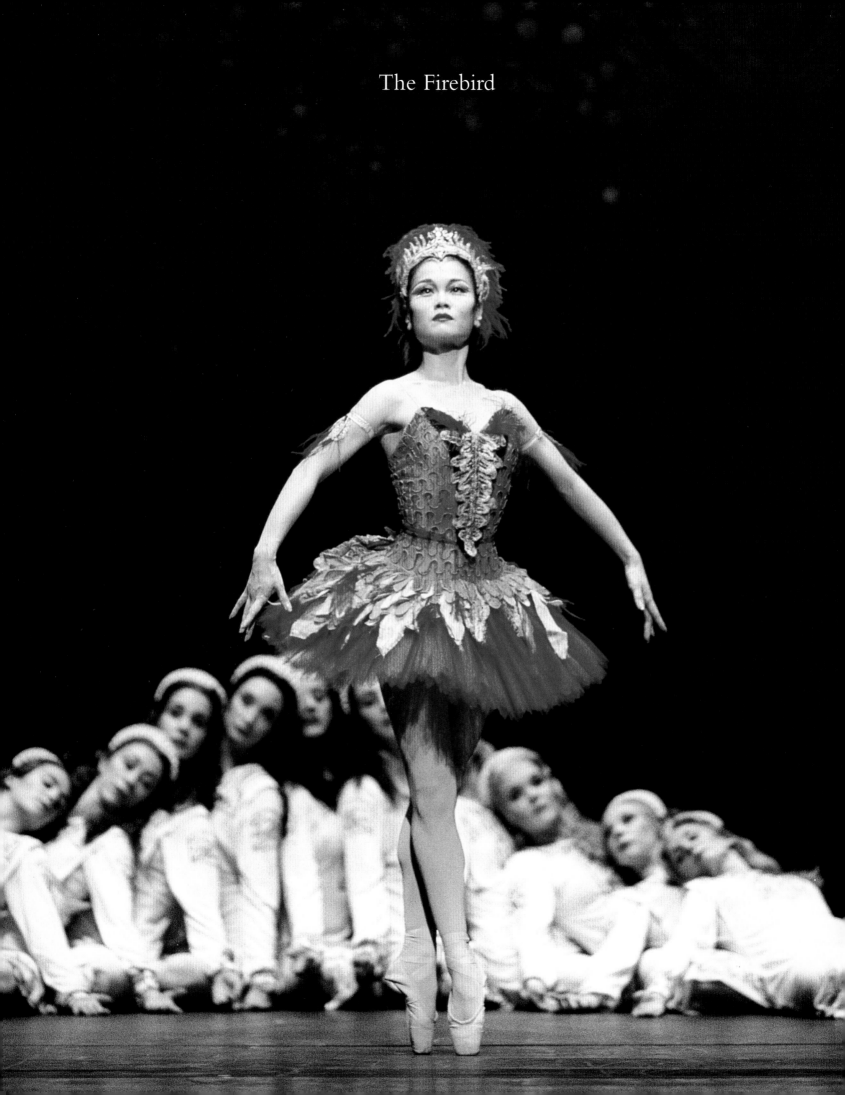

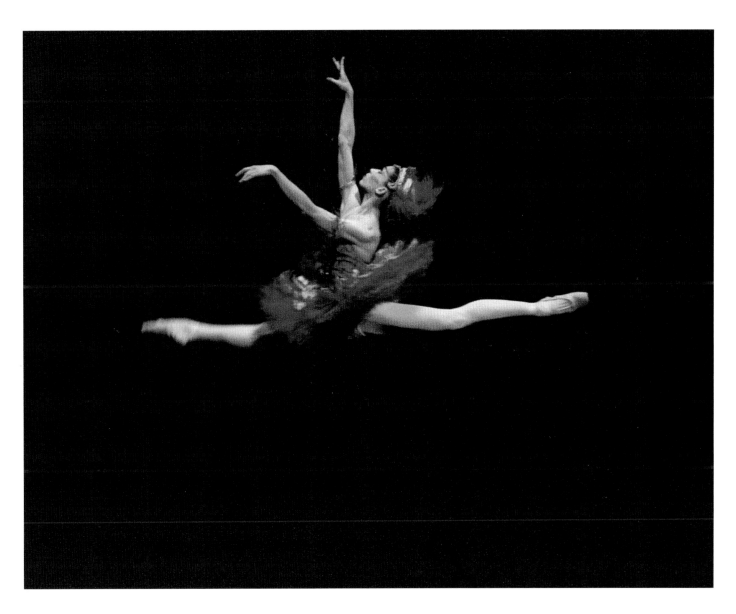

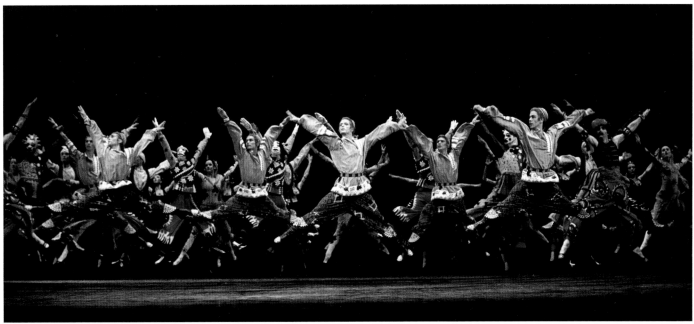

Above: Leanne Benjamin

Left: Miyako Yoshida

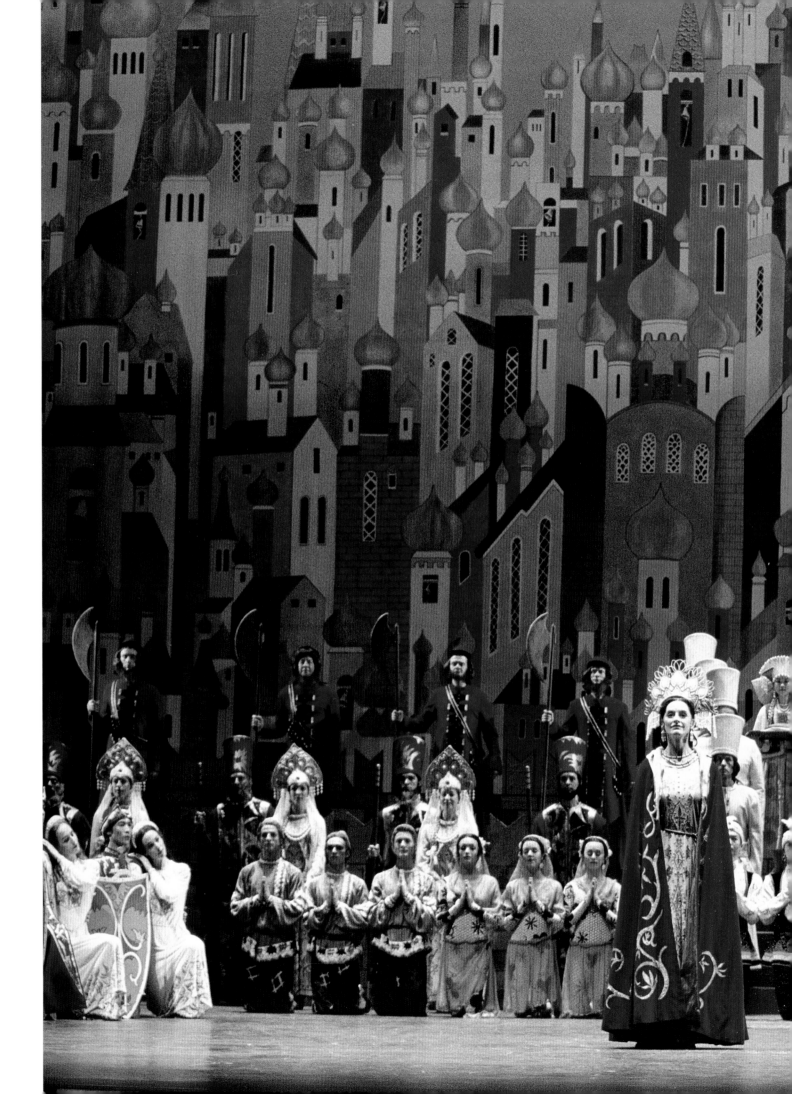

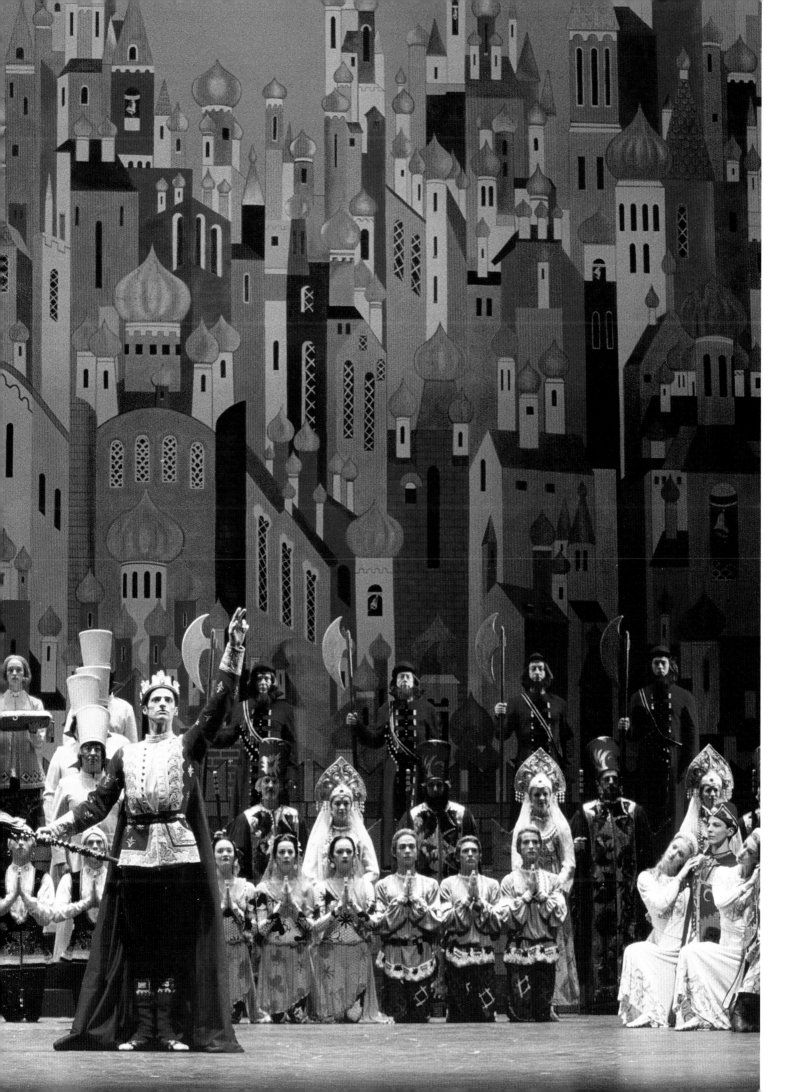

Below: Nigel Burley

Opposite: David Drew

Previous pages:
Final Tableau – Elizabeth
McGorian, Jonathan Cope

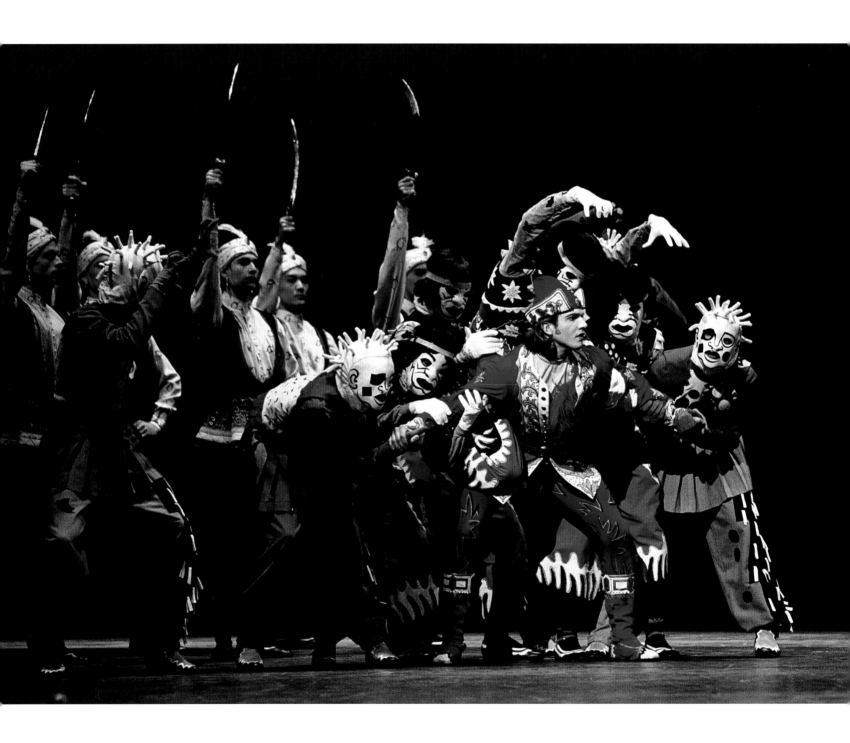

34

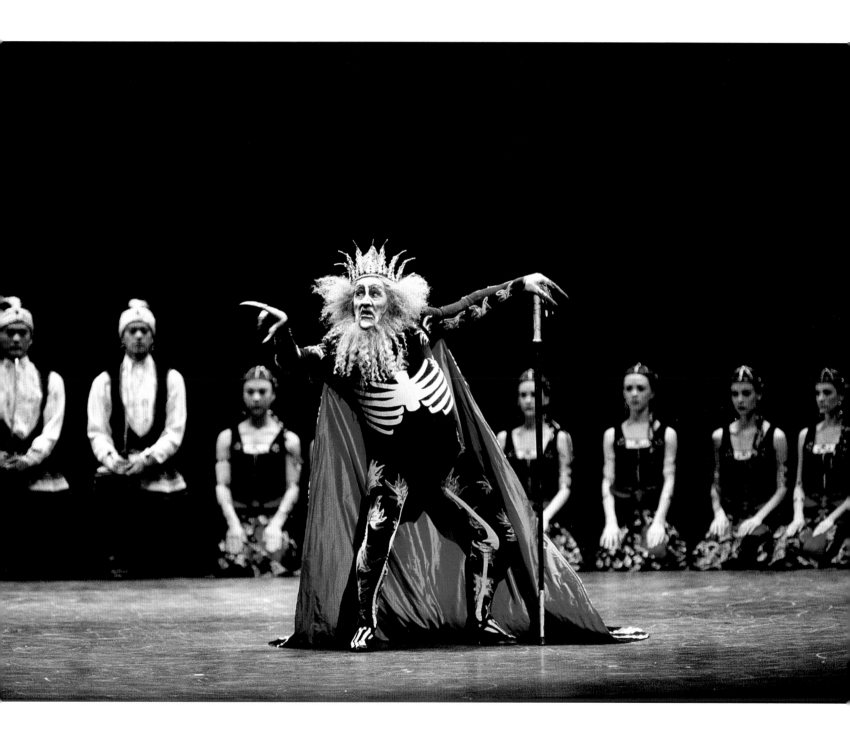

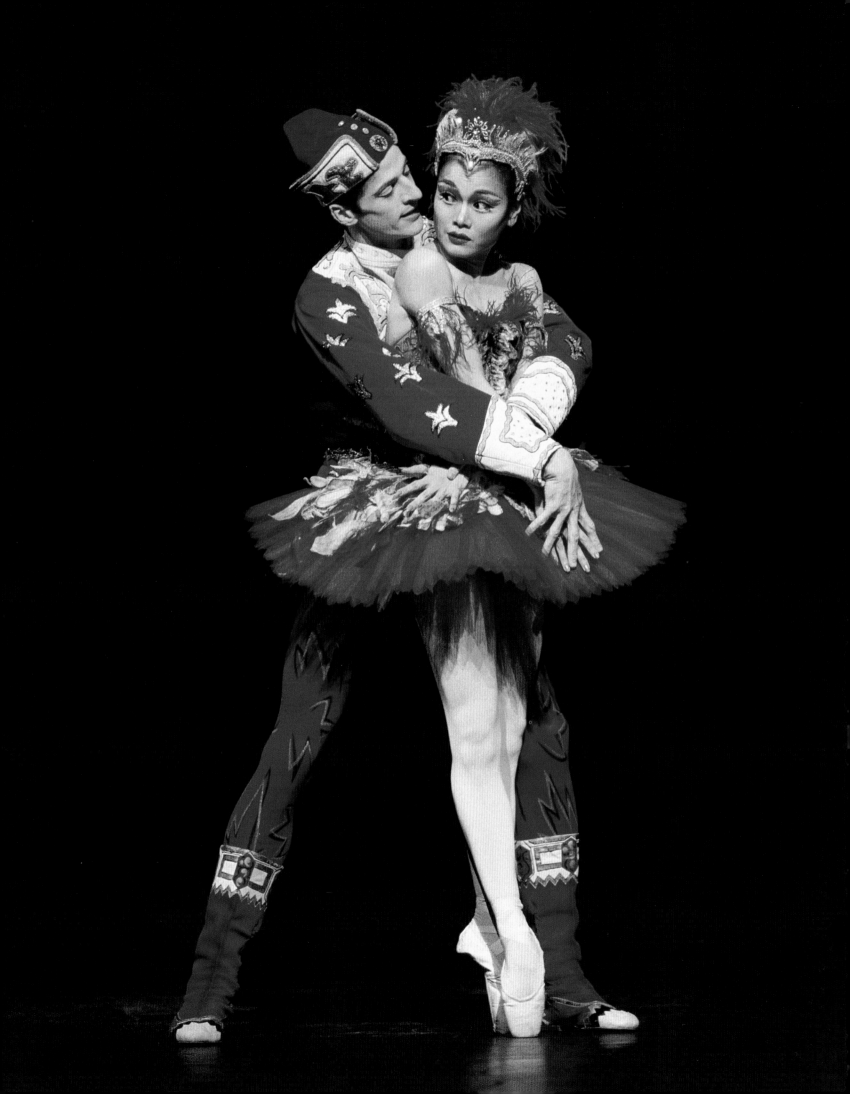

L'Après-midi d'un faune

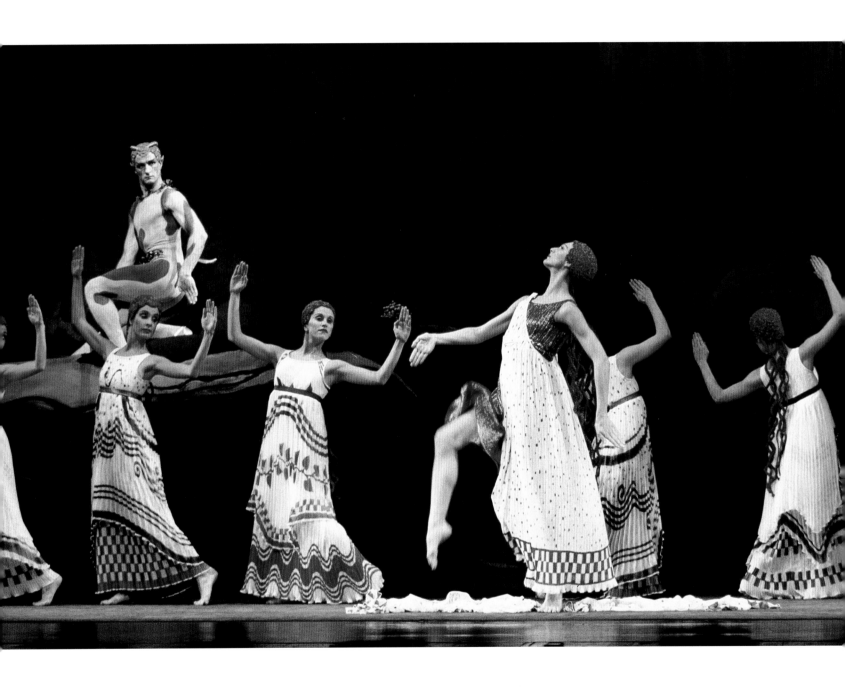

Irek Mukhamedov and
Zenaida Yanowsky

Previous page: Irek Mukhamedov

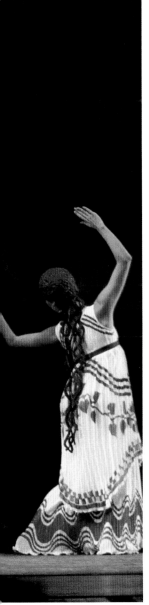
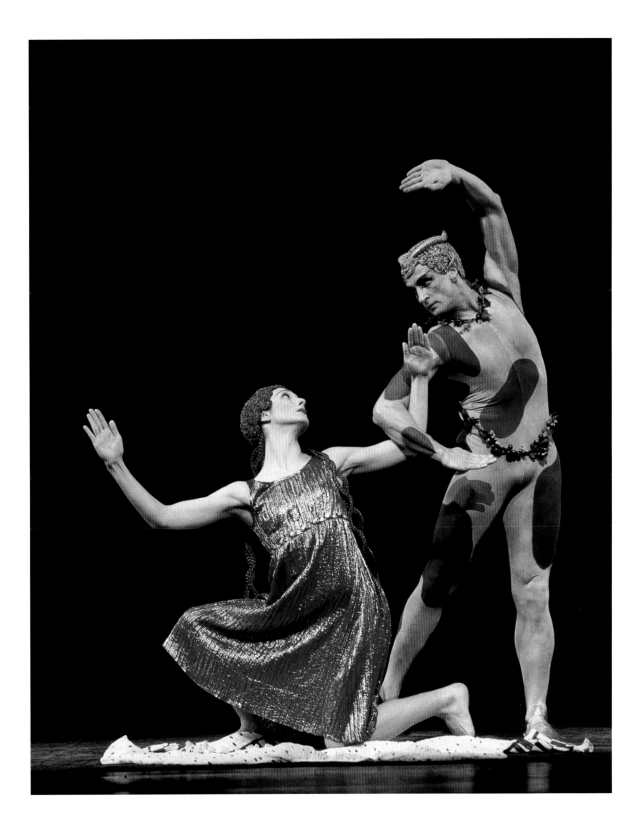

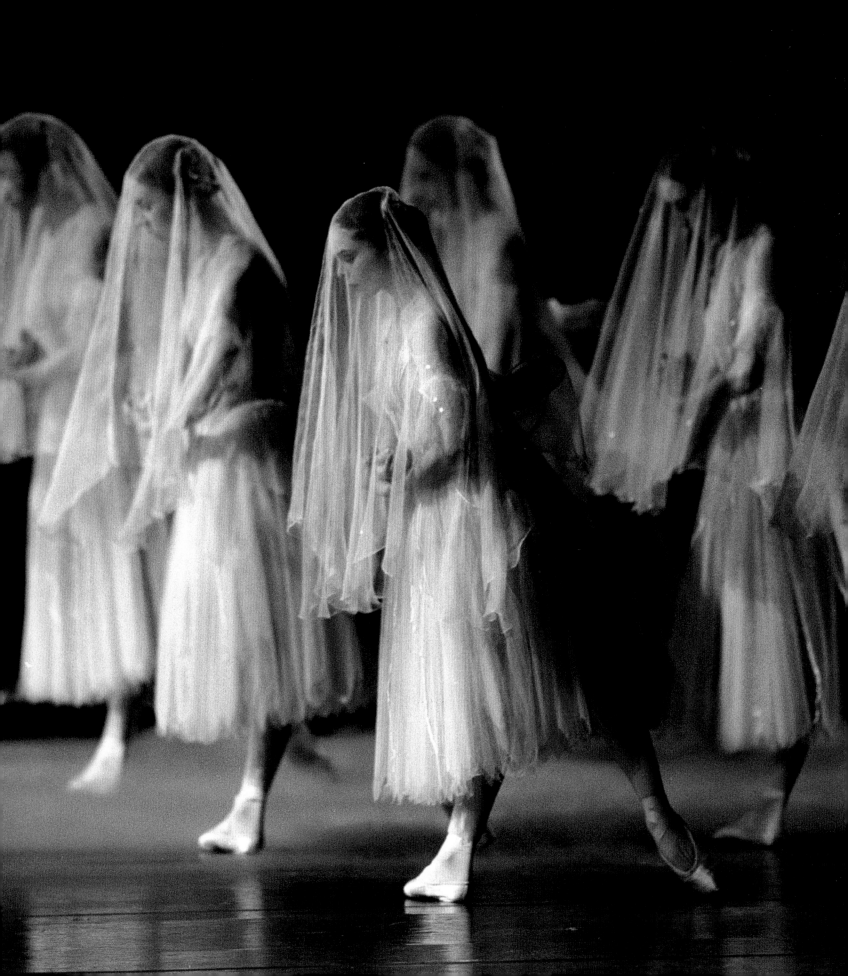

Giselle

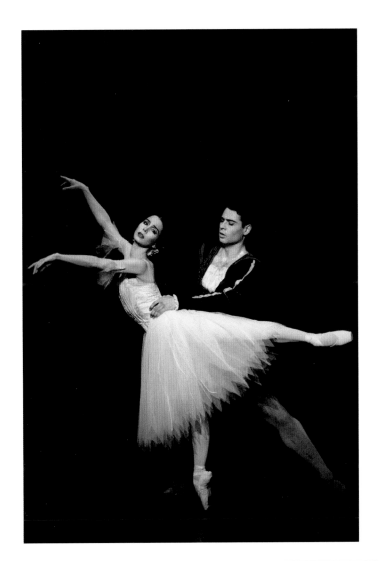

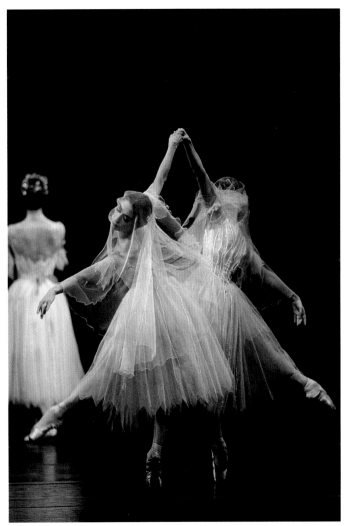

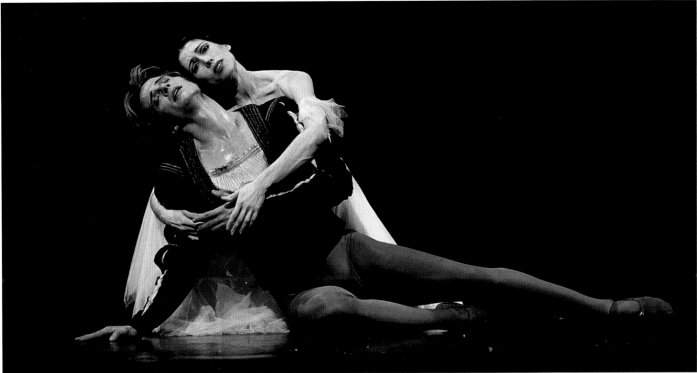

Above: Leanne Benjamin, Ethan Stiefel

Top left: Tamara Rojo, Inaki Urlezaga

41

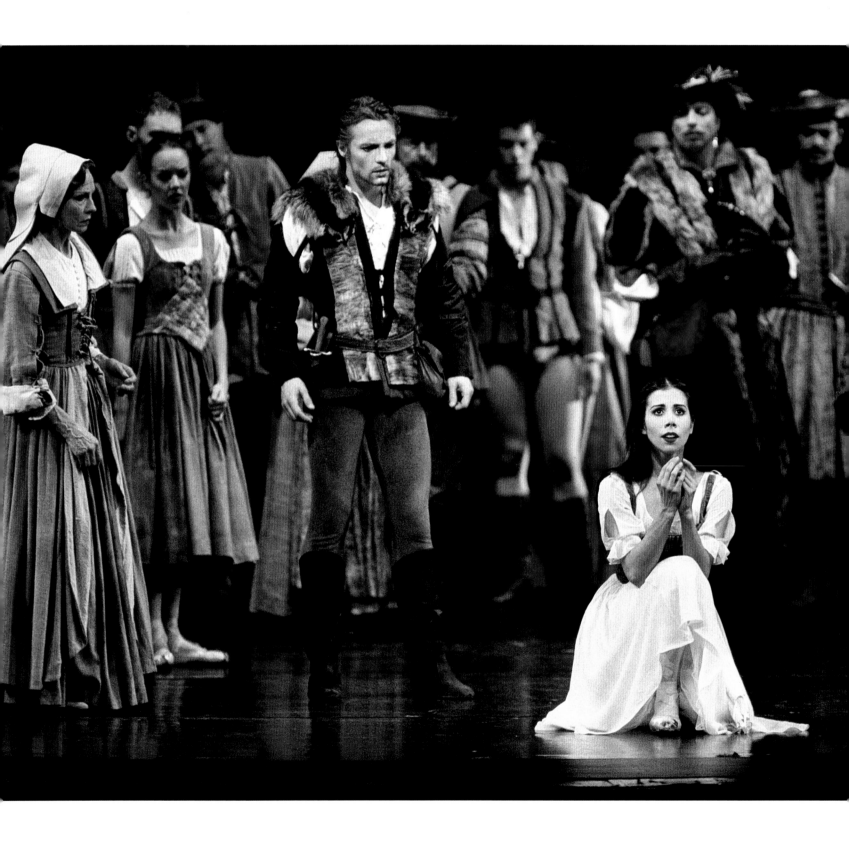

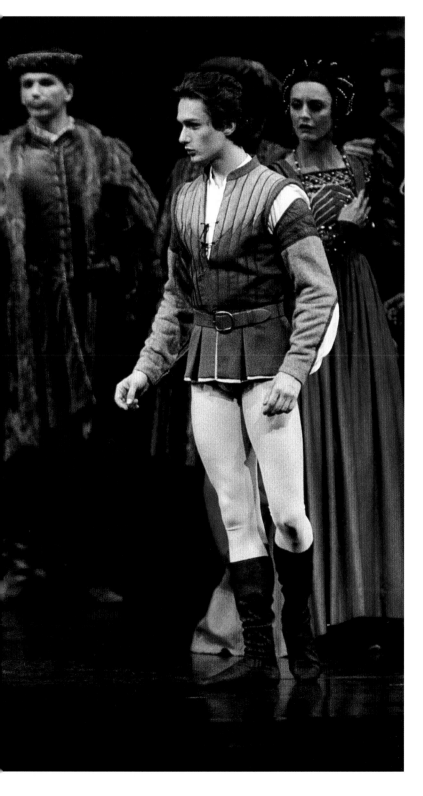

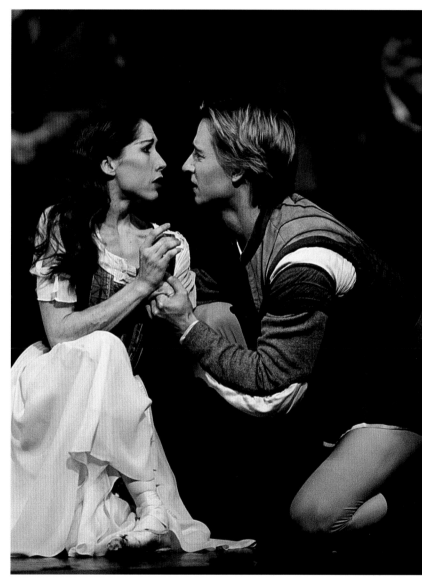

Above: Leanne Benjamin, Ethan Stiefel

Left: Sandra Conley, Thomas Whitehead, Jaimie Tapper, Ivan Putrov

Following pages, top: Christopher Saunders, Nicola Tranah, Genesia Rosato, Alina Cojocaru, *bottom:* Sian Murphy, Jenny Tattersall, Alastair Marriott, Jaimie Tapper

43

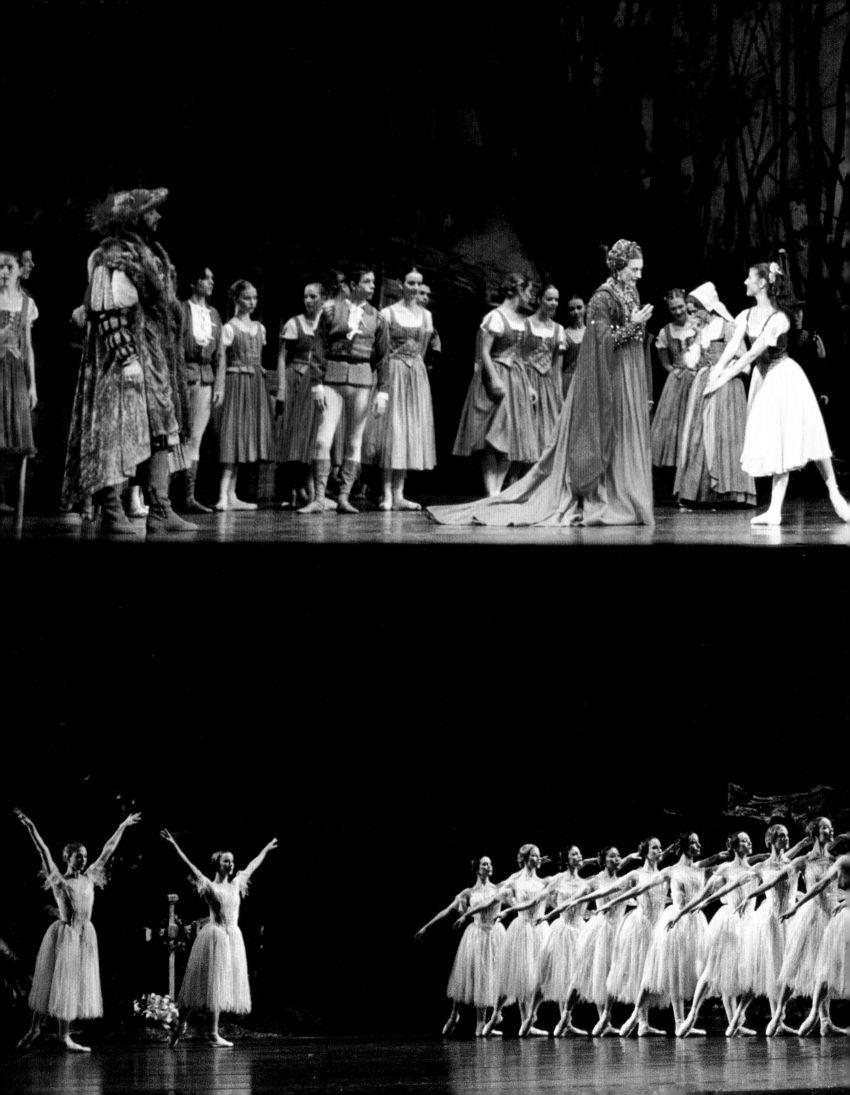

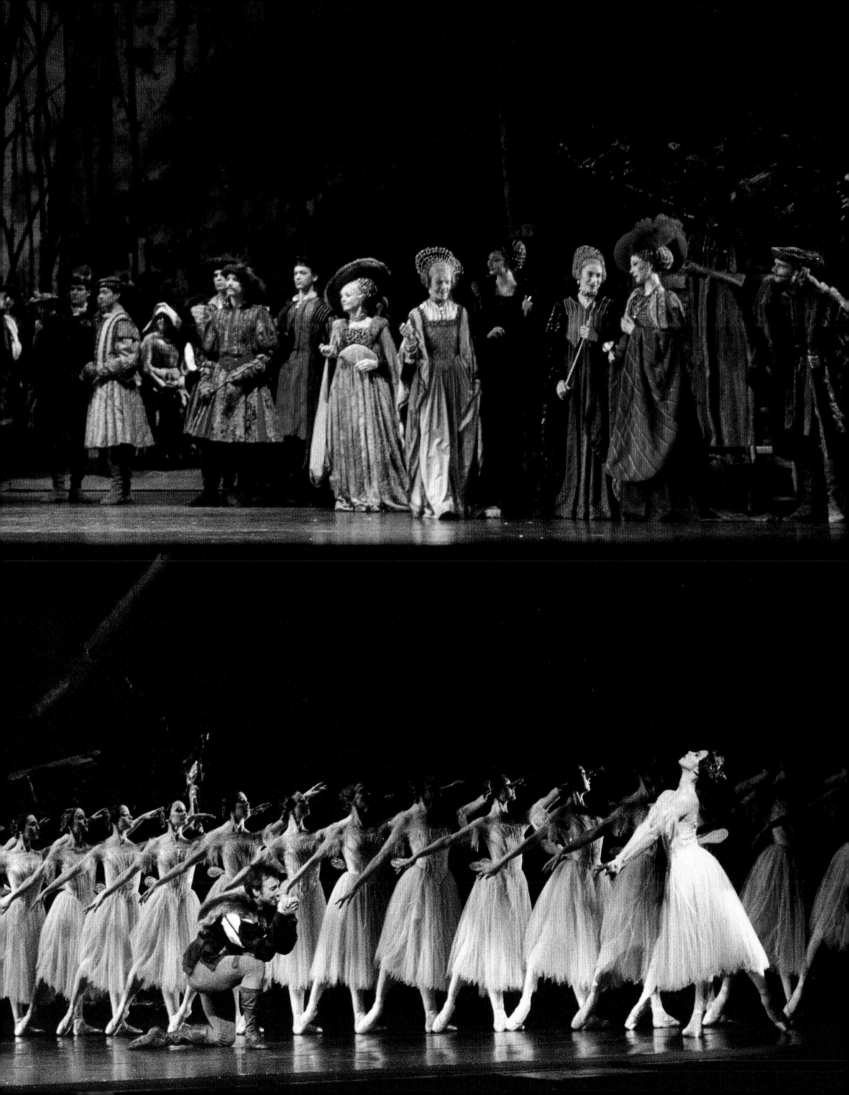

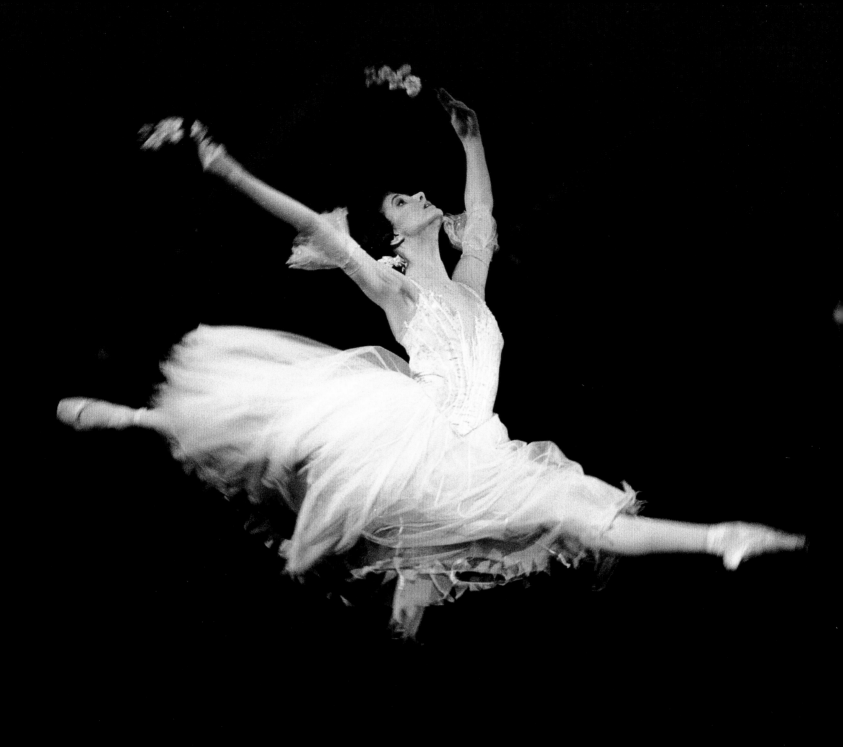

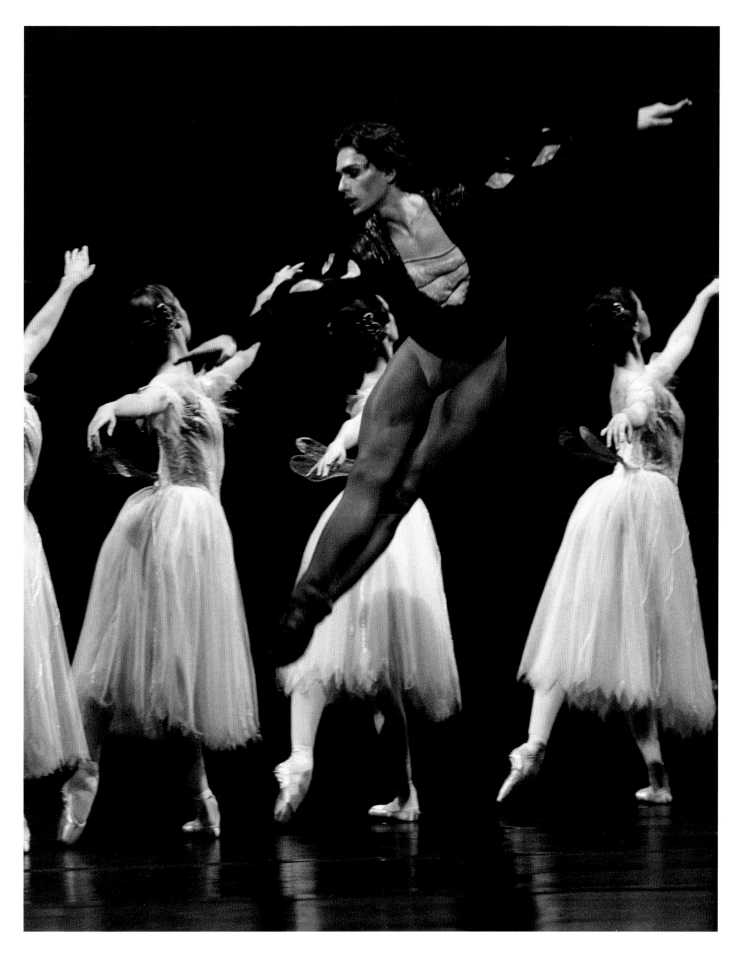

Above: Ivan Putrov

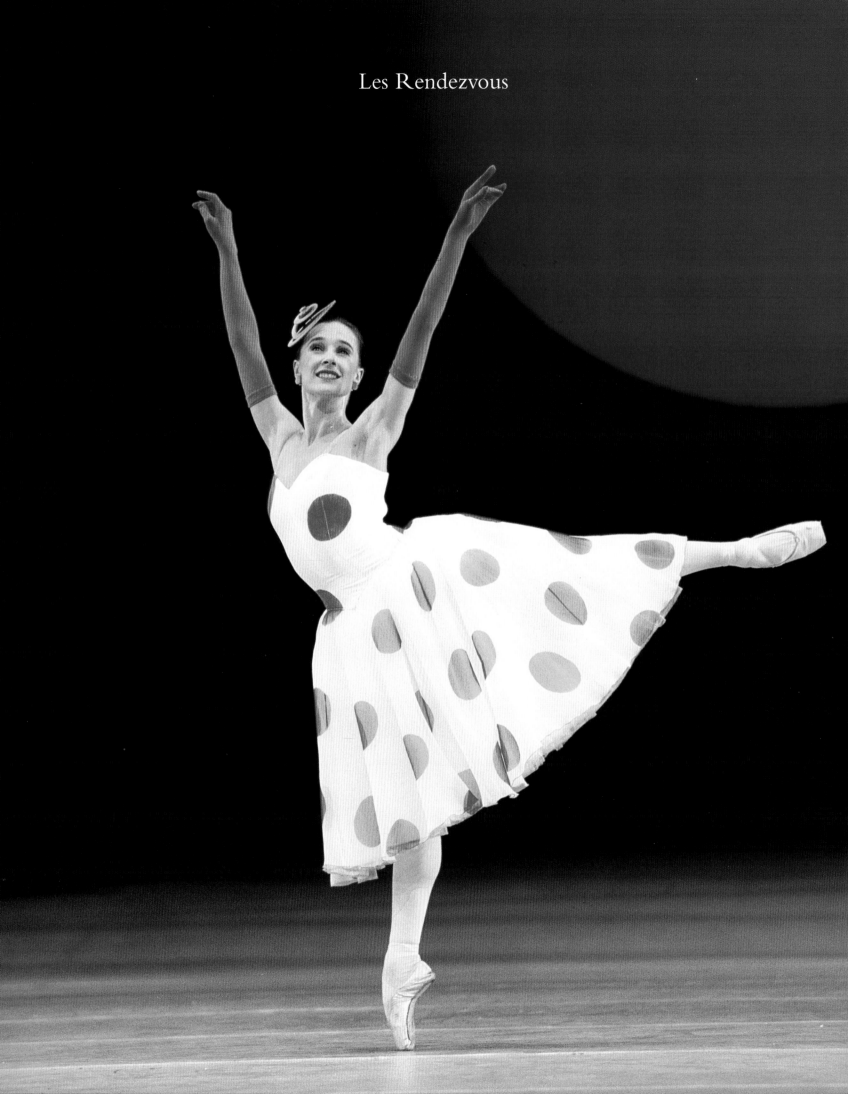

Les Rendezvous

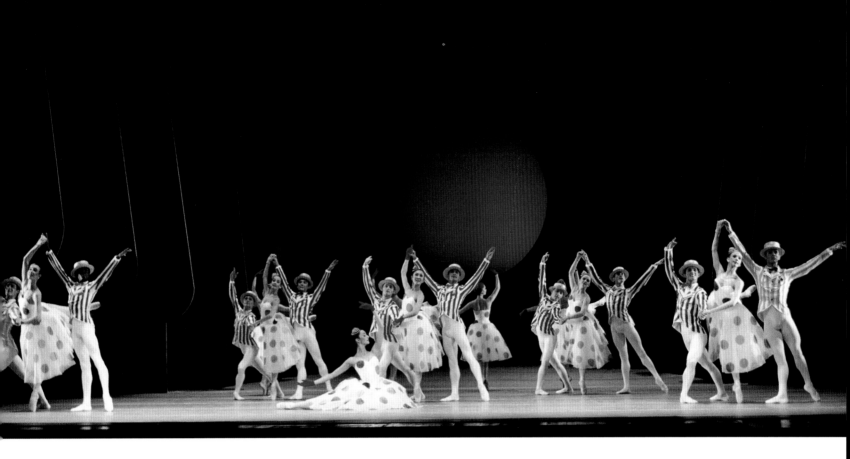

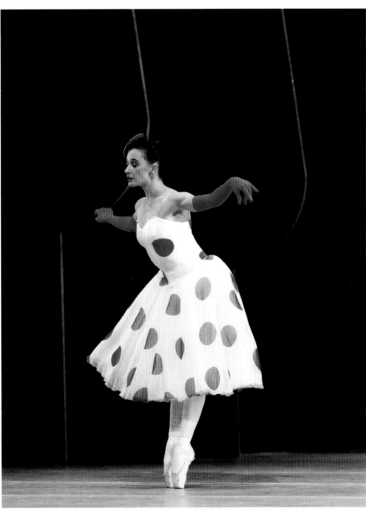

Gillian Revie

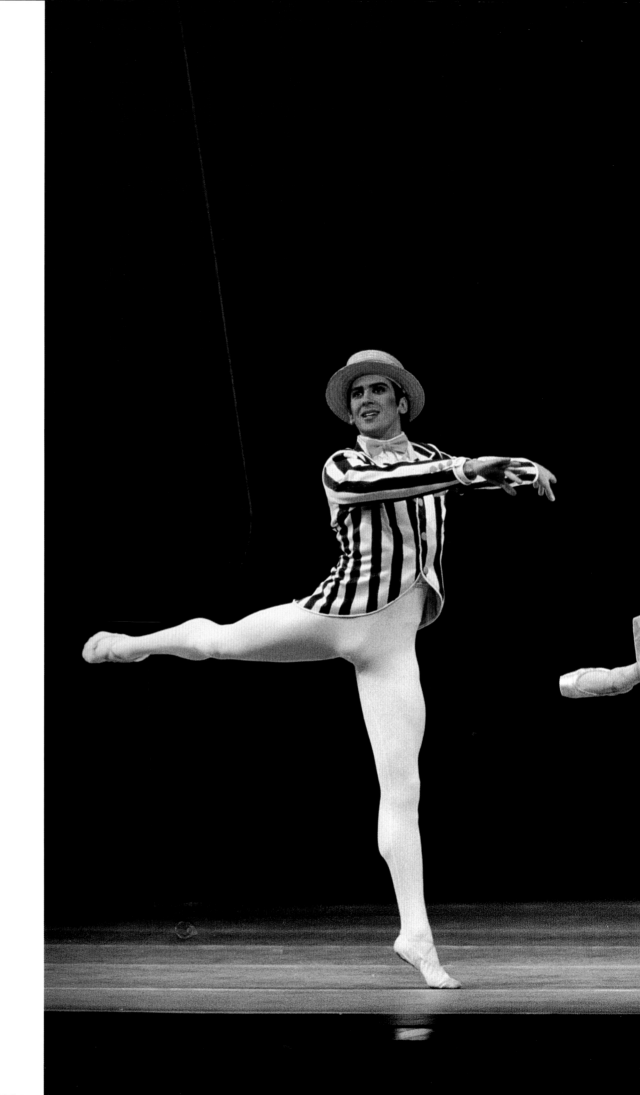

Justin Meissner, Jaimie Tapper,
Jonathan Howells

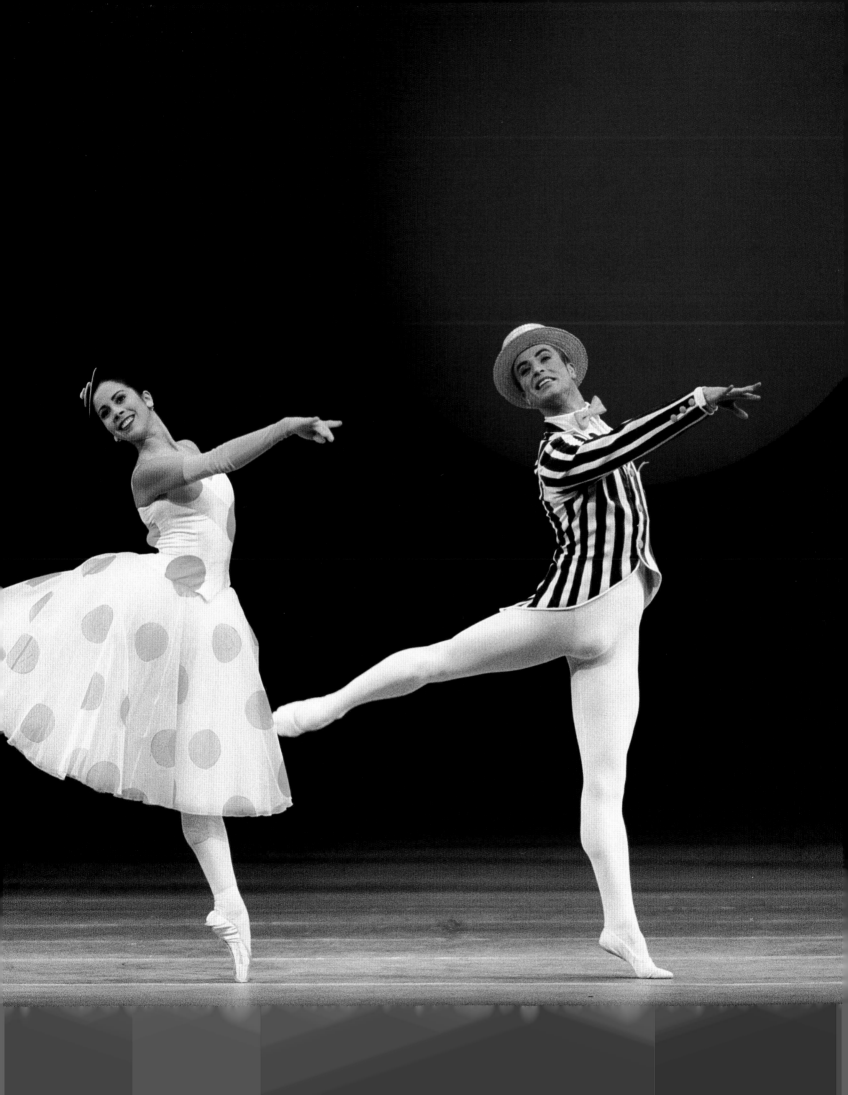

Symphonic Variations

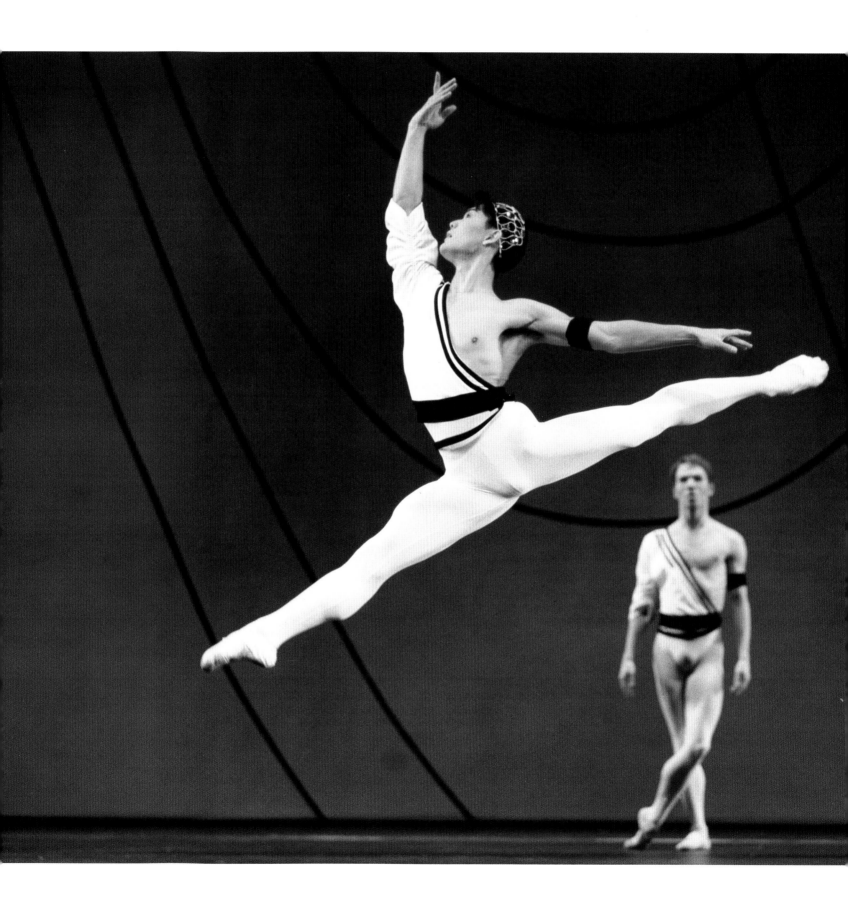

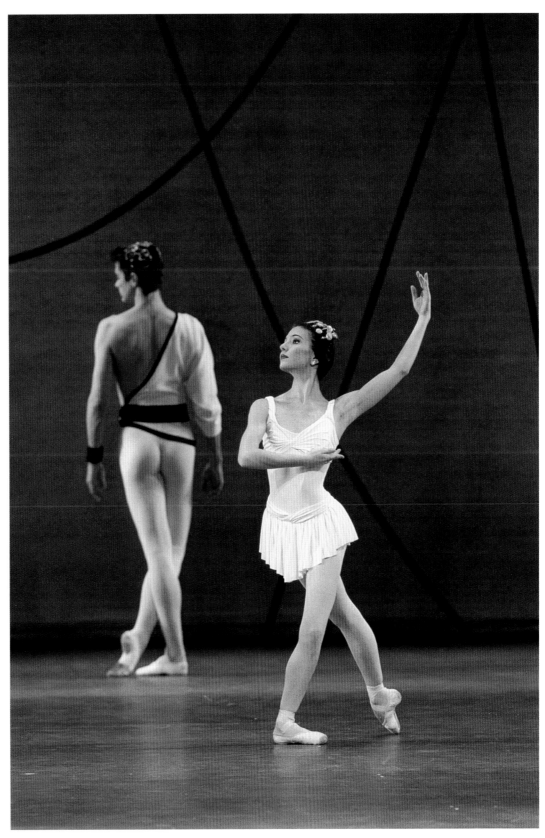

Above: Bruce Sansom, Alina Cojocaru

Opposite: Yohei Sasaki, Johan Kobborg

A Stranger's Taste

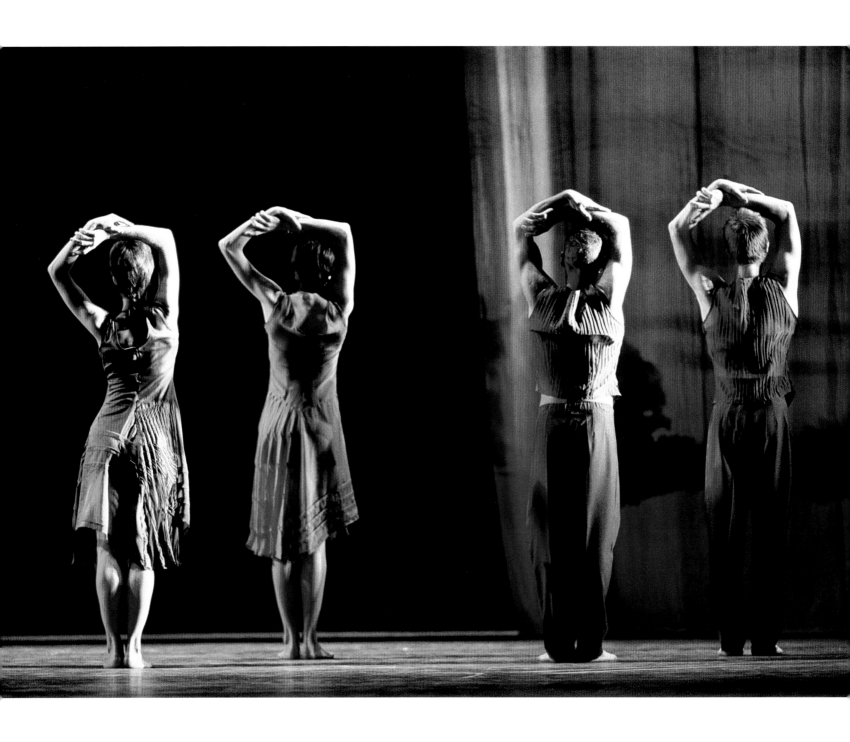

Right: Peter Abegglen

Overleaf left: Bruce Sansom,
Gillian Revie, Luke Heydon
right: Sarah Wildor

54

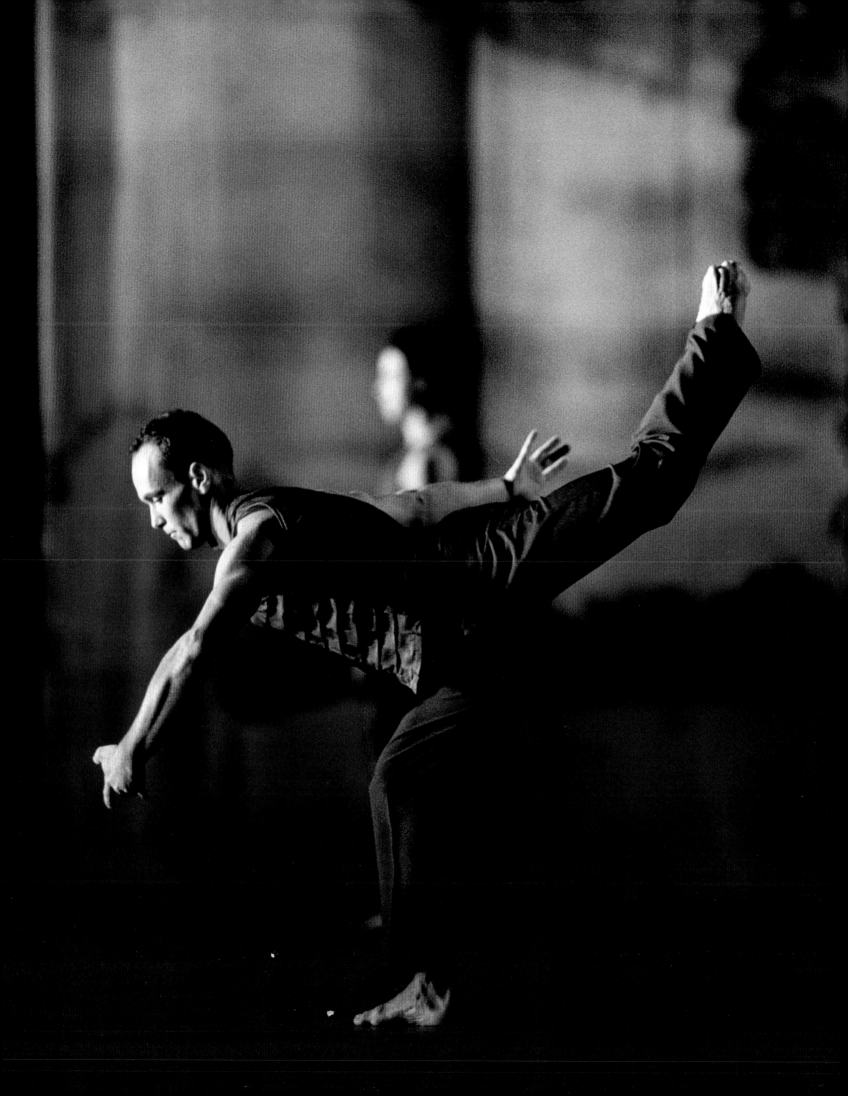

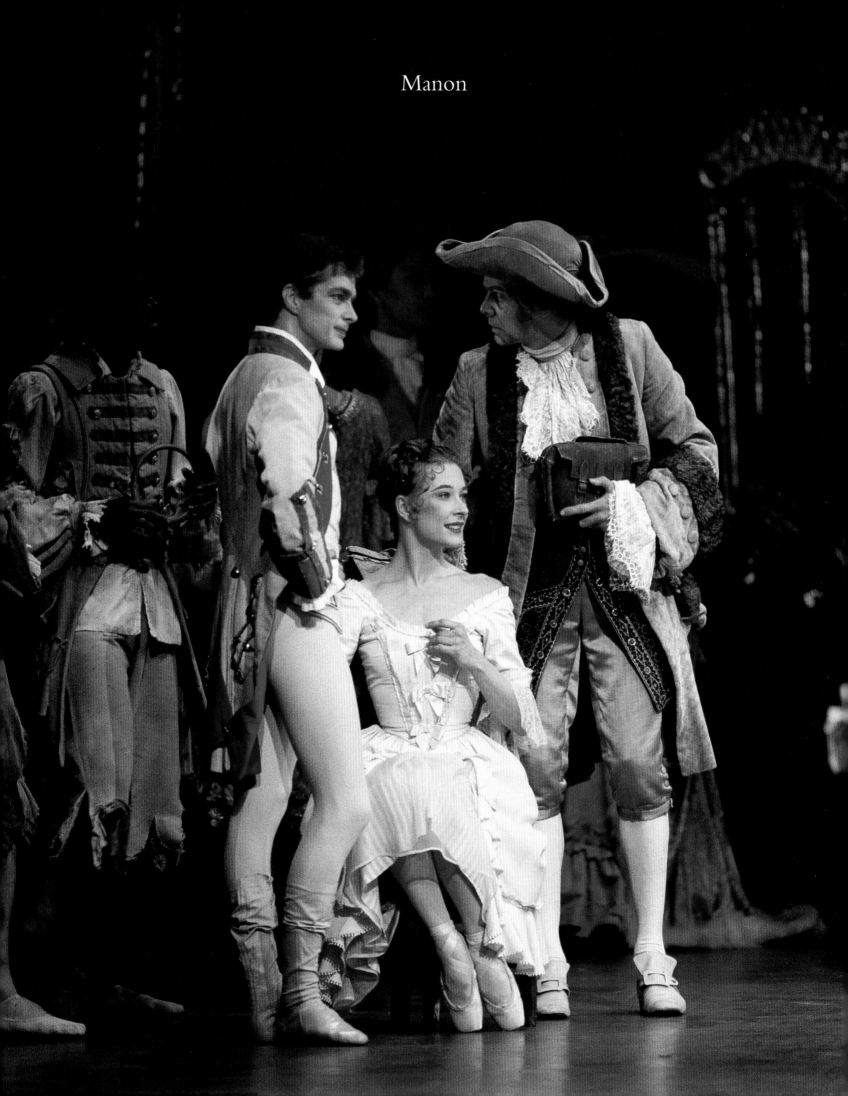

Manon

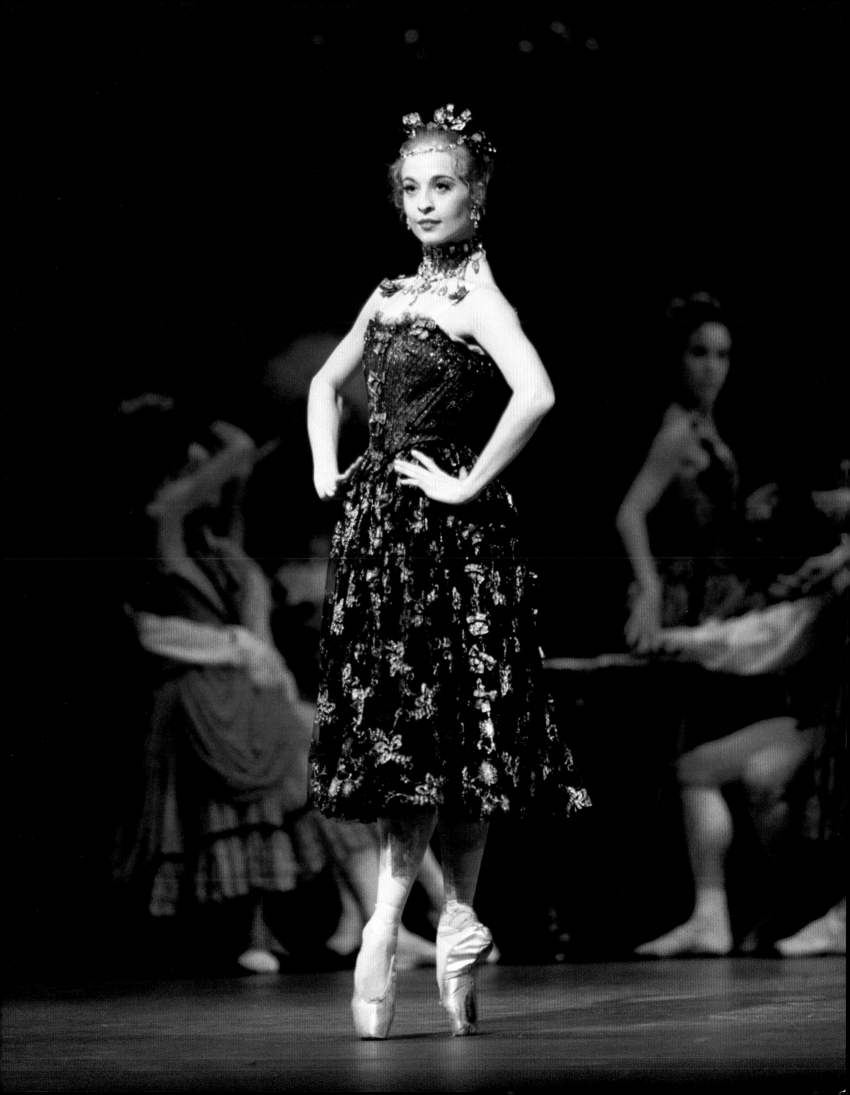

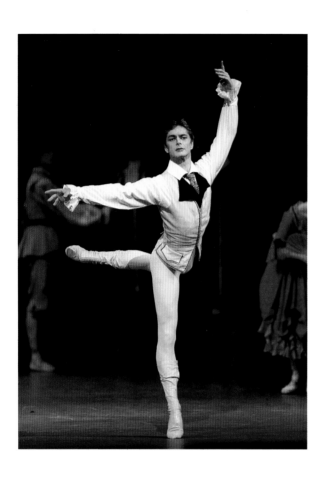

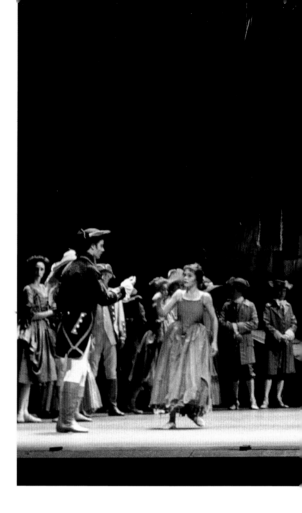

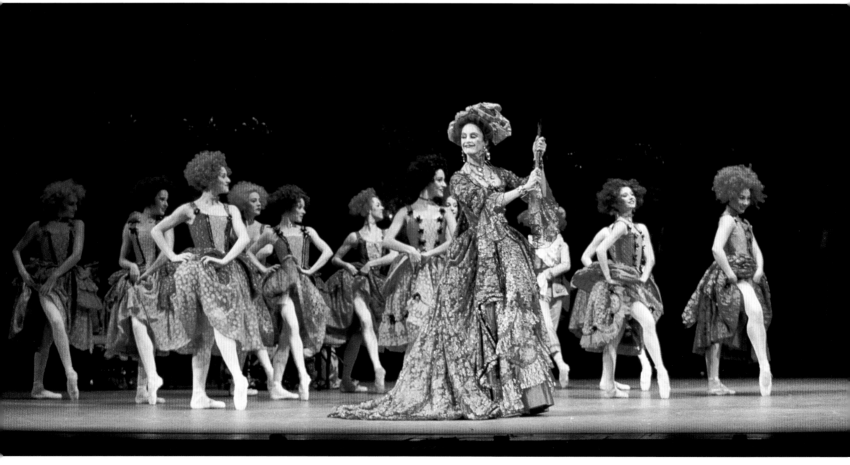

Top left: Bruce Sansom

Above: Elizabeth McGorian (Madam with Corps de ballet)

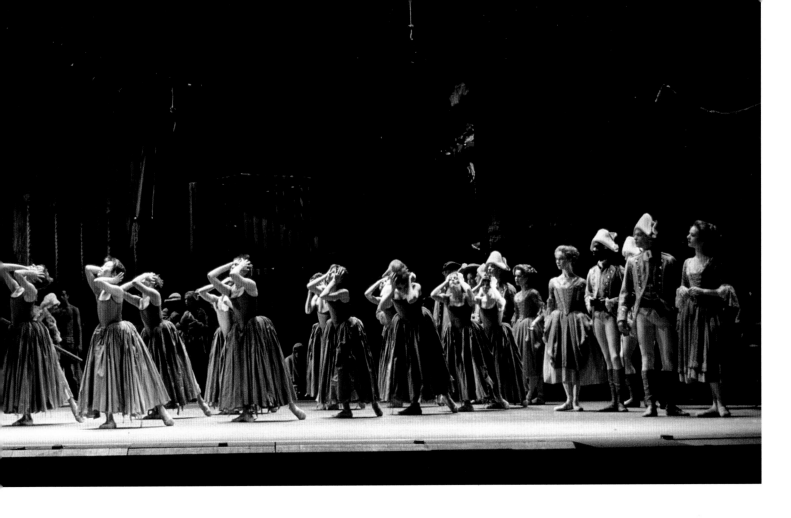

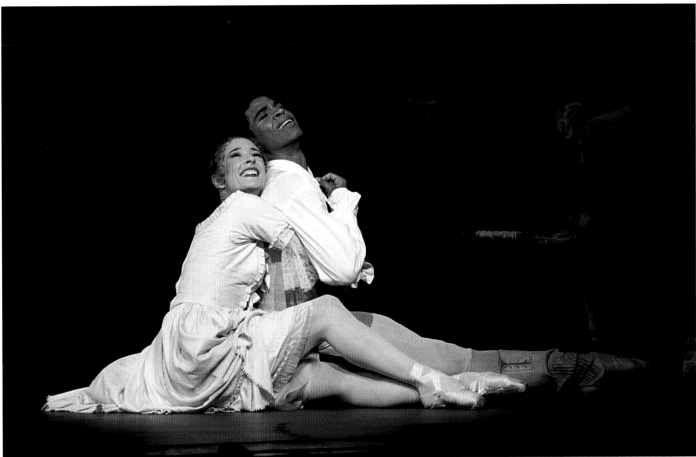

Above: Gillian Revie, Carlos Acosta

Overleaf: Sarah Wildor, Inaki Urlezaga

59

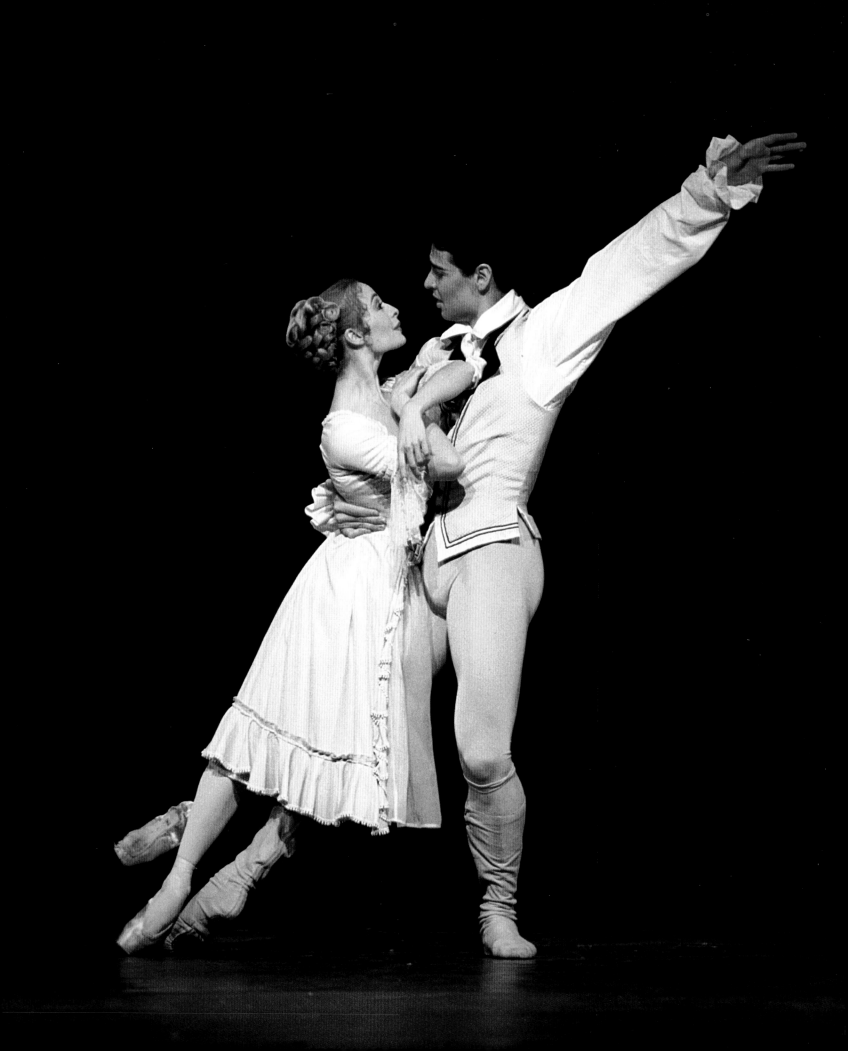

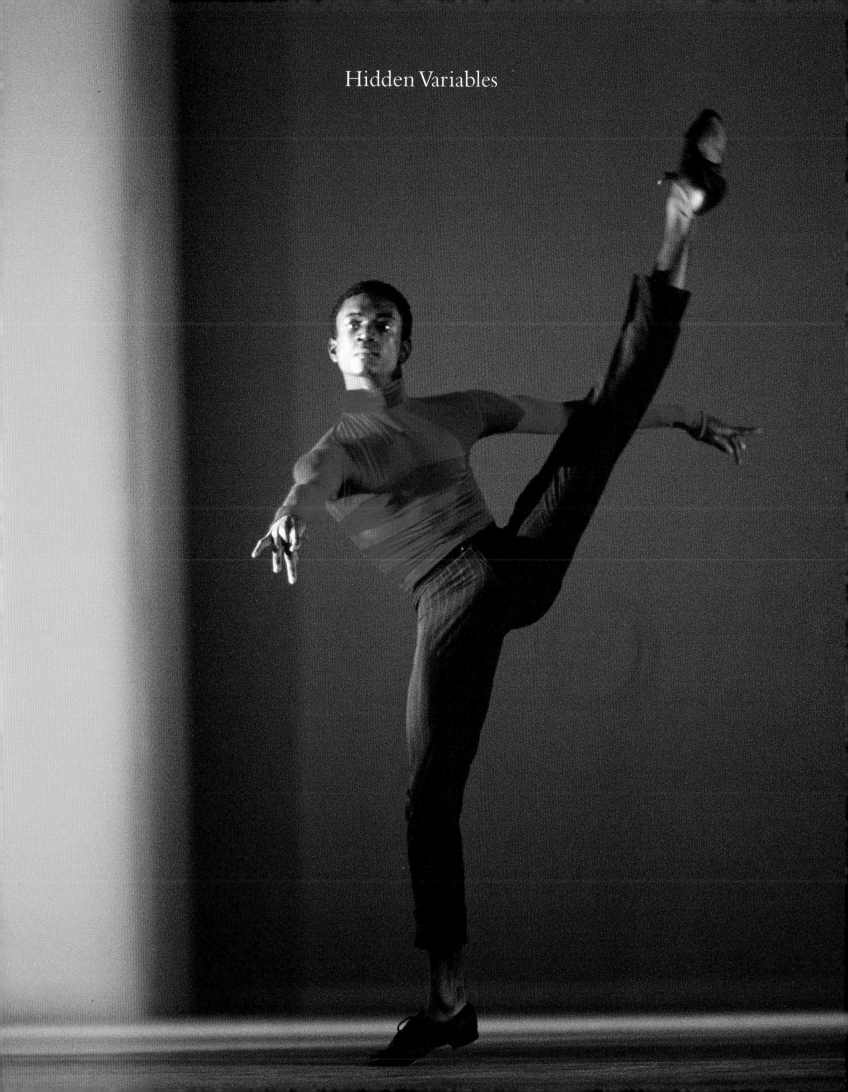

Hidden Variables

Right: Mara Galeazzi

Previous page: Jerry Douglas

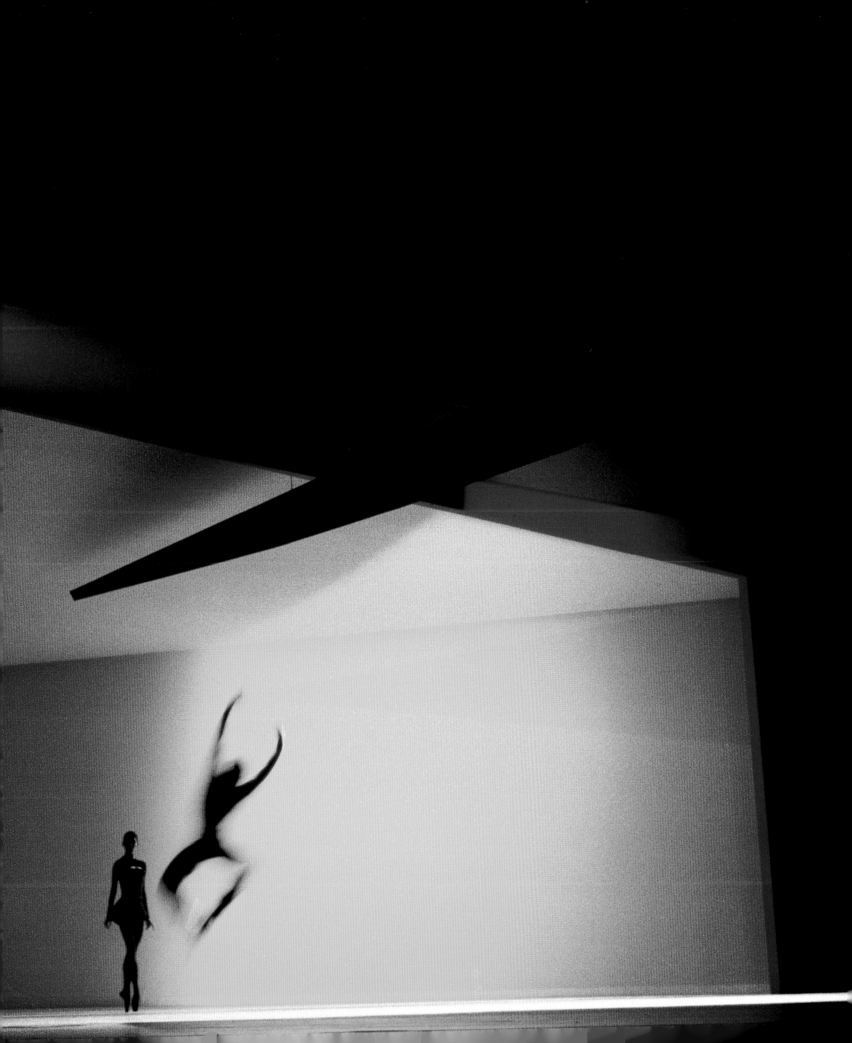

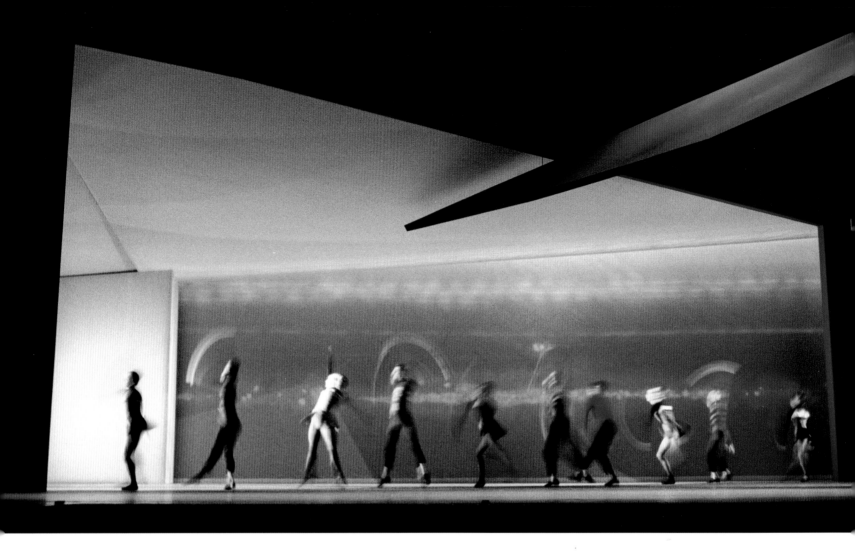

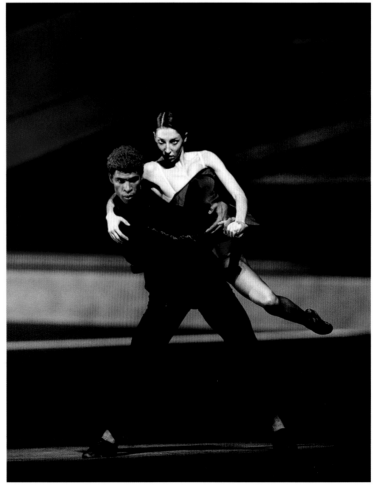

Left: Carlos Acosta, Mara Galeazzi

Right: Luke Heydon, Christopher Saunders, Irek Mukhamedov, Bennet Gartside

64

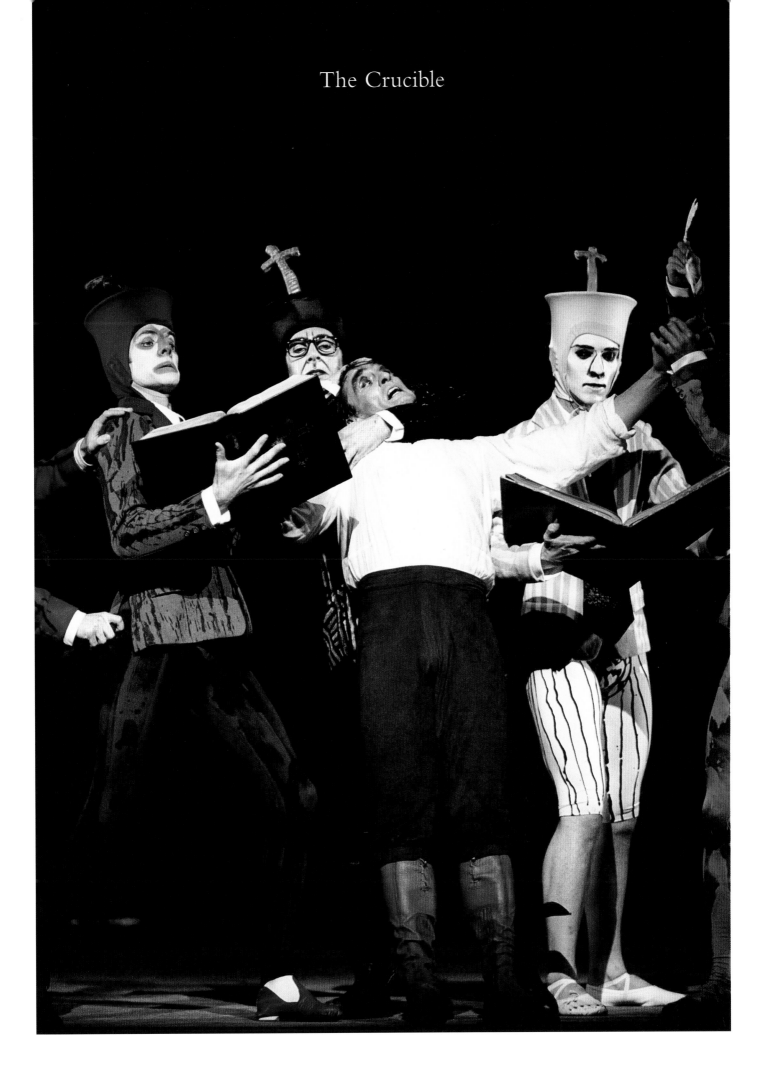

The Crucible

Les Biches

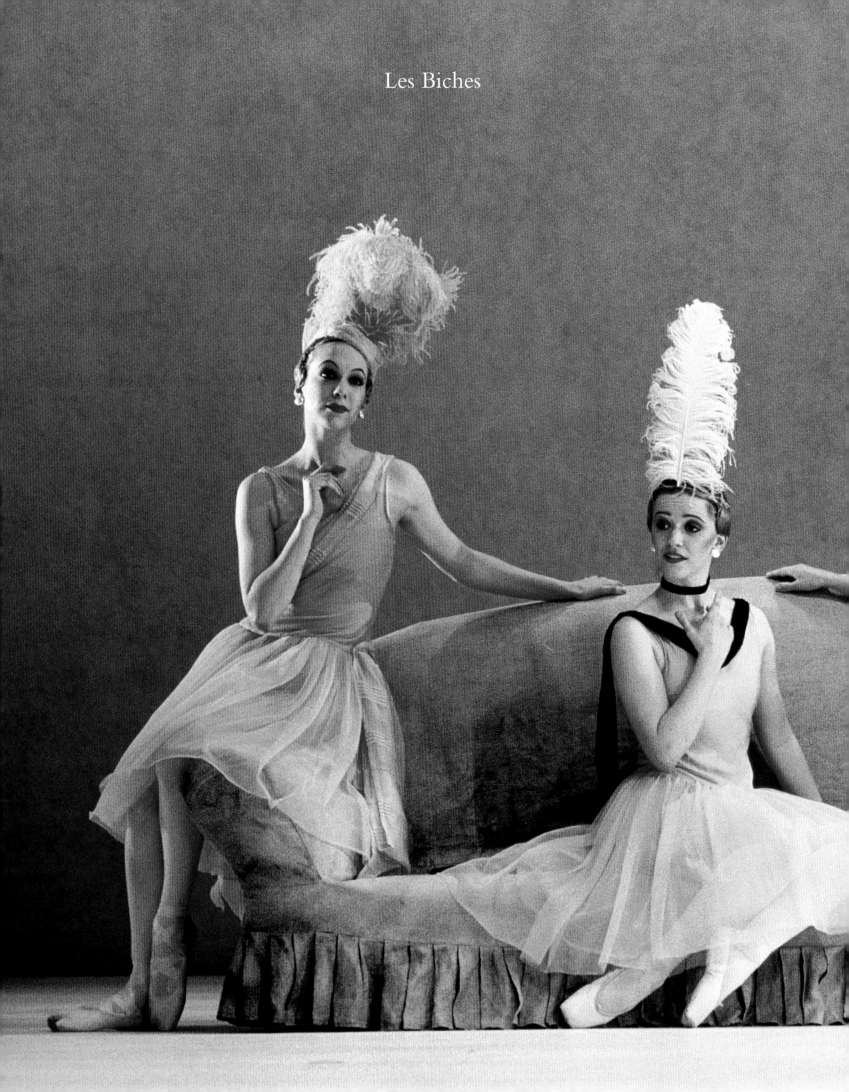

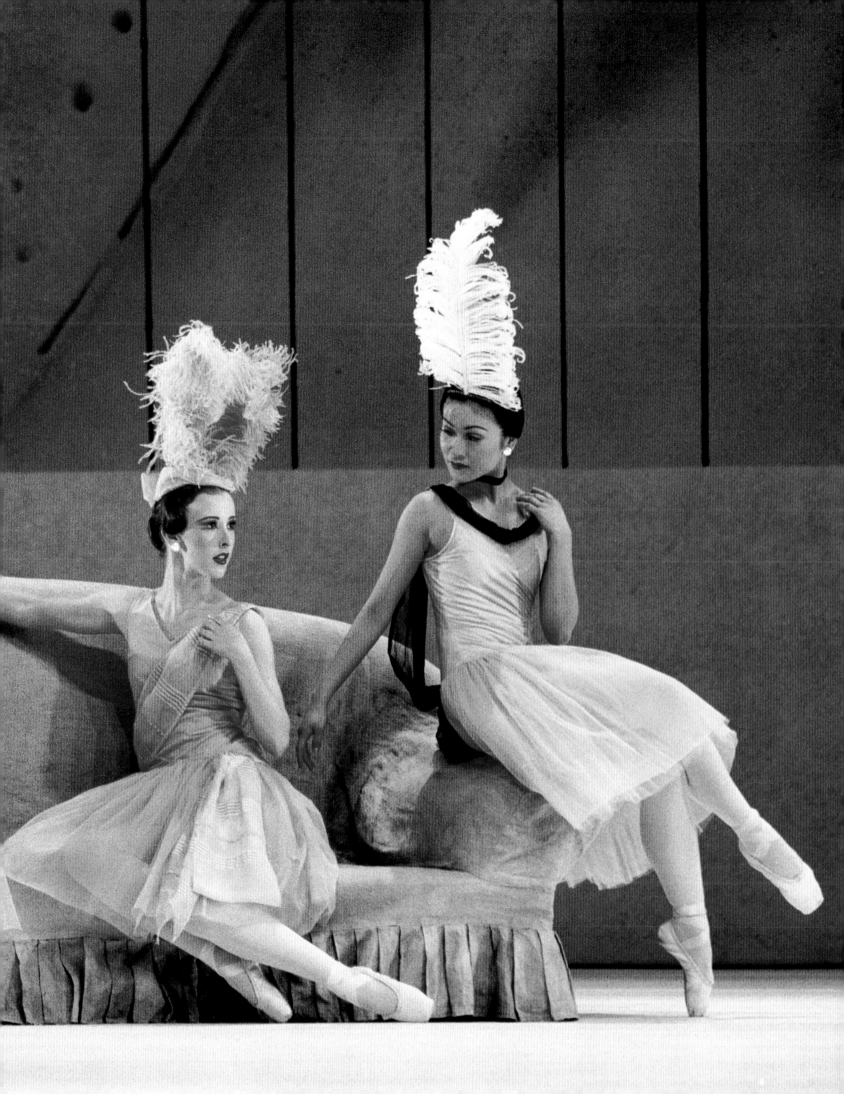

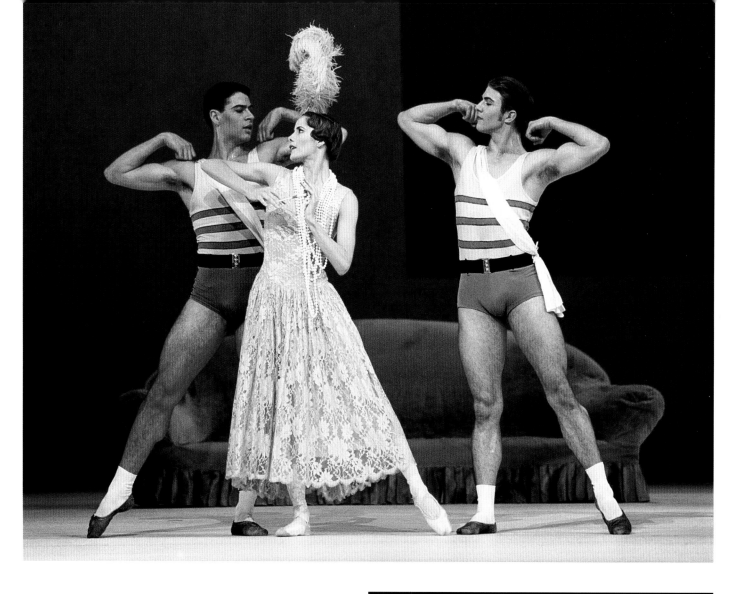

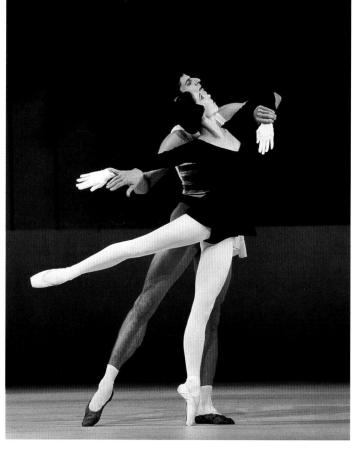

Above: Inaki Urlezaga, Darcey Bussell,
Nigel Burley

Right: Jonathan Cope, Mara Galeazzi

Opposite: Darcey Bussell

Previous pages: Sian Murphy, Julie Lack,
Jenny Tattersall, Mayuko Maeda

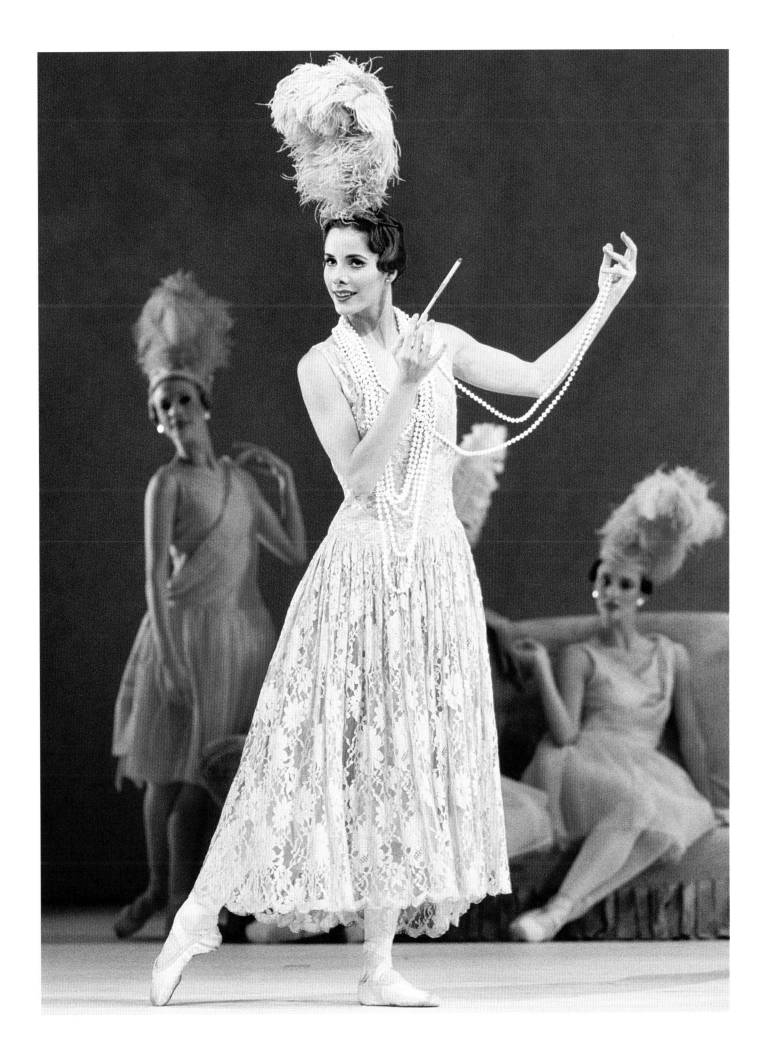

Coppélia

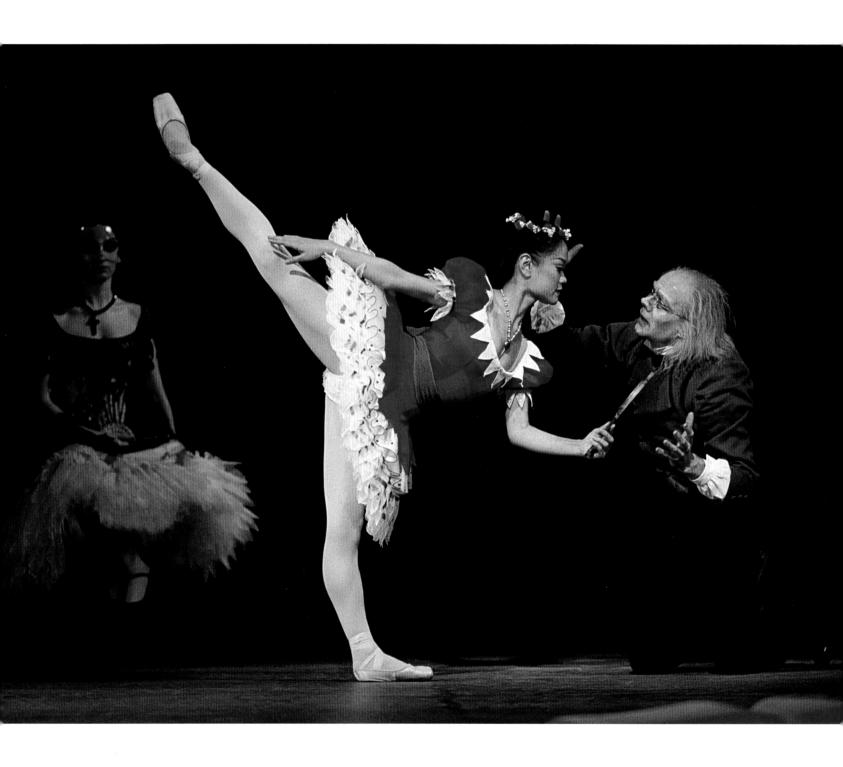

Above: Miyako Yoshida, Luke Heydon

Right: Ethan Stiefel, Sarah Wildor

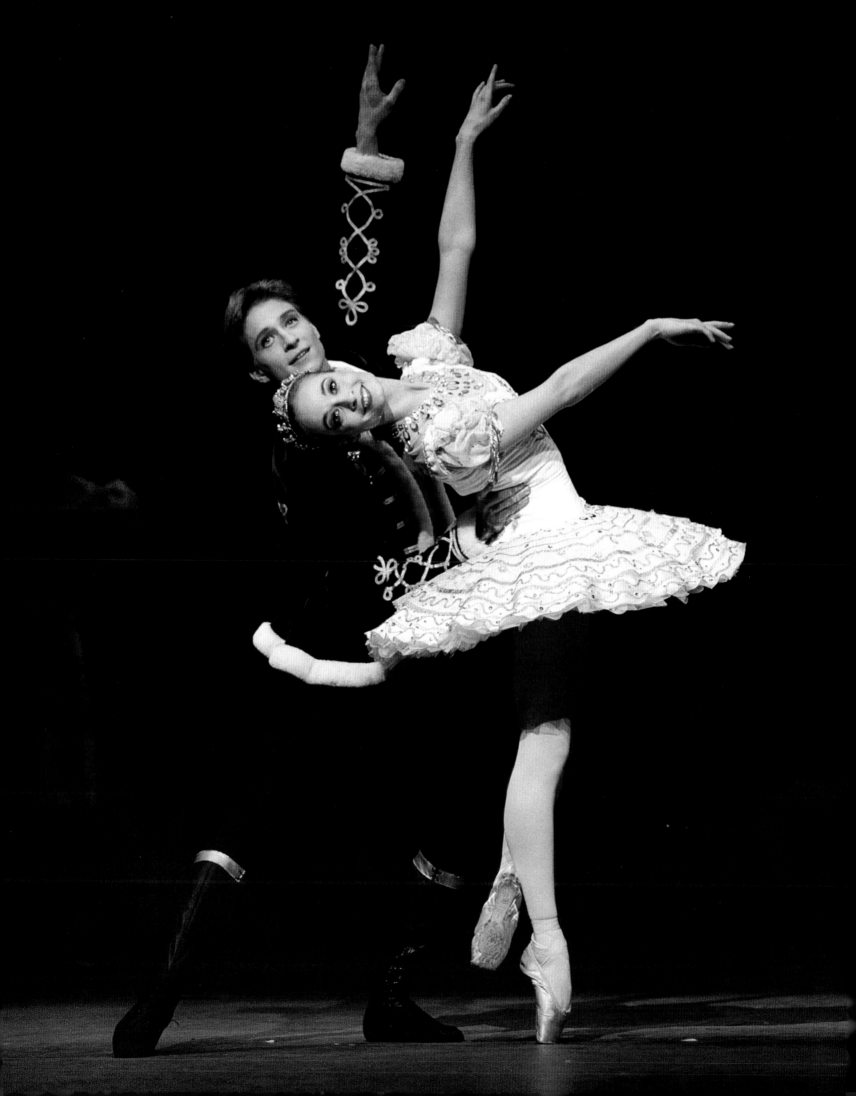

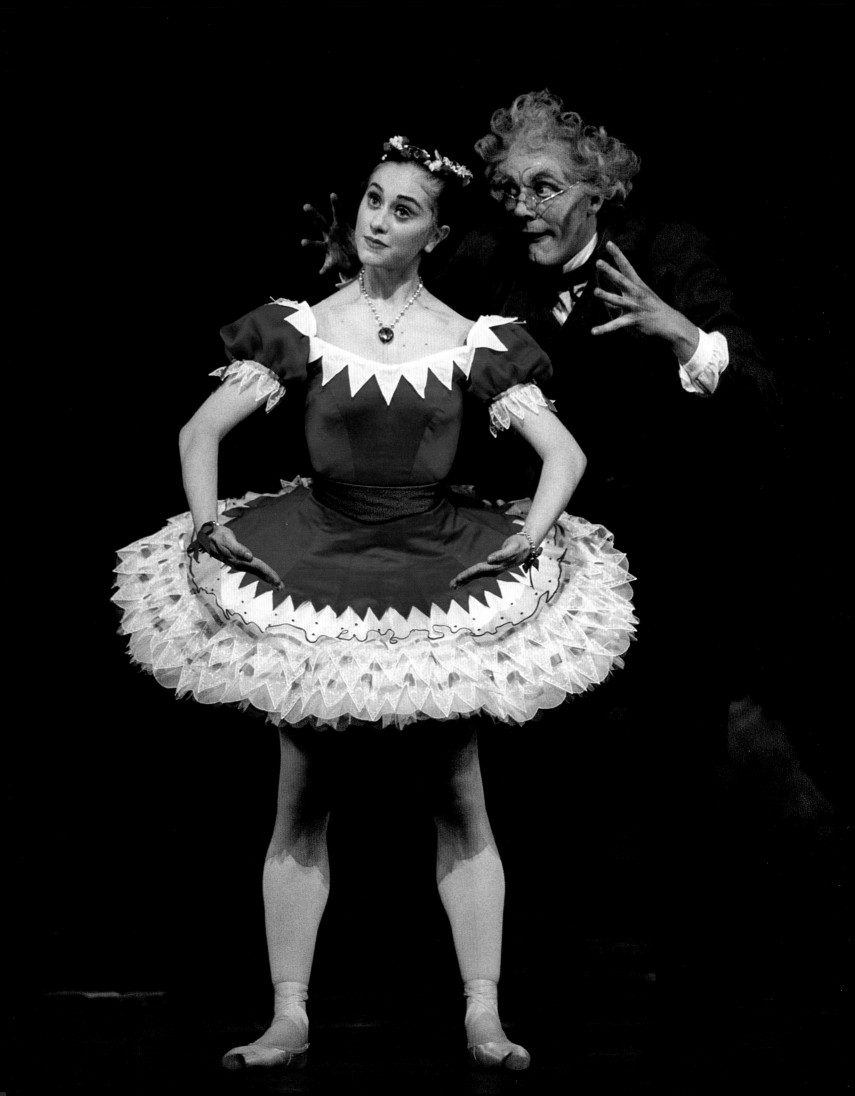

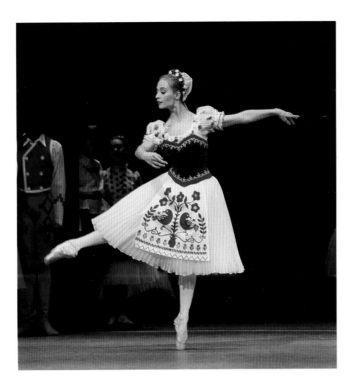

Opposite: Marianela Nunez,
William Tuckett

Left: Sarah Wildor

Below: Miyako Yoshida, Carlos Acosta

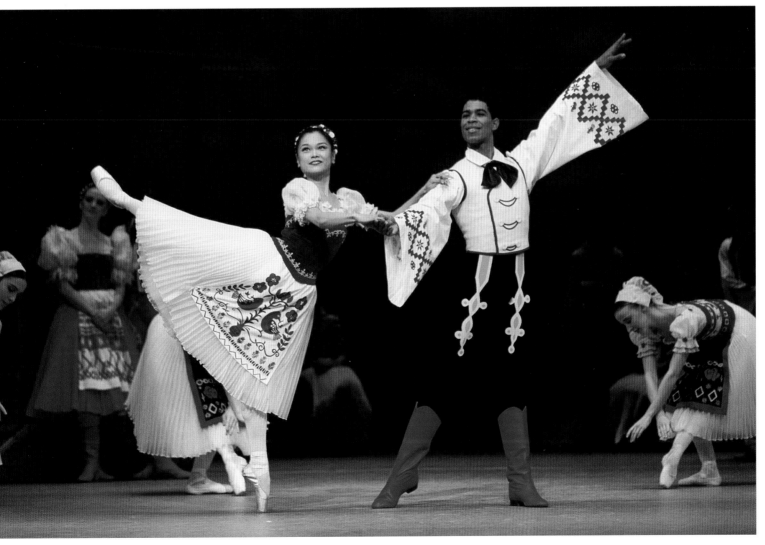

Triad

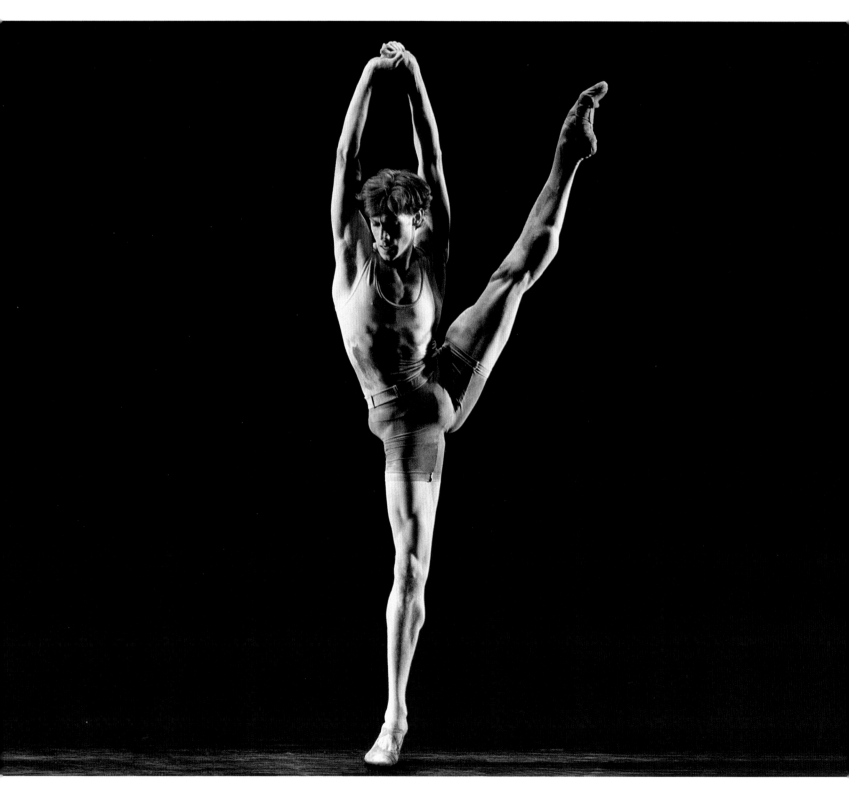

Above: Edward Watson

Right: Nicola Tranah, Christopher Saunders

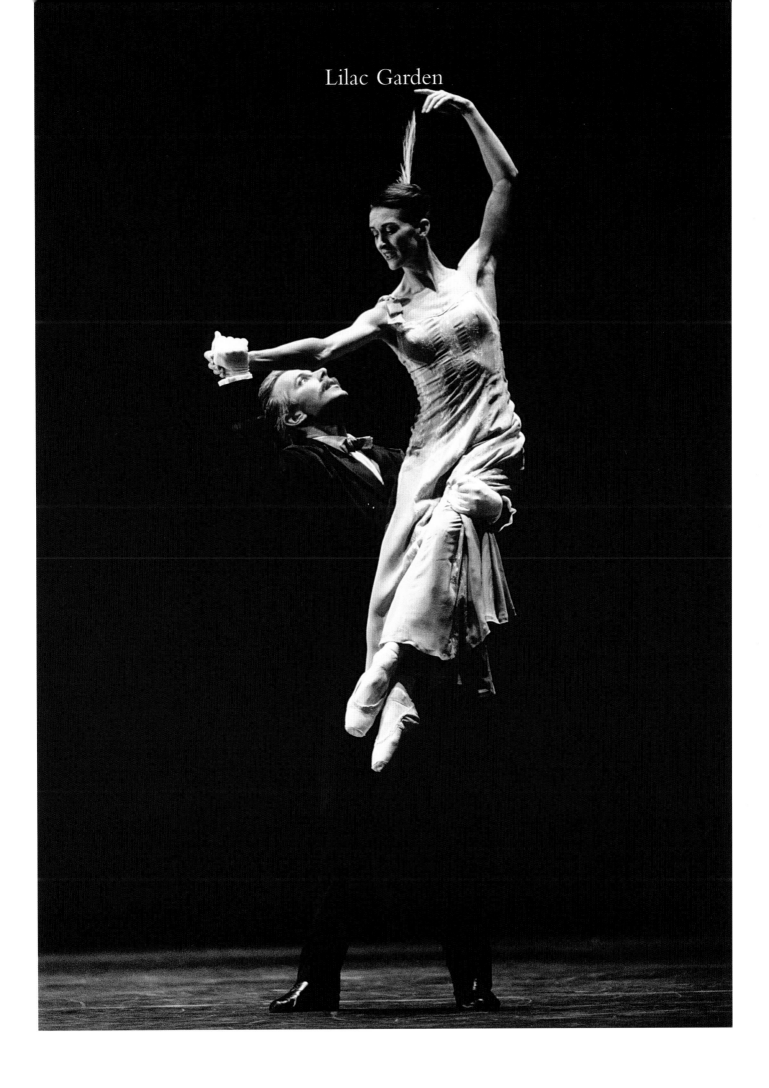

Lilac Garden

Swan Lake

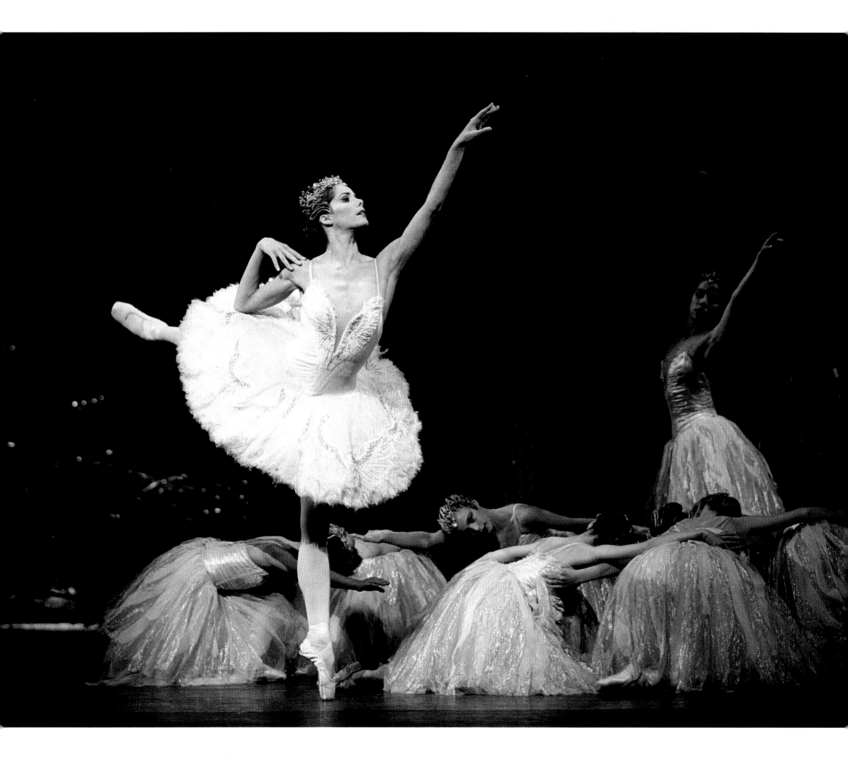

Above: Darcey Bussell

Right: Christopher Saunders, Darcey Bussell

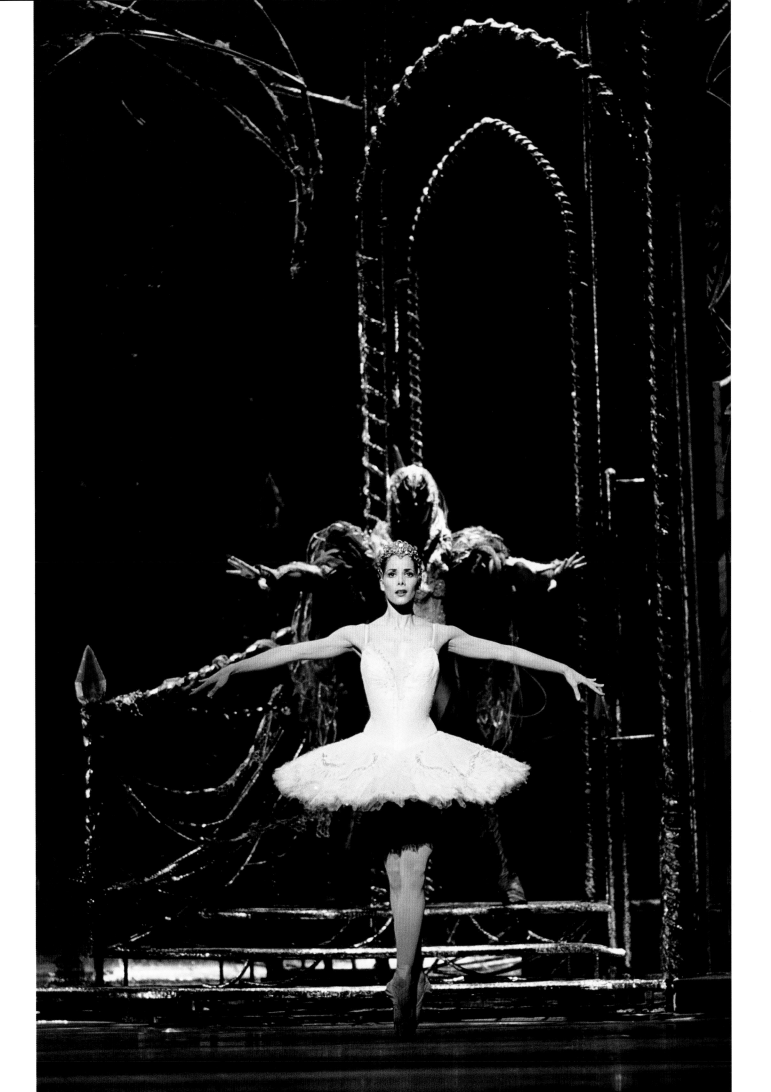

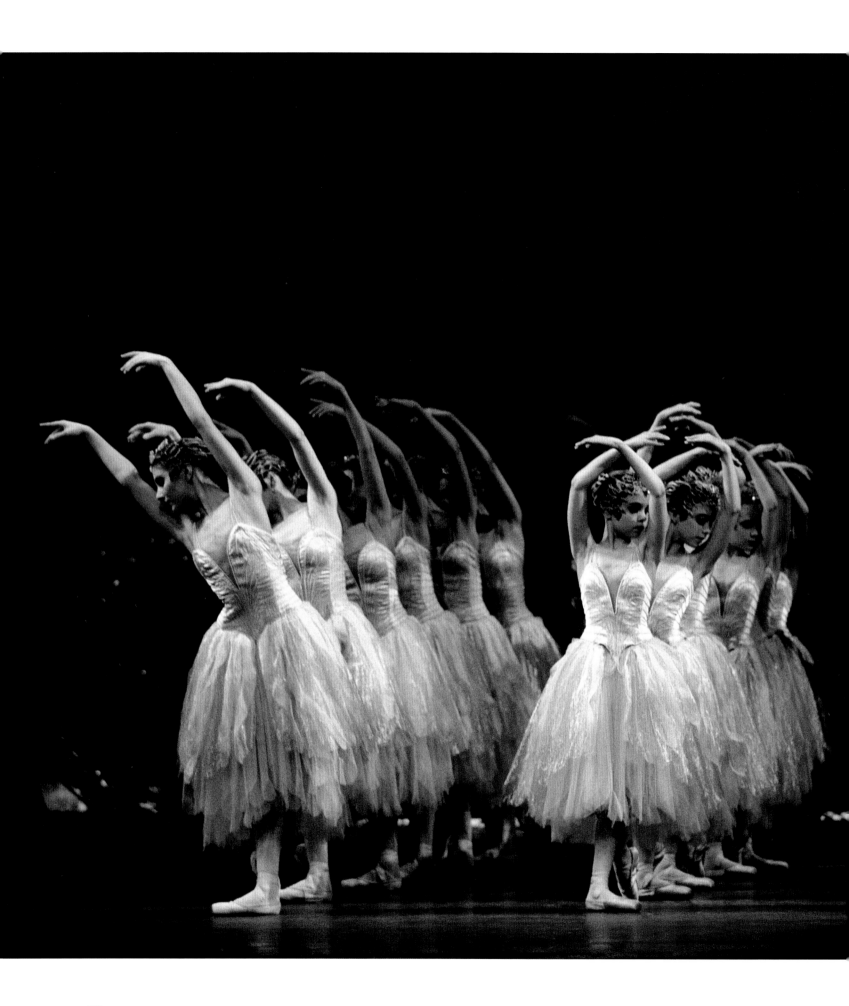

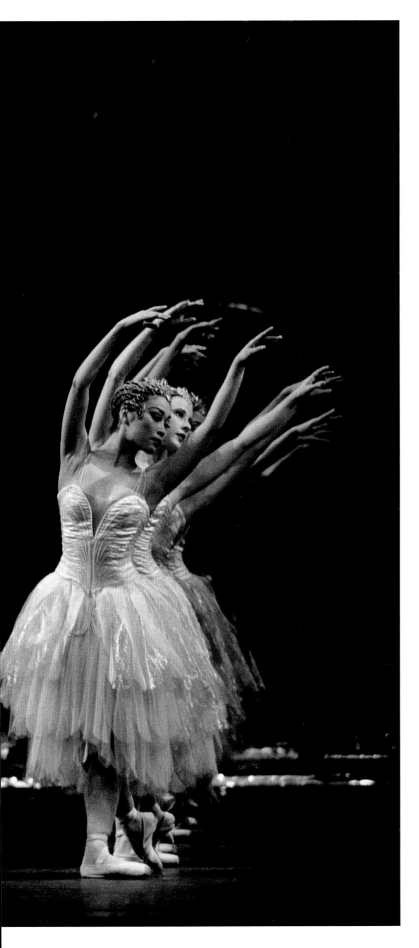

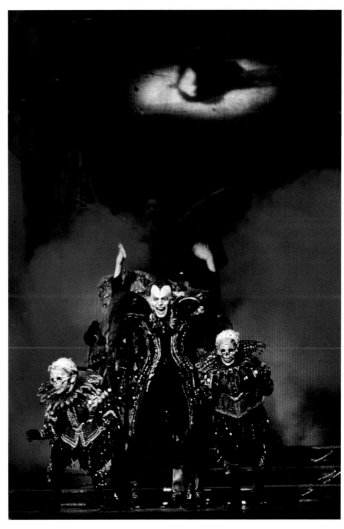

Above: Luke Heydon

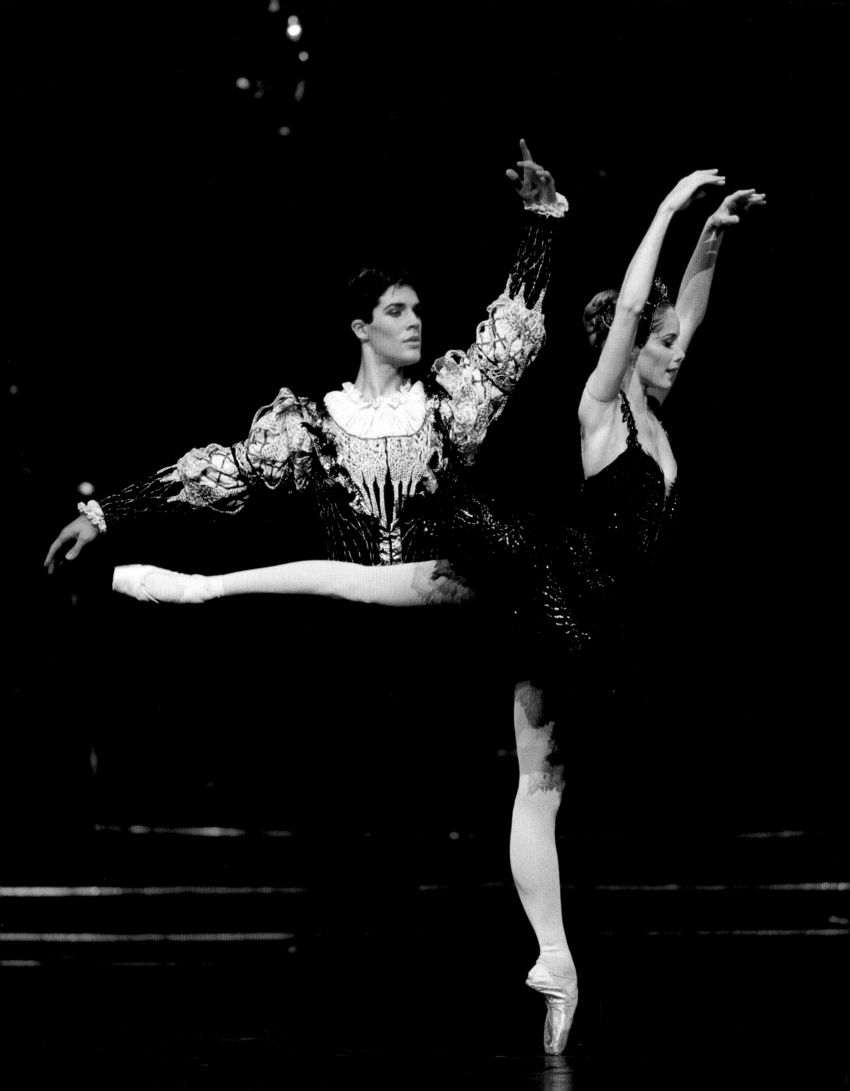

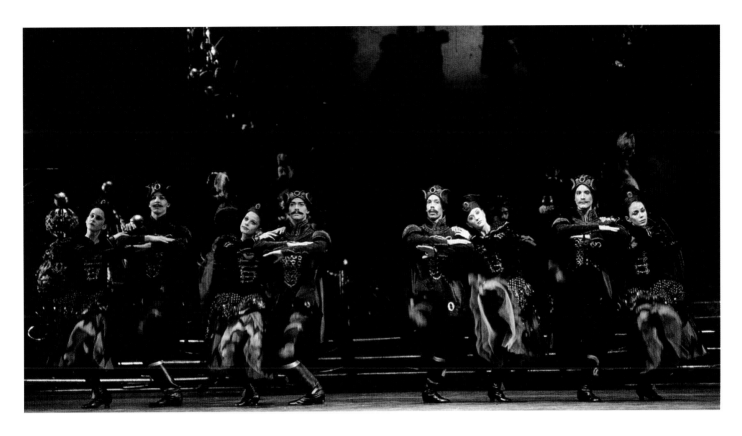

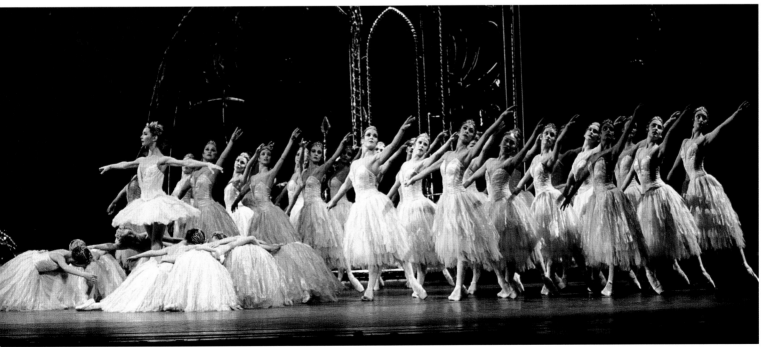

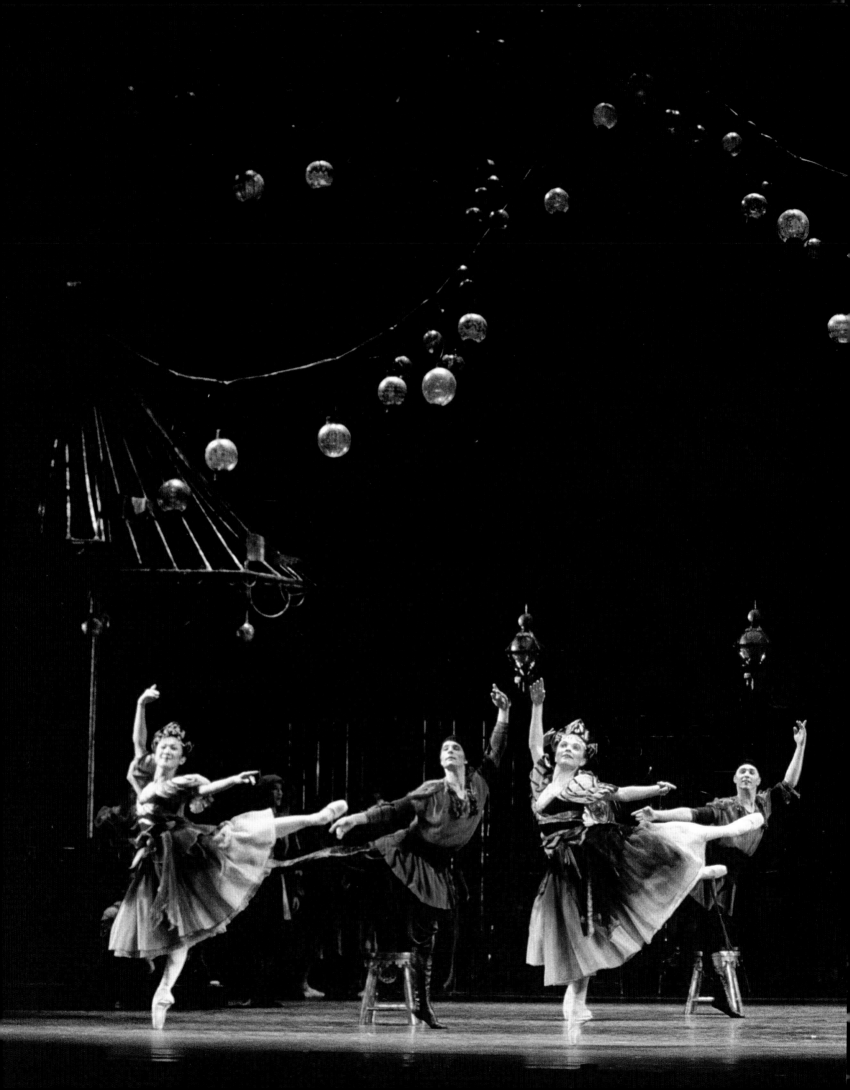

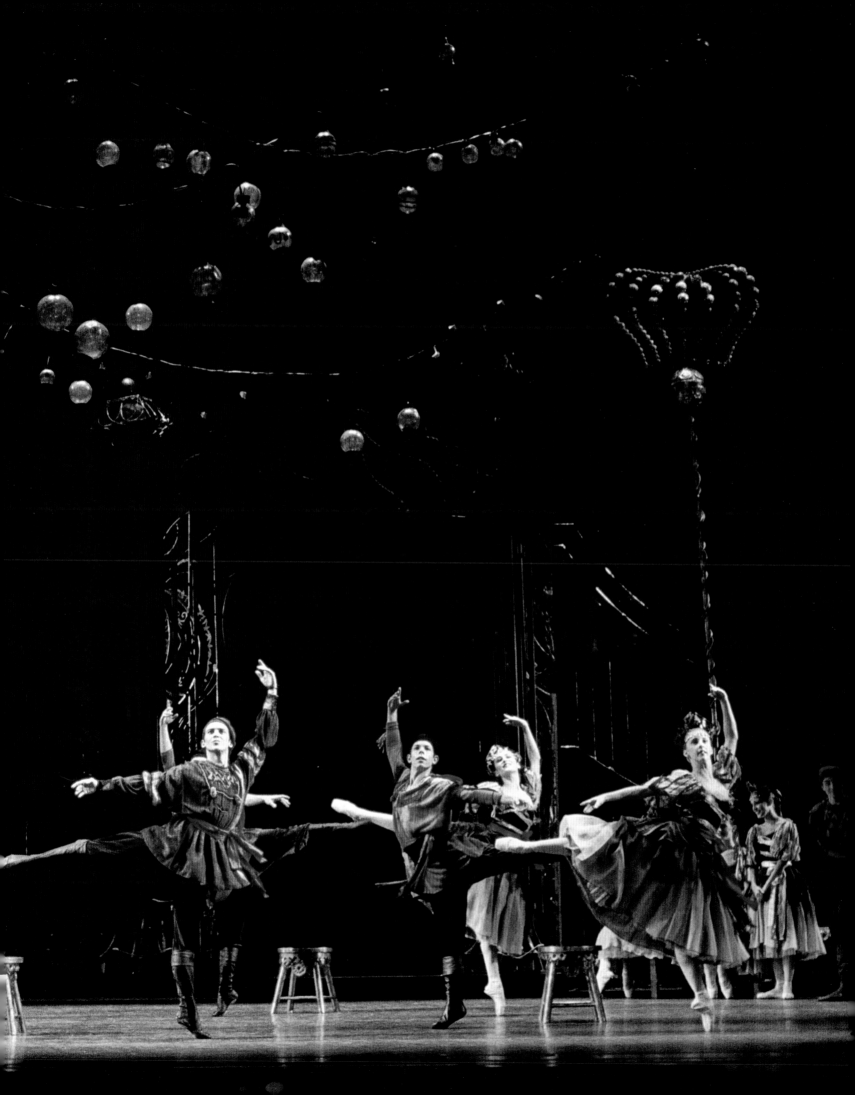

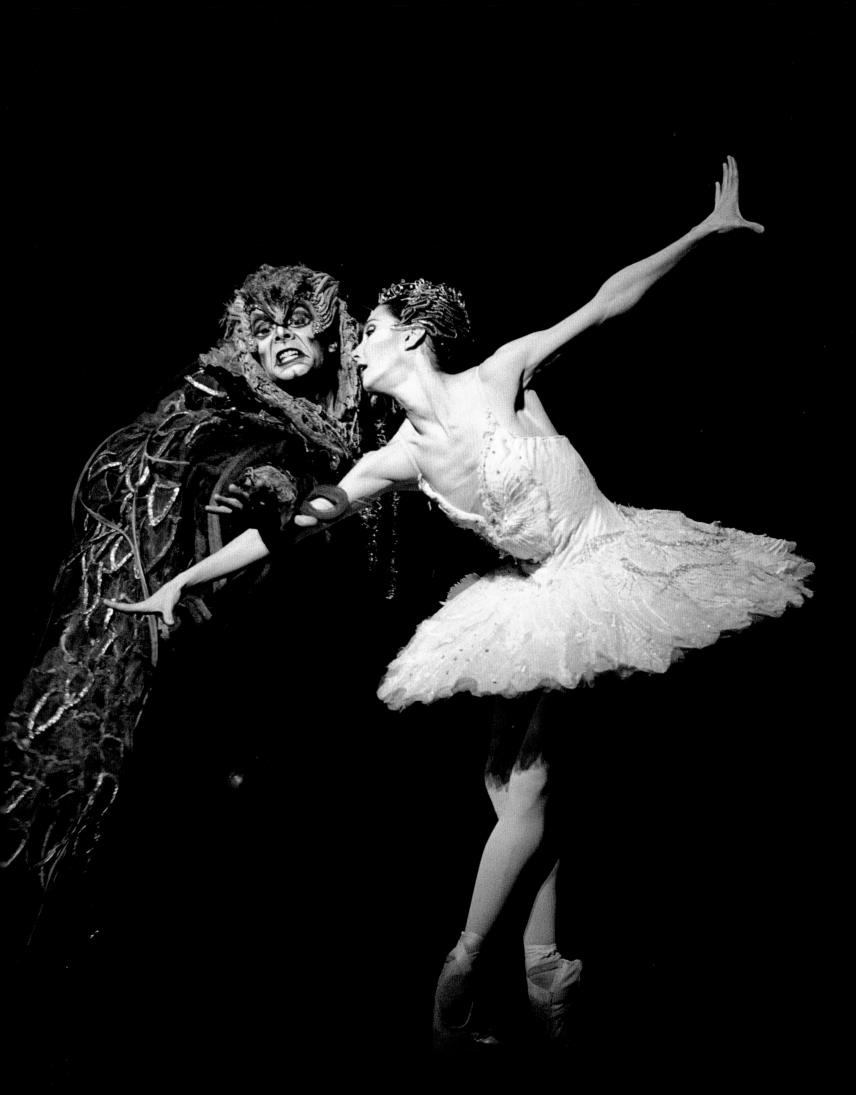

Monotones

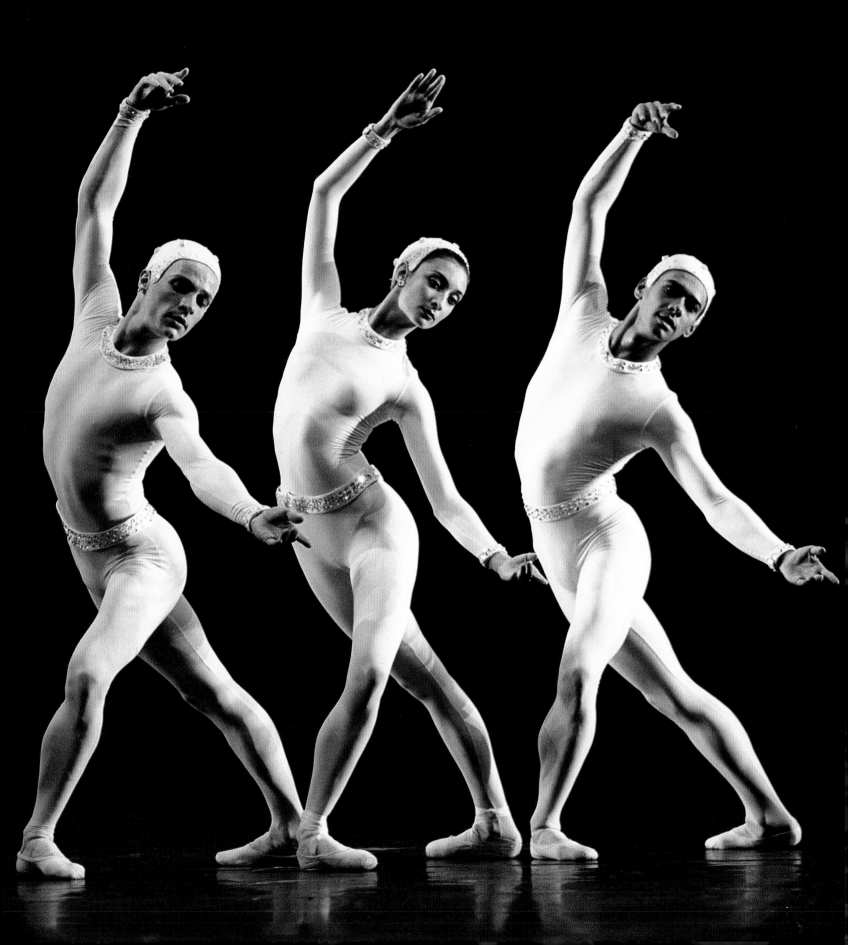

This House Will Burn

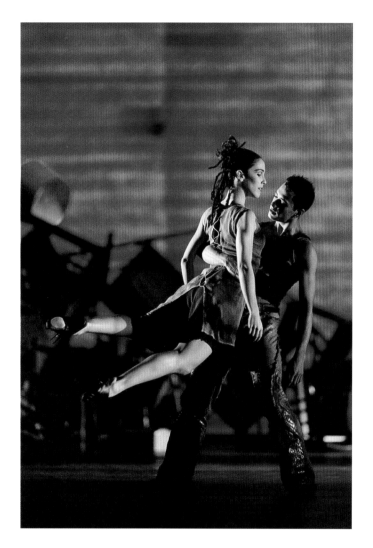 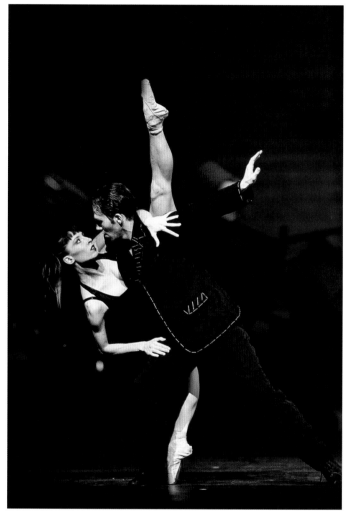

Above left: Laura Morera, Joshua Tuifua

Above right: Mara Galeazzi, Johan Kobborg

Opposite: Johan Kobborg, Mara Galeazzi

Previous pages, left: Luke Heydon, Tamara Rojo: *right* Thomas Whitehead, Christina Arestis, Joshua Tuifua

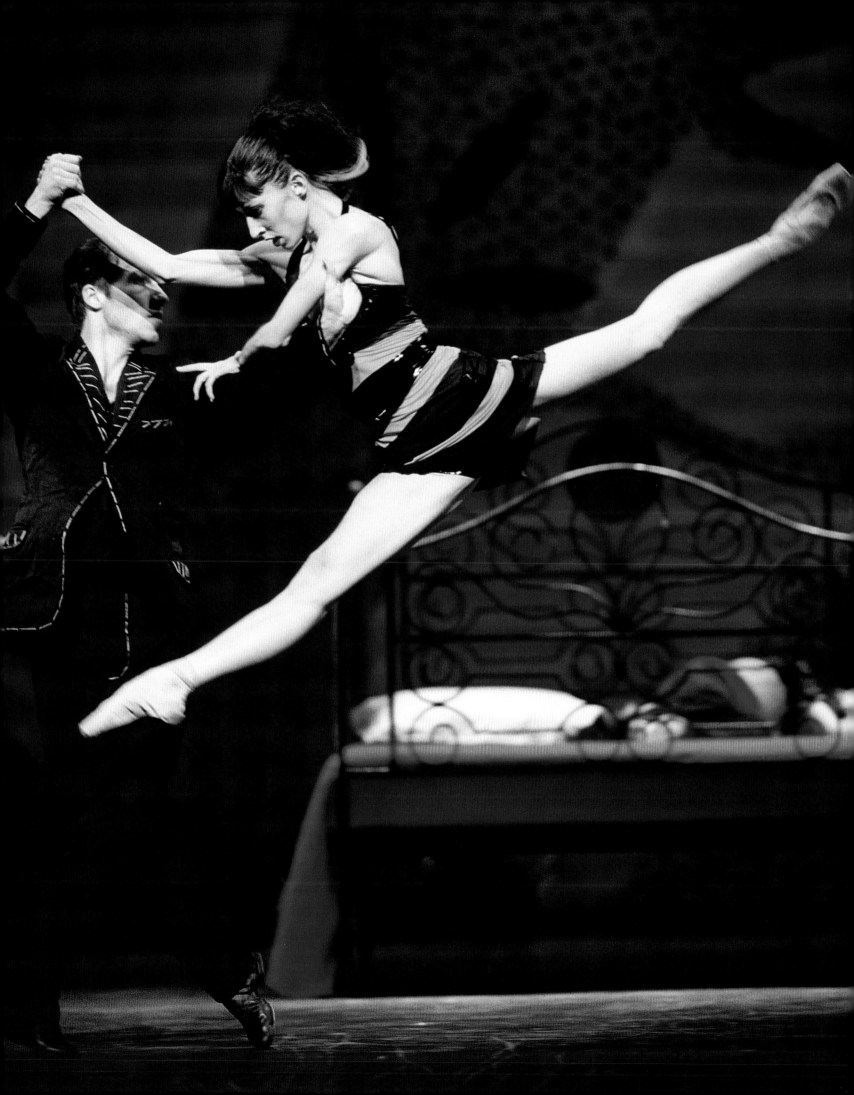

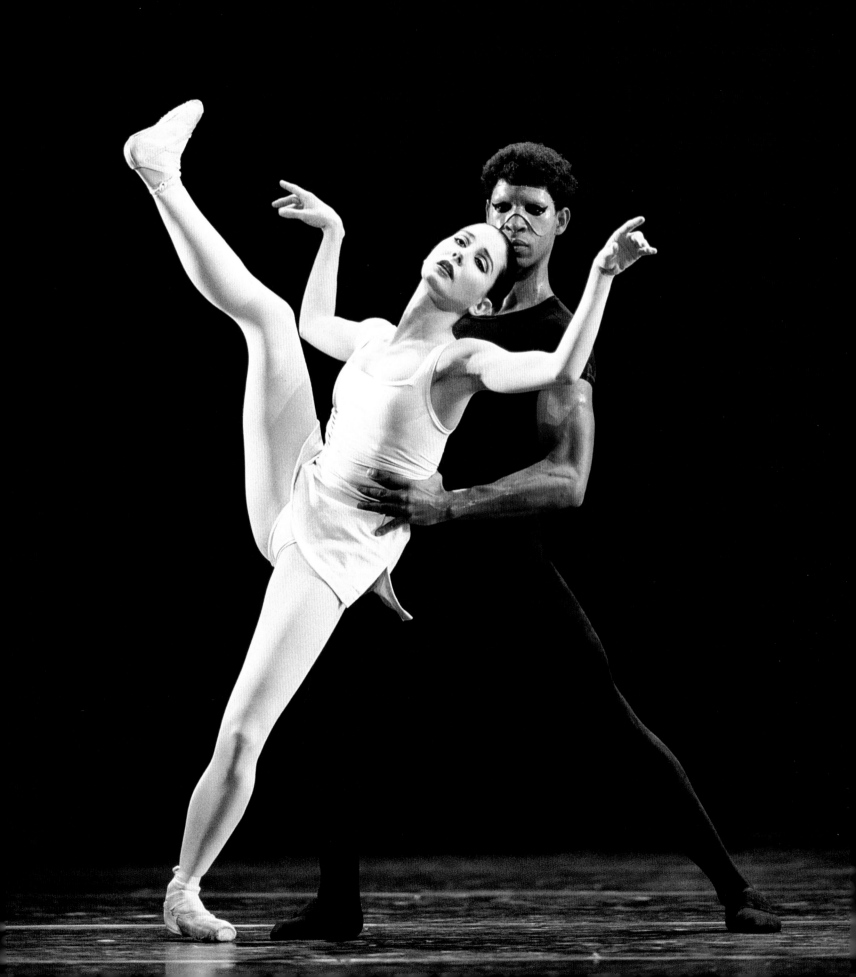

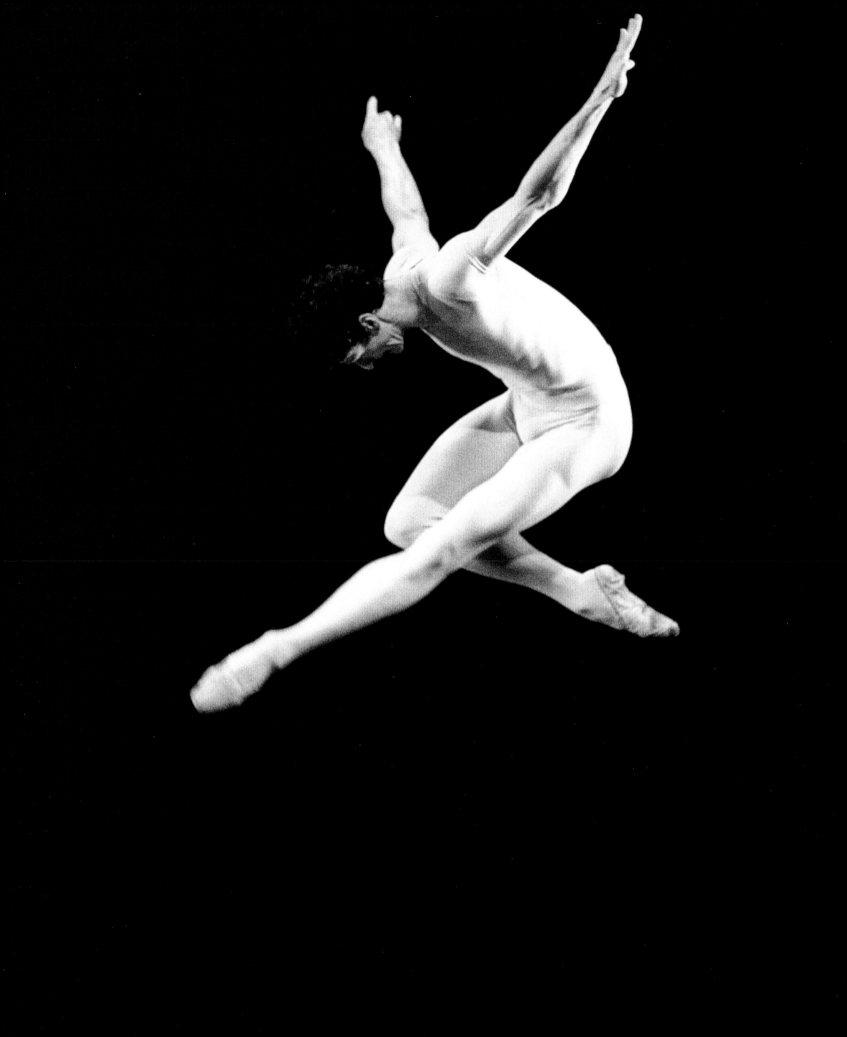

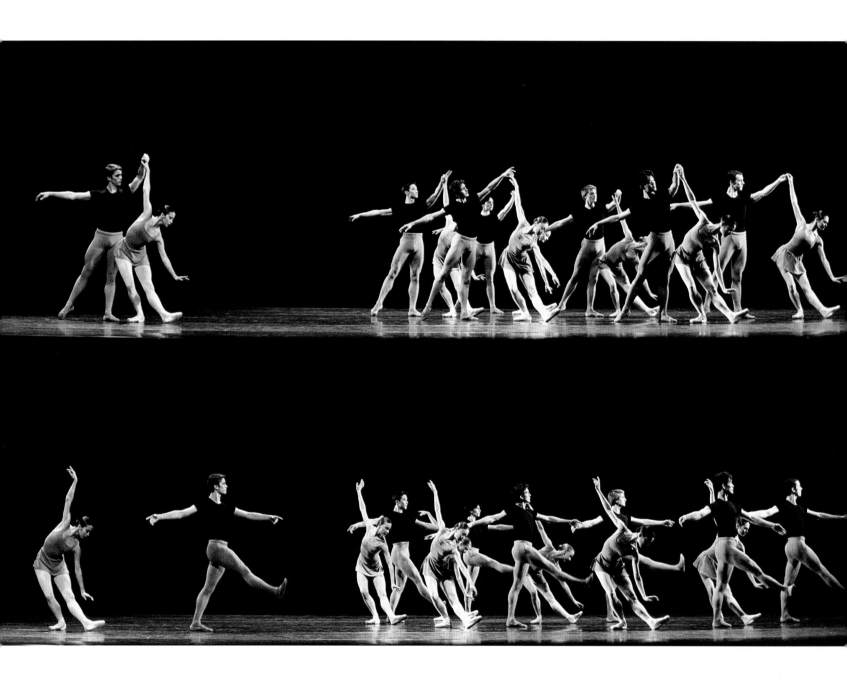

Right: Tamara Rojo, Jonathan Cope,
Carlos Acosta

Previous pages, left: Tamara Rojo, Carlos
Acosta, *right:* Jonathan Cope

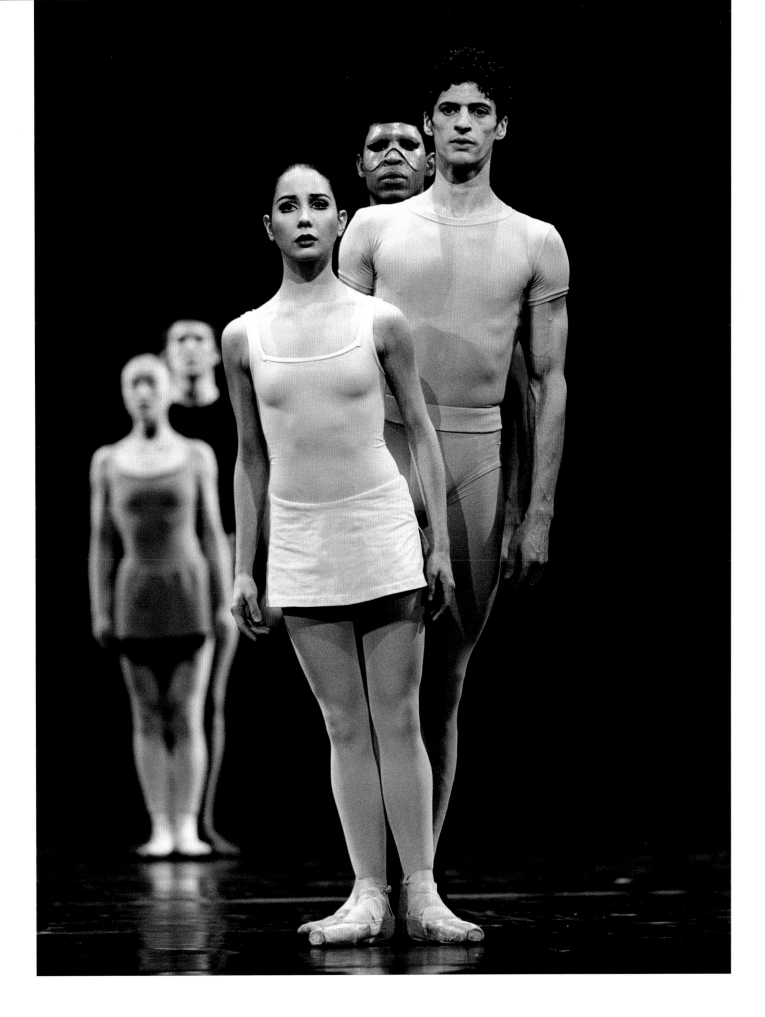

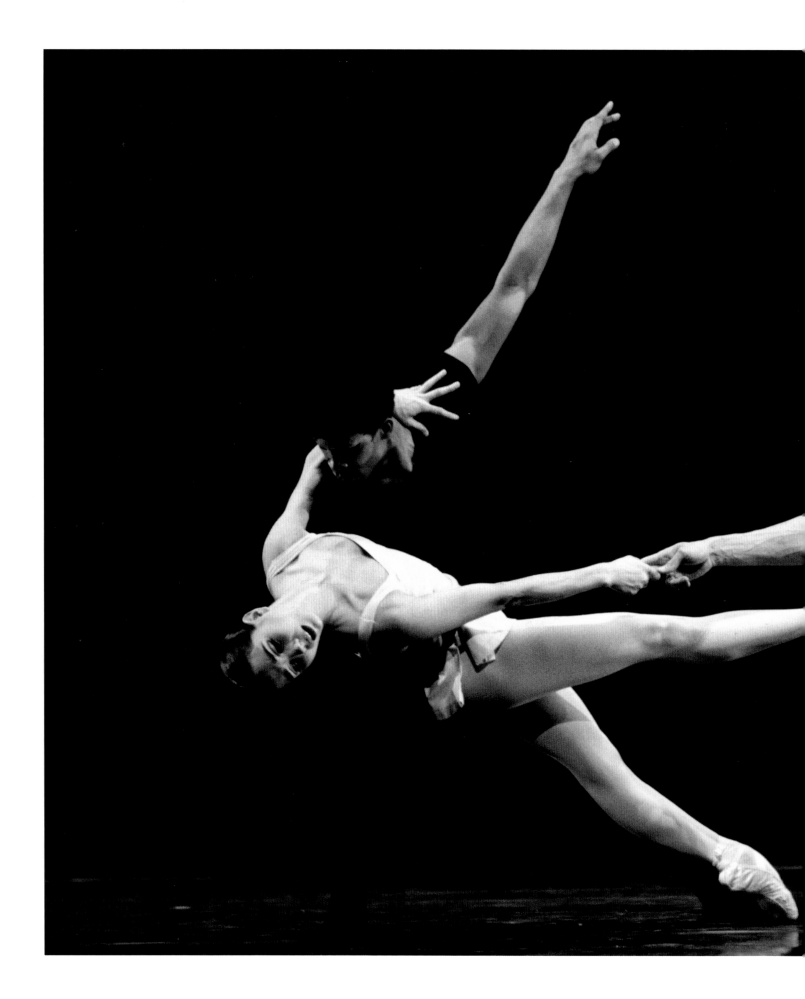

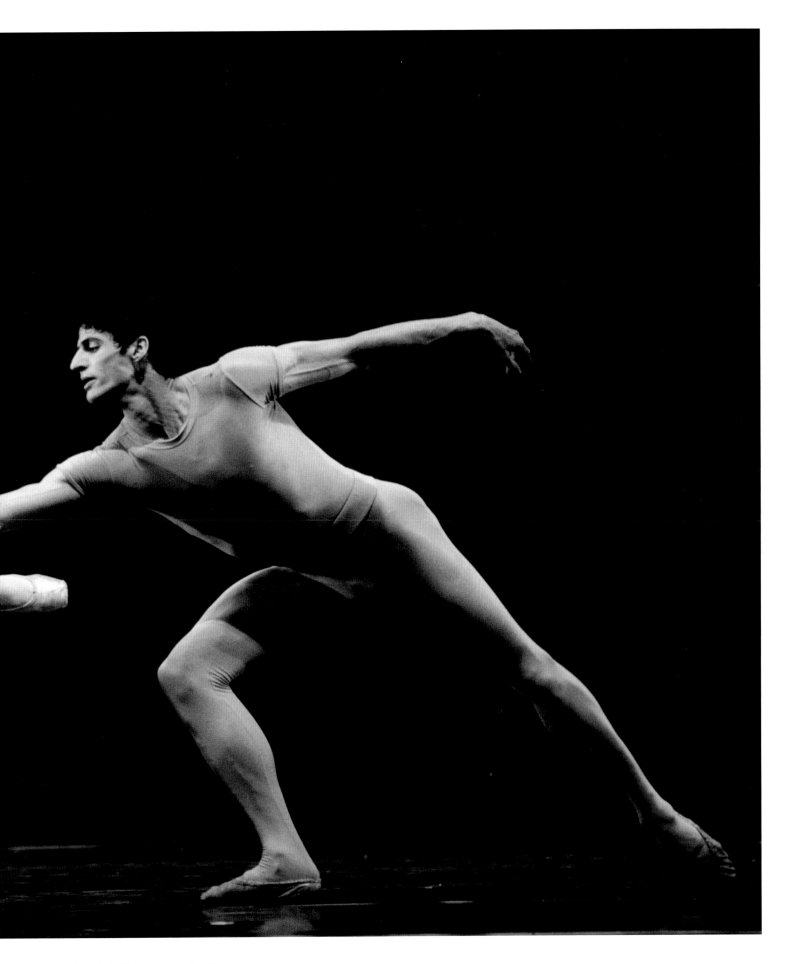

Tamara Rojo, Carlos Acosta, Jonathan Cope

Overleaf: Carlos Acosta

93

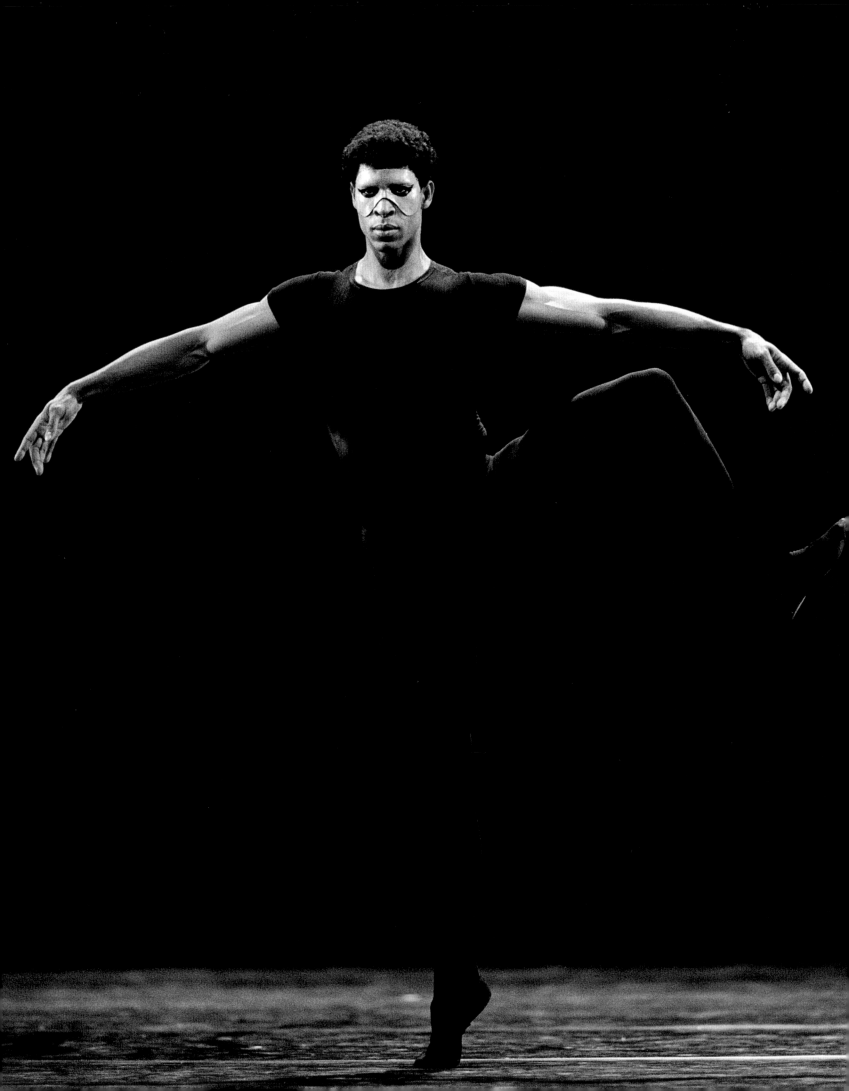

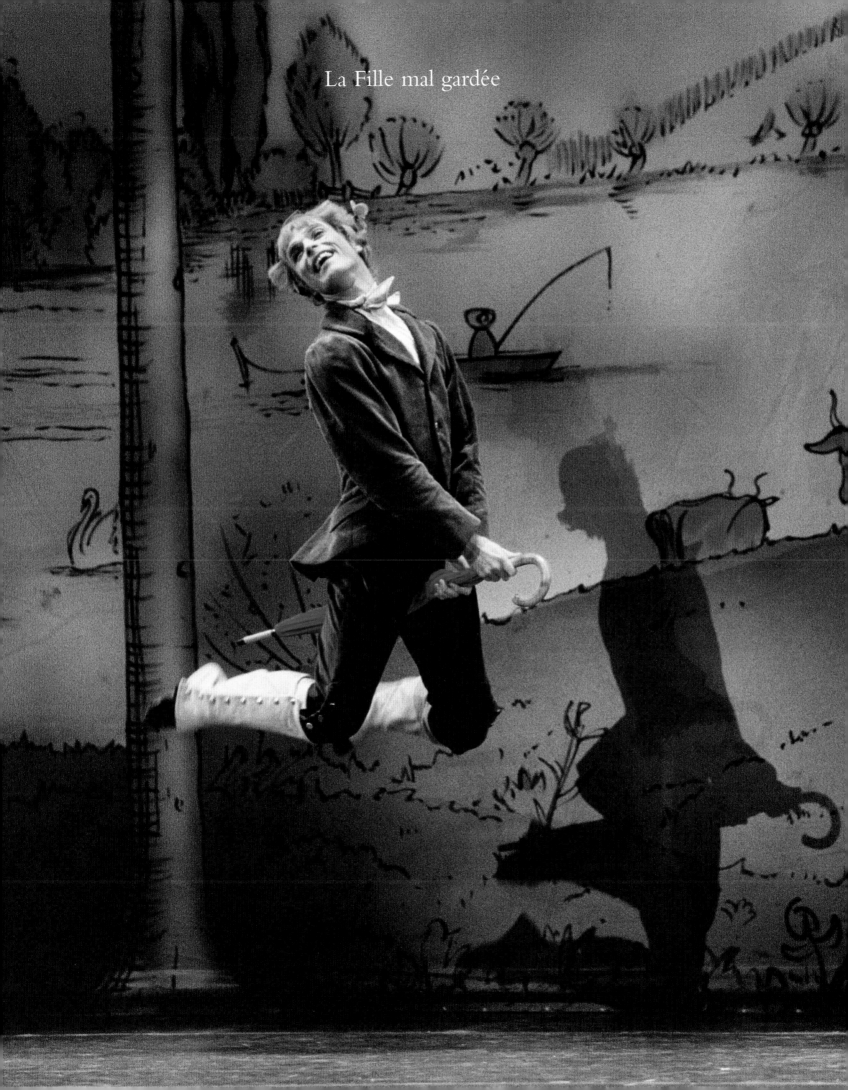

La Fille mal gardée

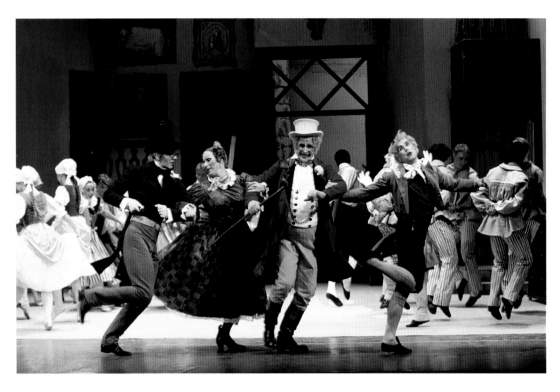

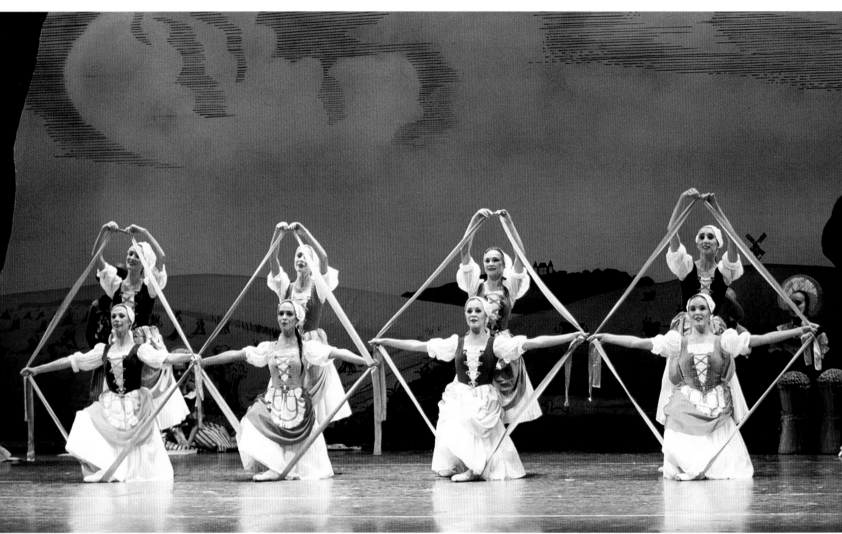

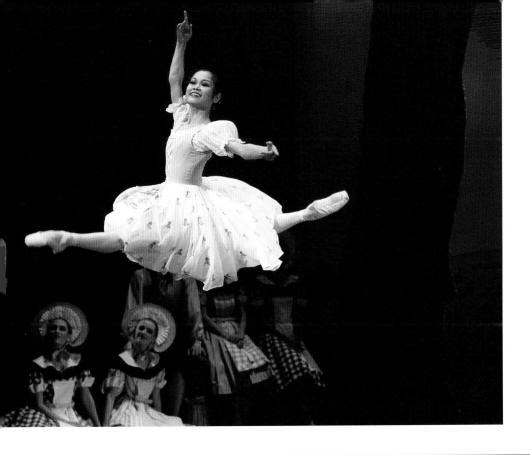

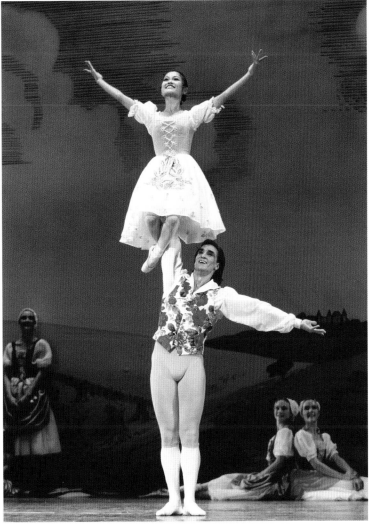

Top: Miyako Yoshida

Left: Irek Mukhamedov, Miyako Yoshida

Opposite top: Christopher Saunders,
Ashley Page, David Drew, Peter
Abegglen

Previous page: Jonathan Howells

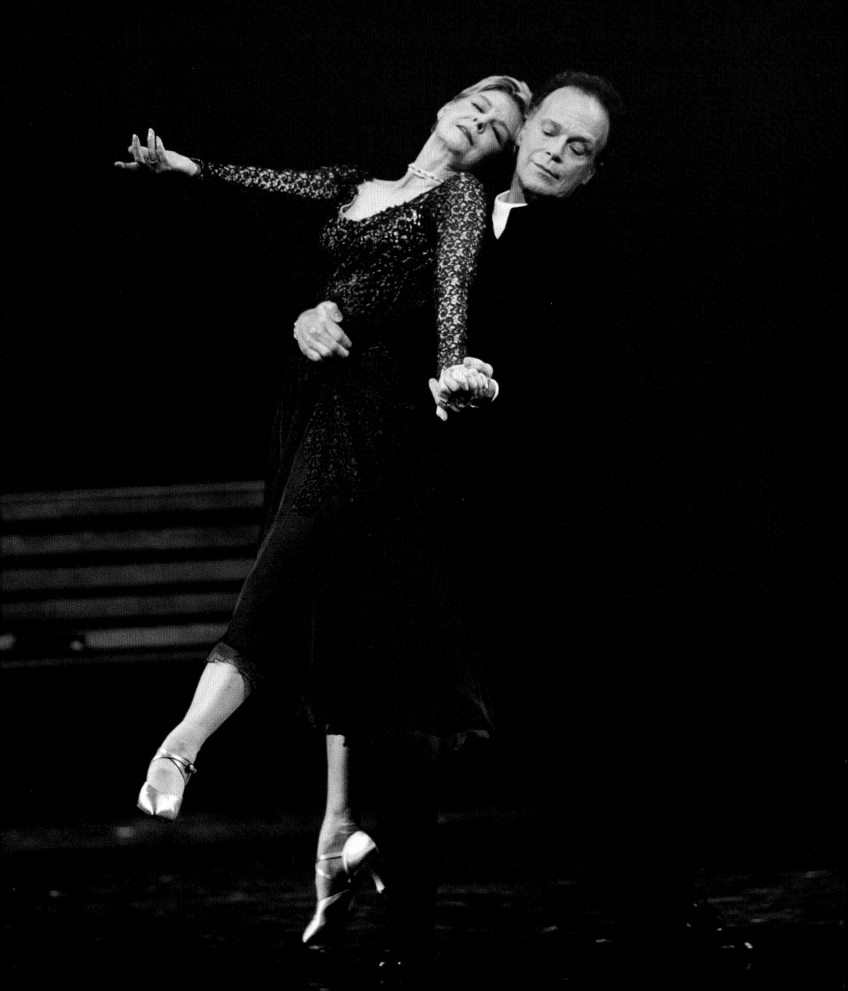

Knight at the Ballet

Left: Dame Vivien Duffield, Sir Anthony Dowell

Opposite: Dame Antoinette Sibley,
Sir Anthony Dowell

Les Noces

Above: Zenaida Yanowsky

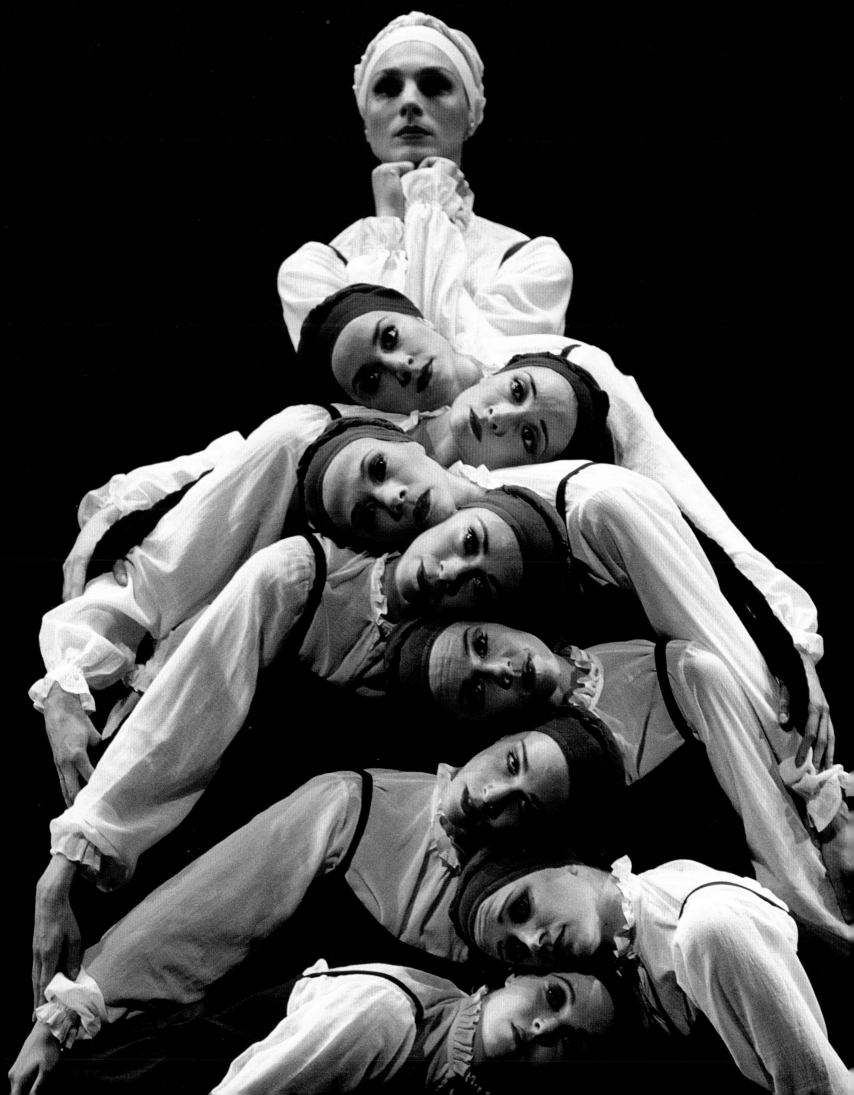

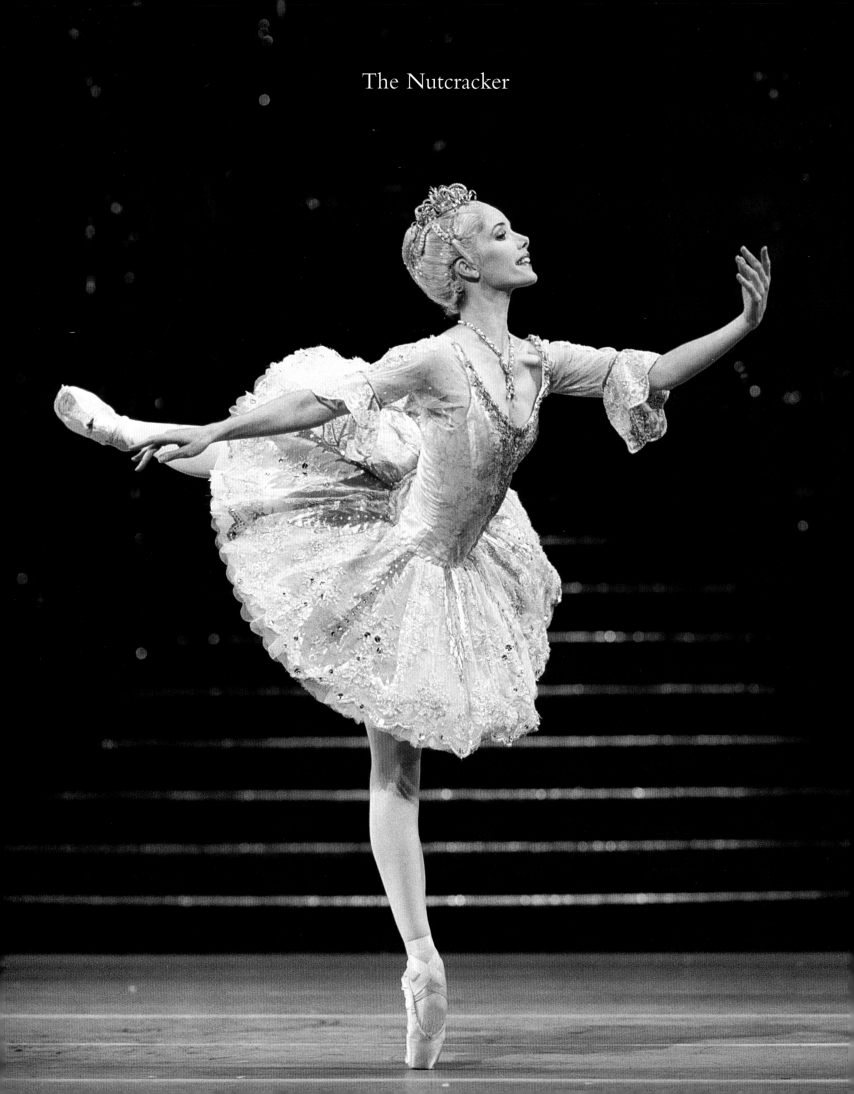

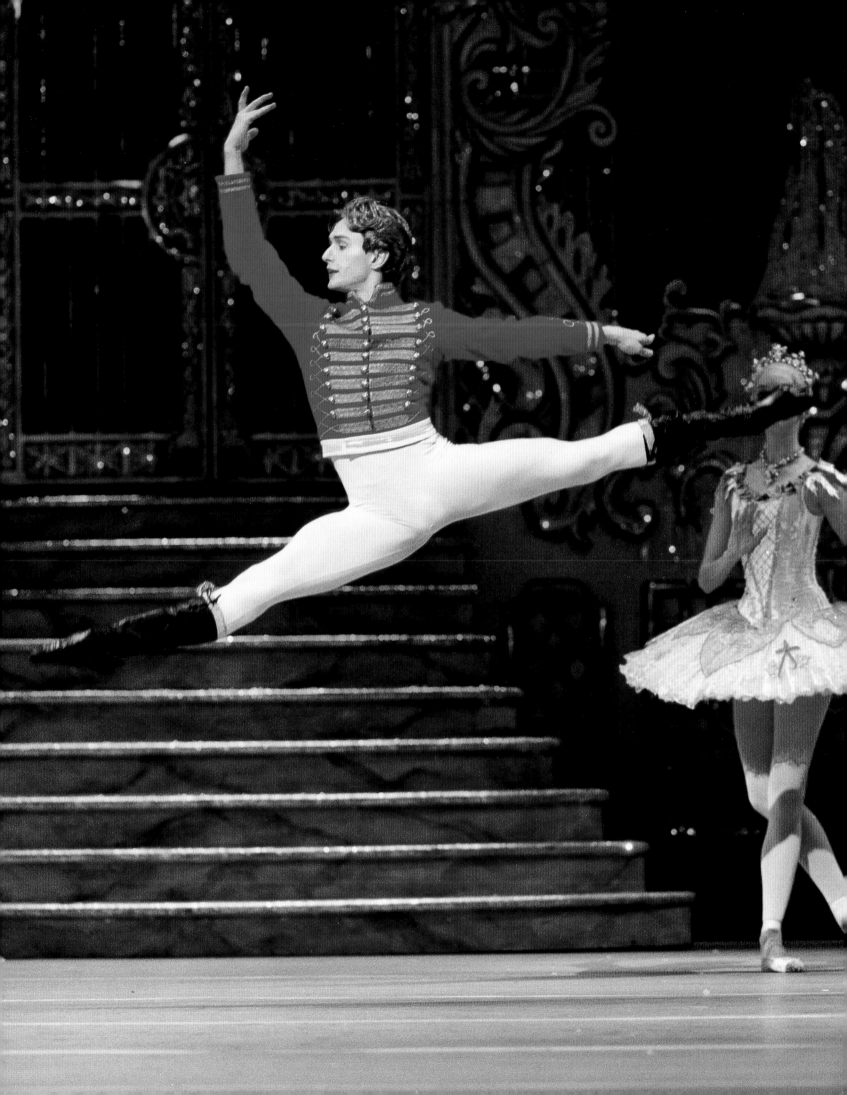

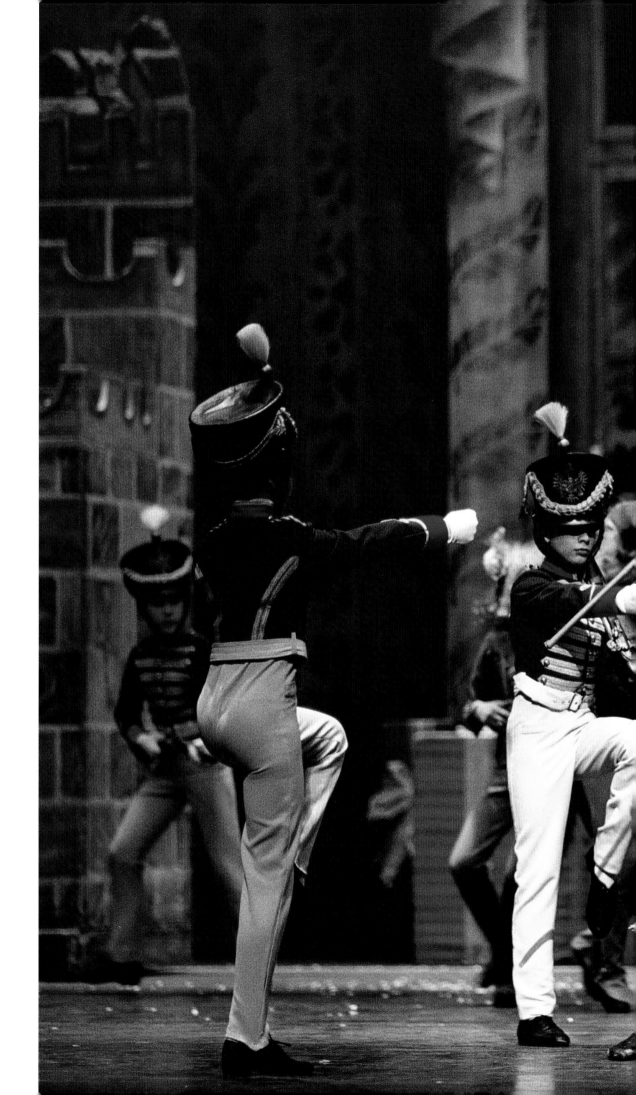

Previous pages, left: Darcey Bussell,
right: Ivan Putrov

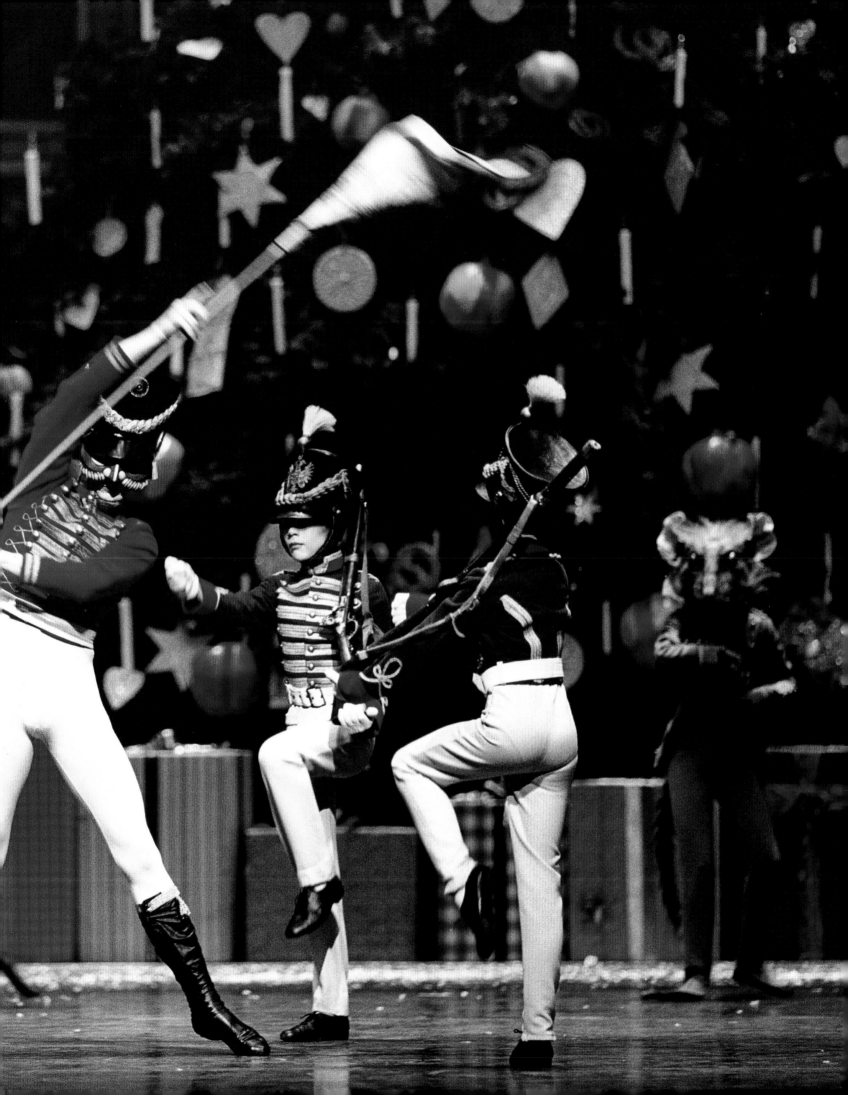

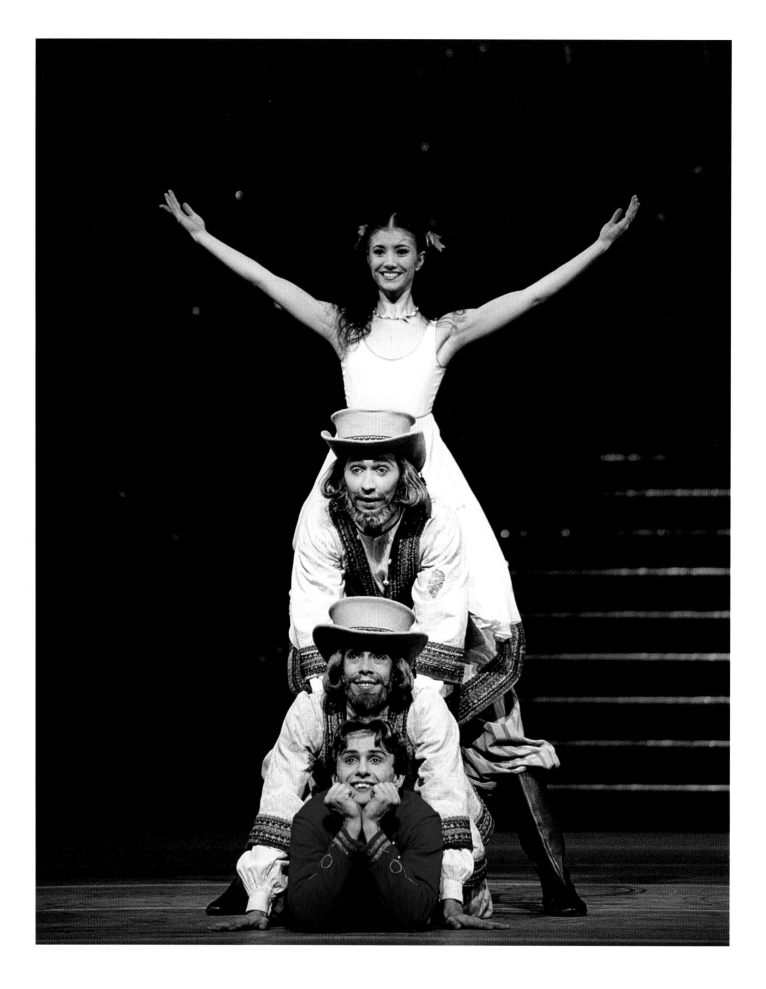

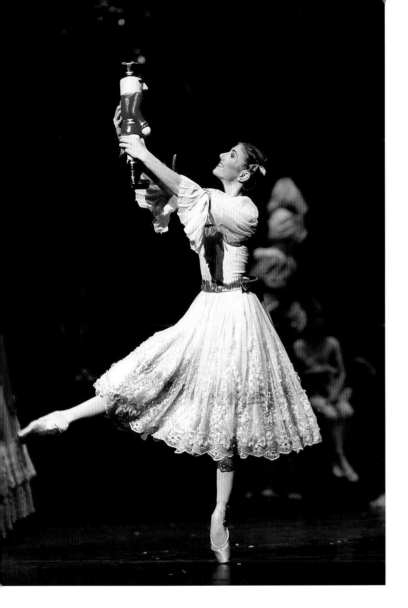

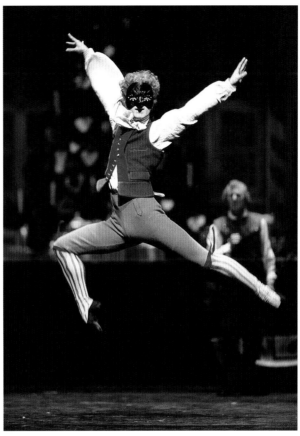

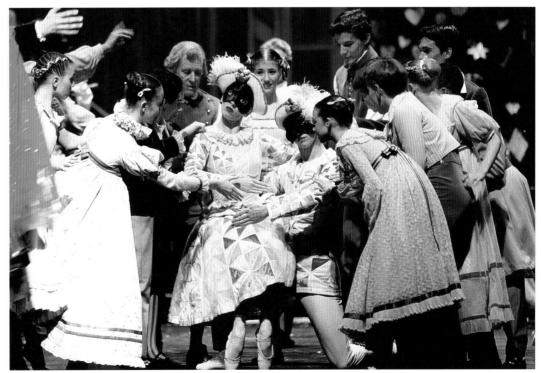

Above: Alina Cojocaru

Above right: Jonathan Howells

Right: Mara Galeazzi, Ricardo Cerveran, Alina Cojocaru

Left: Alina Cojocaru, Bennet Gartside, Tom Sapsford, Ivan Putrov

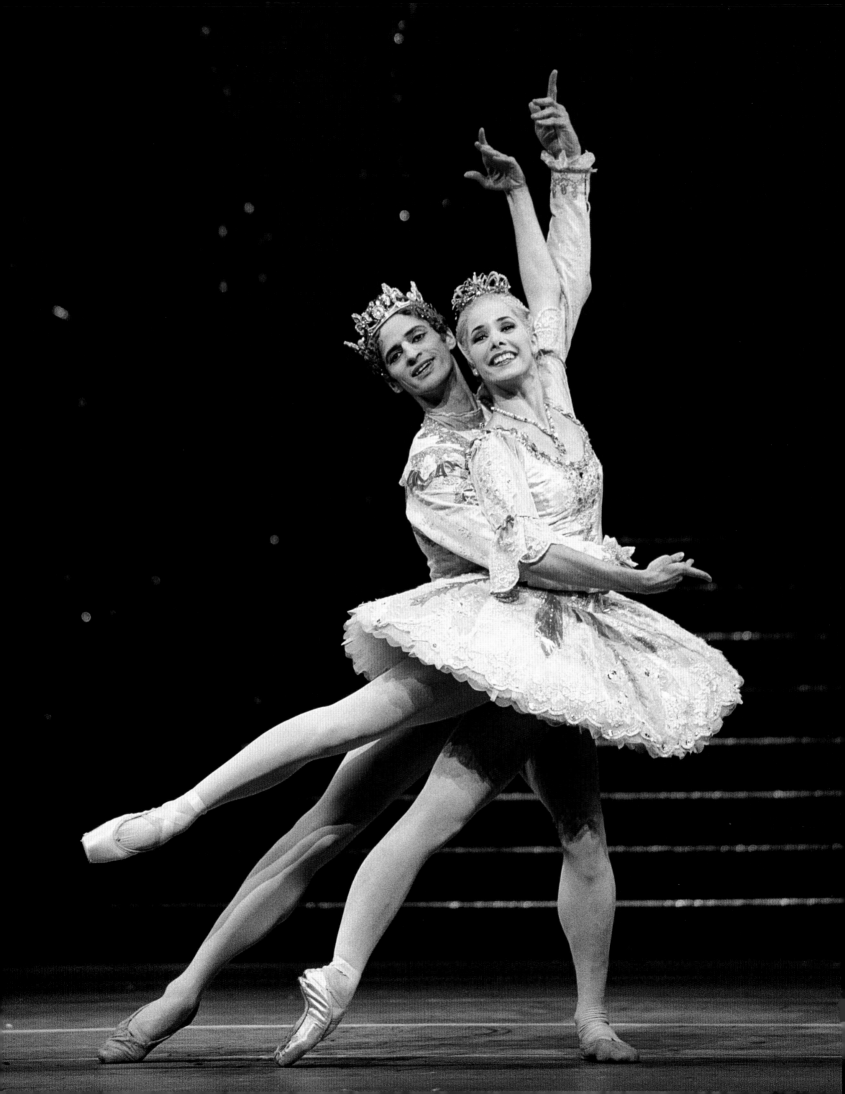

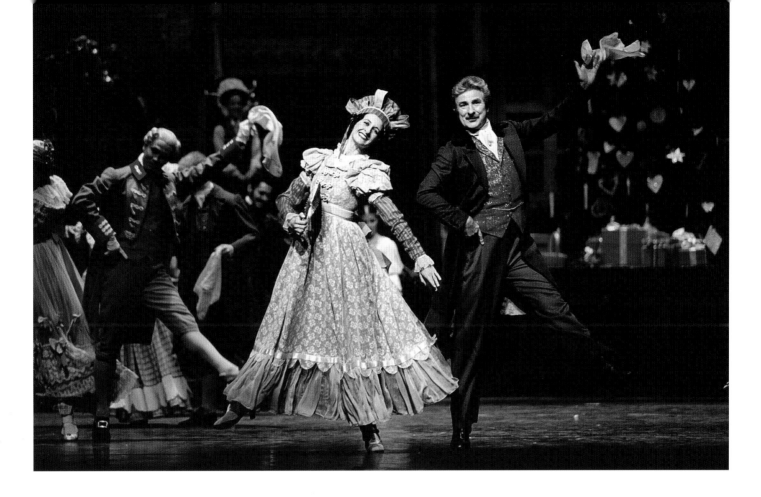

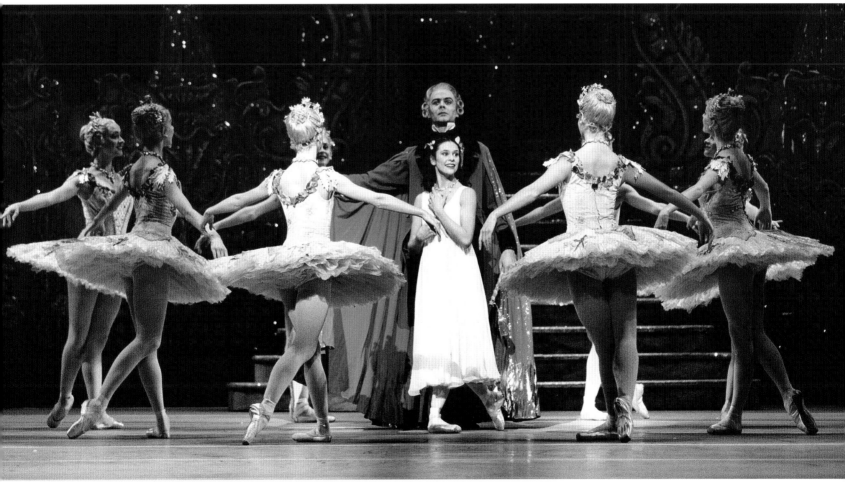

Above: Luke Heydon, Iohna Loots

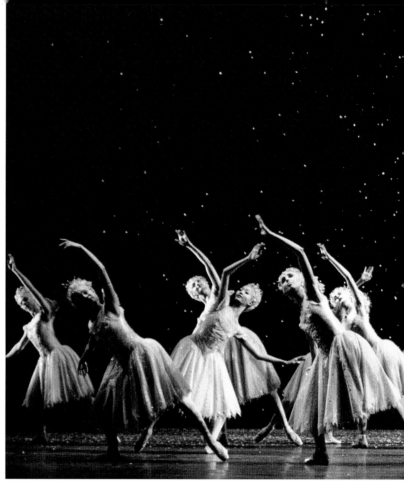

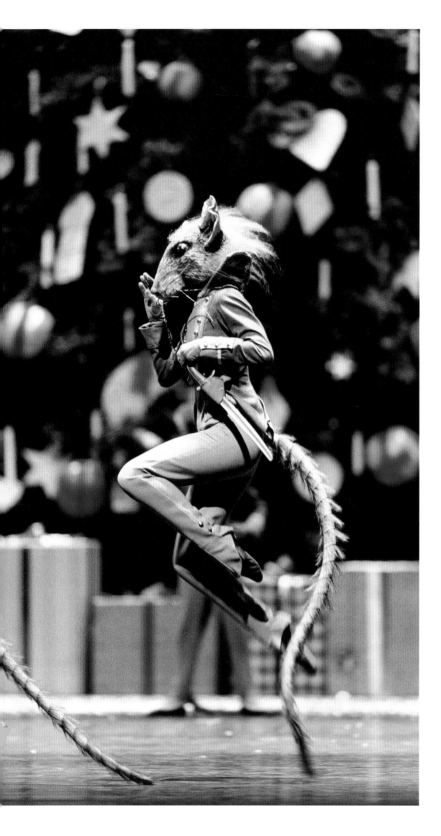

Far right: Alina Cojocaru, Martin Harvey, Yohei Sasaki, Brian Maloney, Giacomo Ciriaci

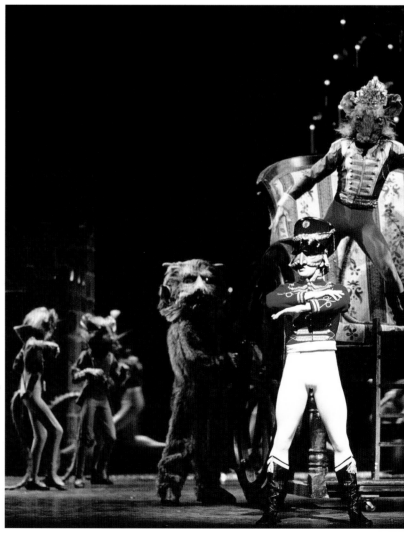

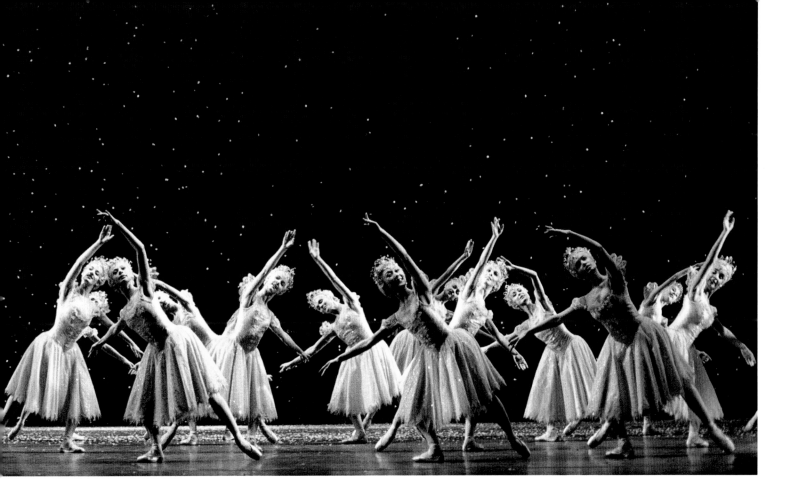

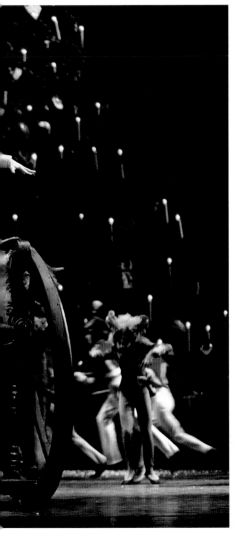

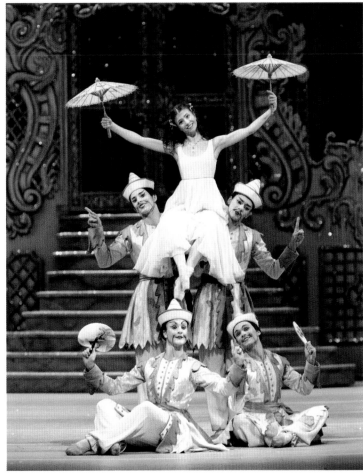

Agon

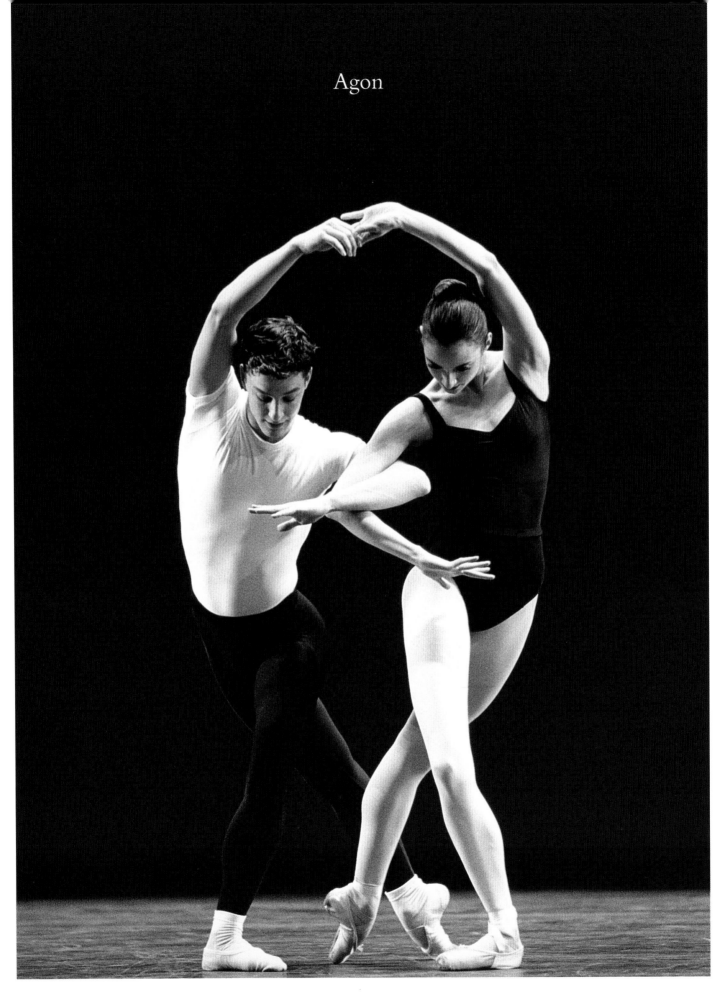

Above: Johannes Stepanek, Christina Arestis

Right: Johan Persson

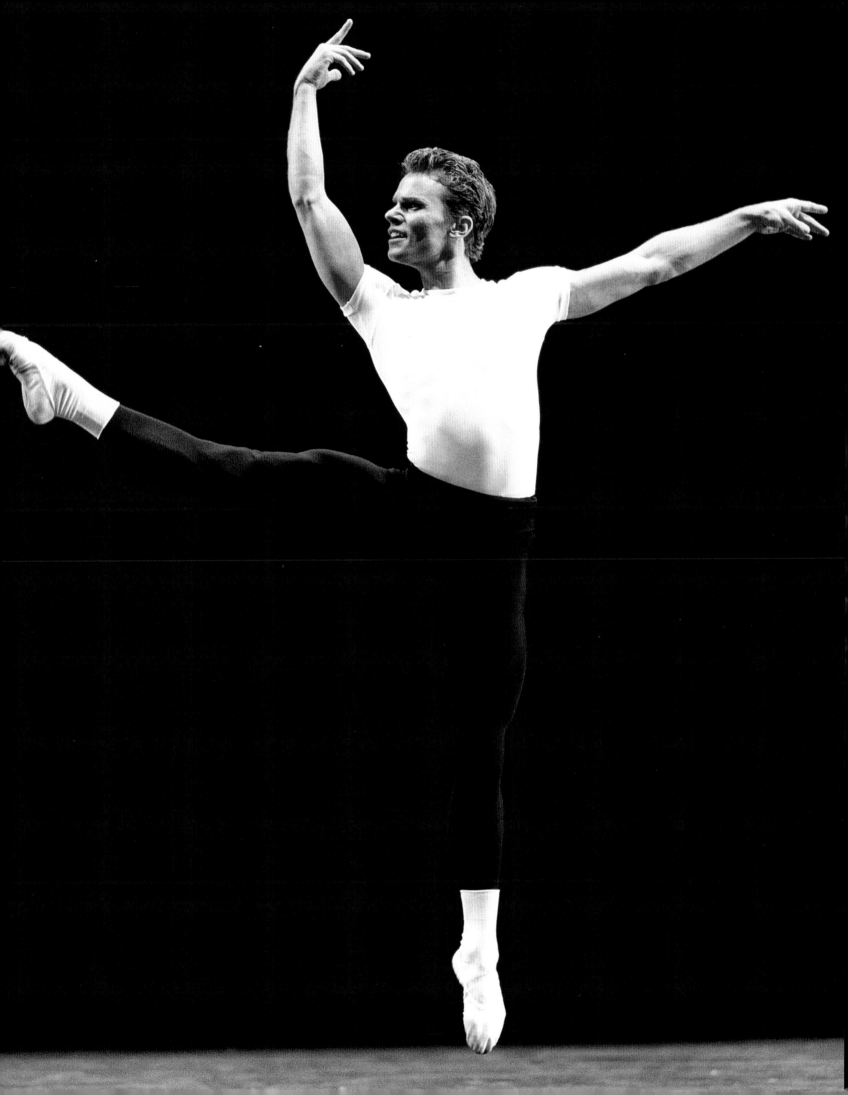

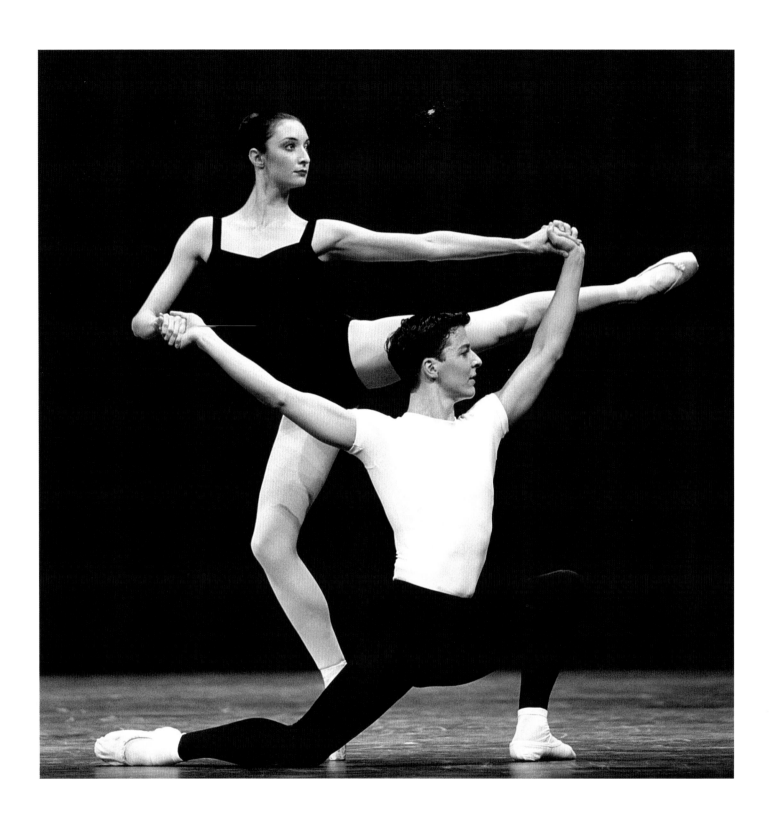

Christina Arestis, Johannes Stepanek

Dance Variations

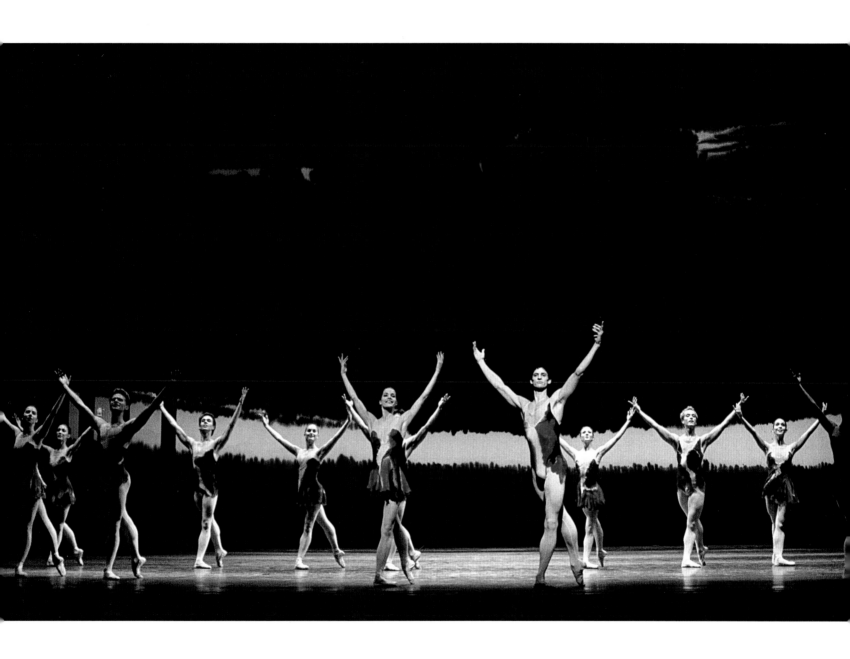

Darcey Bussell, Jonathan Cope

Ondine

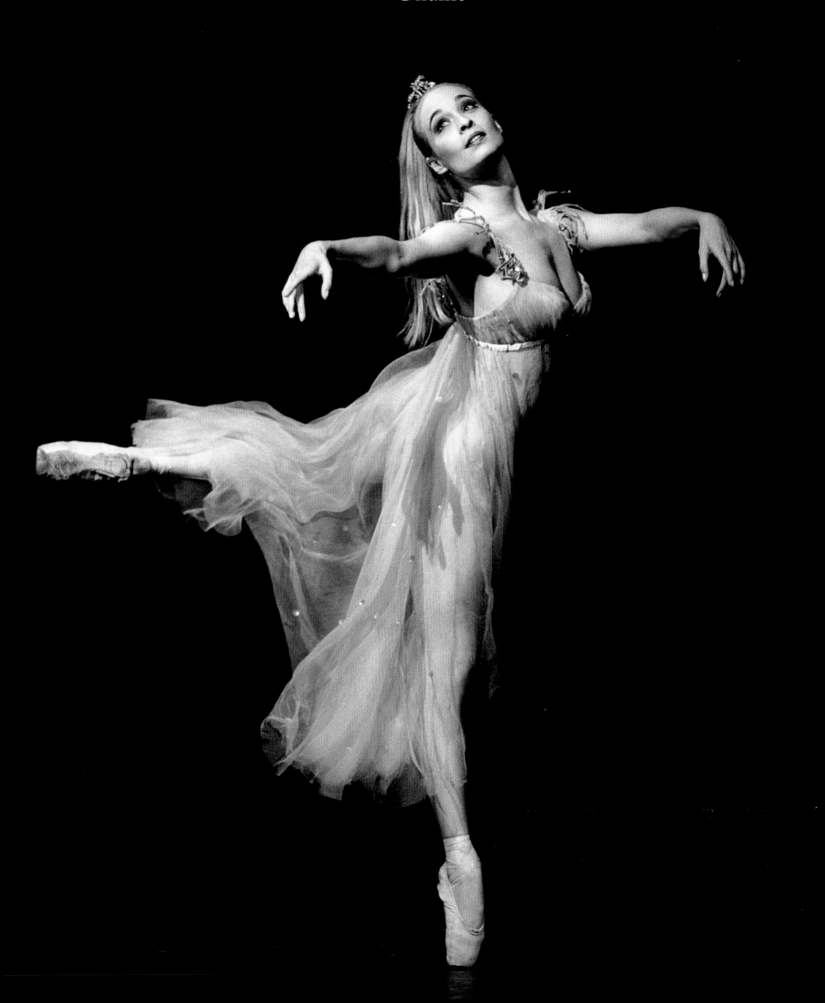

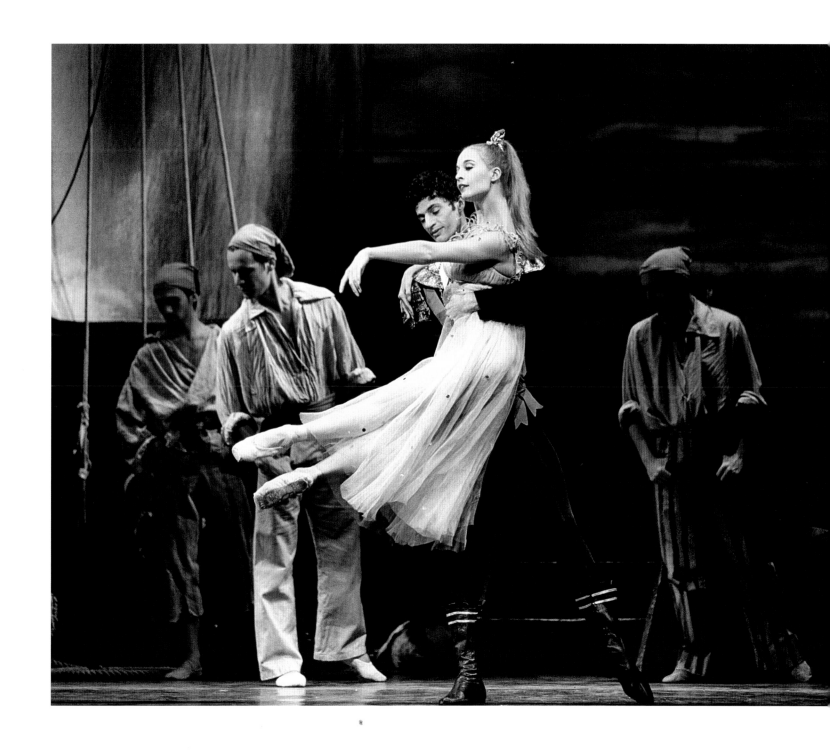

Above: Jonathan Cope, Sarah Wildor

Left: Sarah Wildor

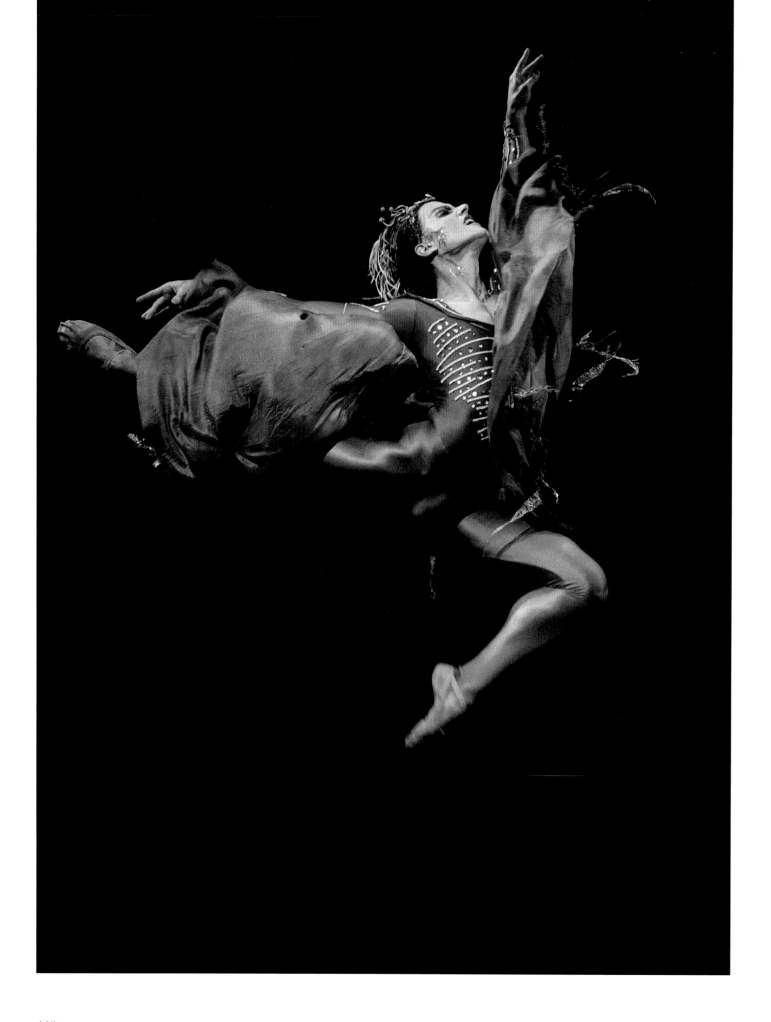

Above: Johan Persson

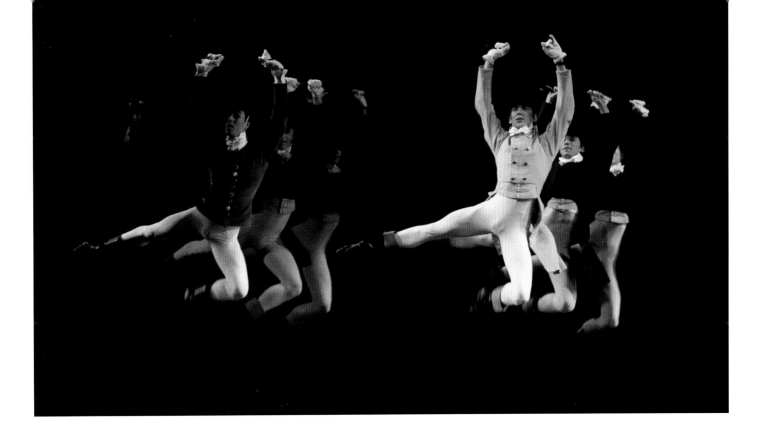

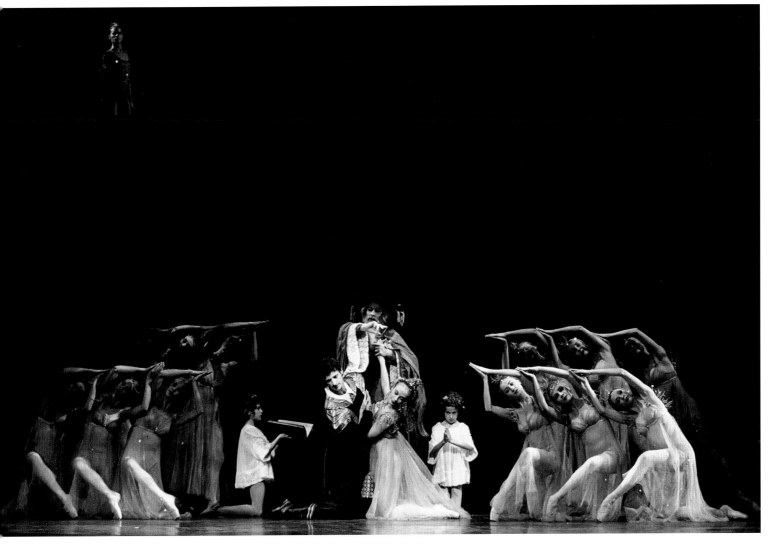

Above: Jonathan Cope, Sarah Wildor

The Concert

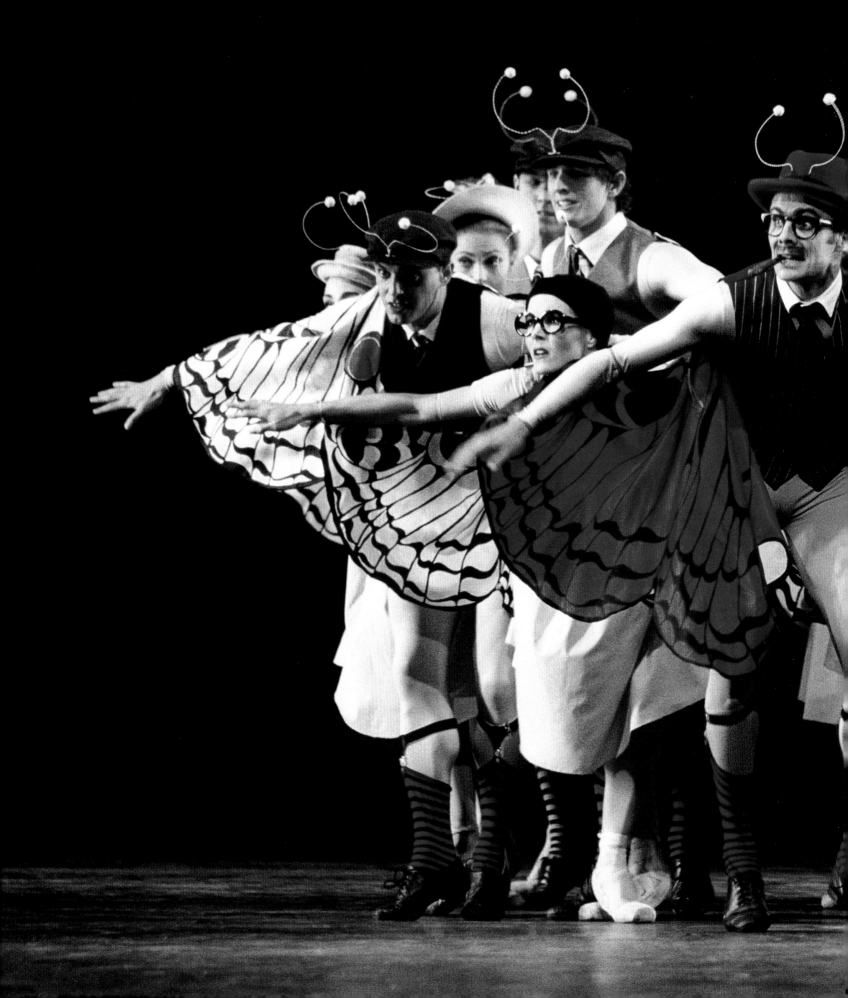

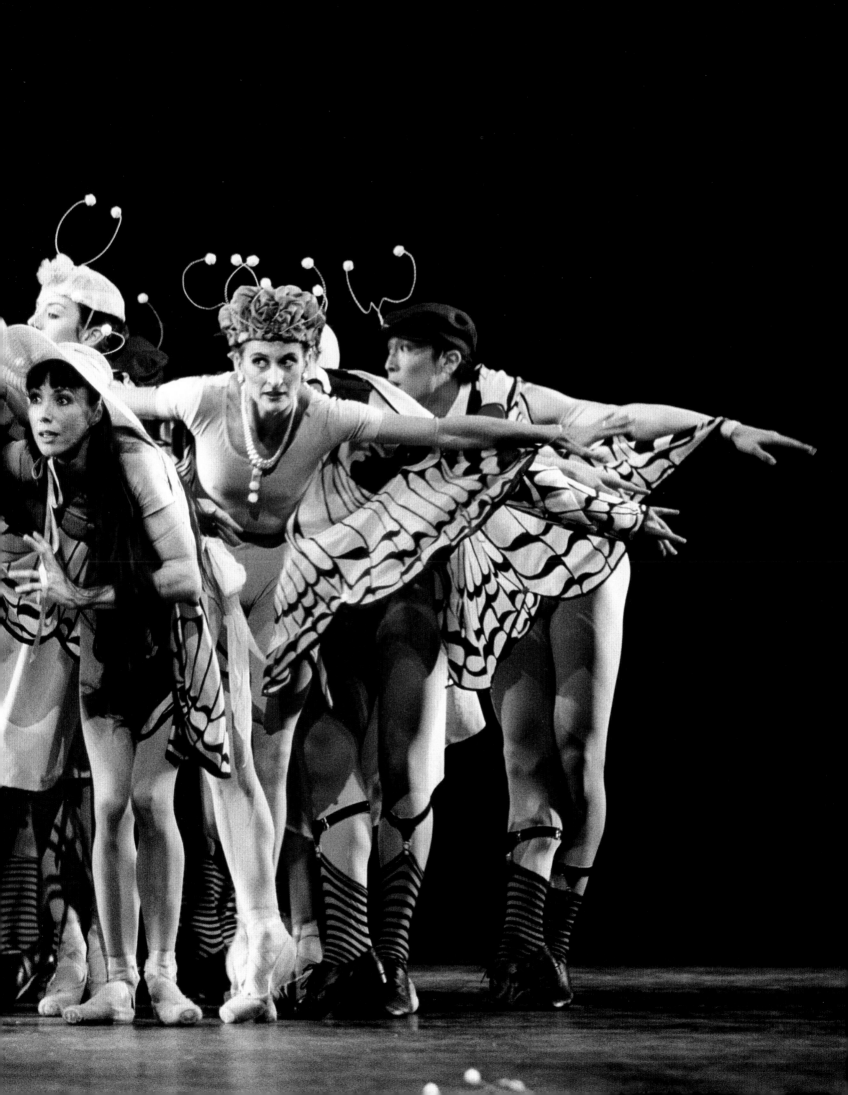

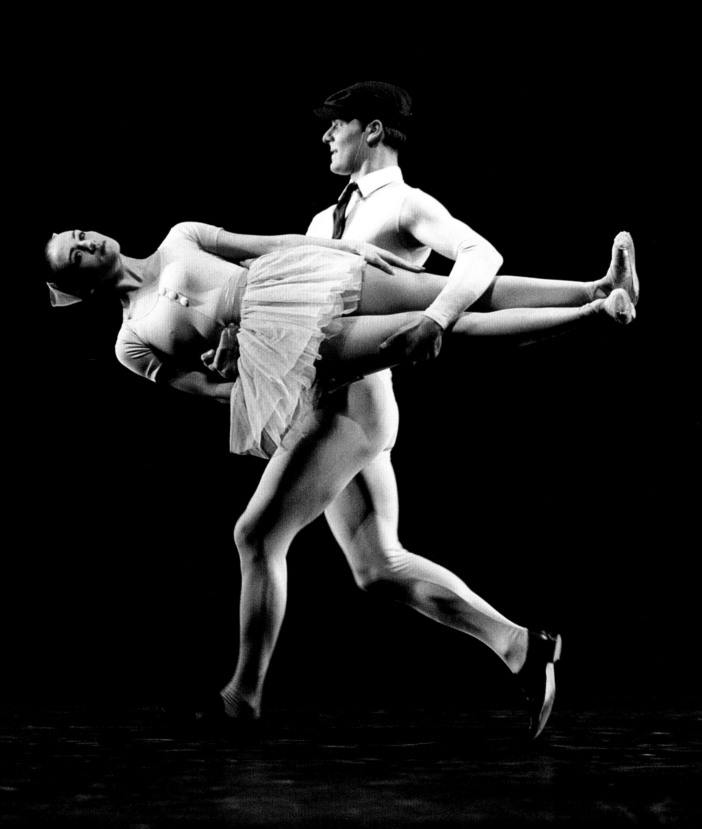

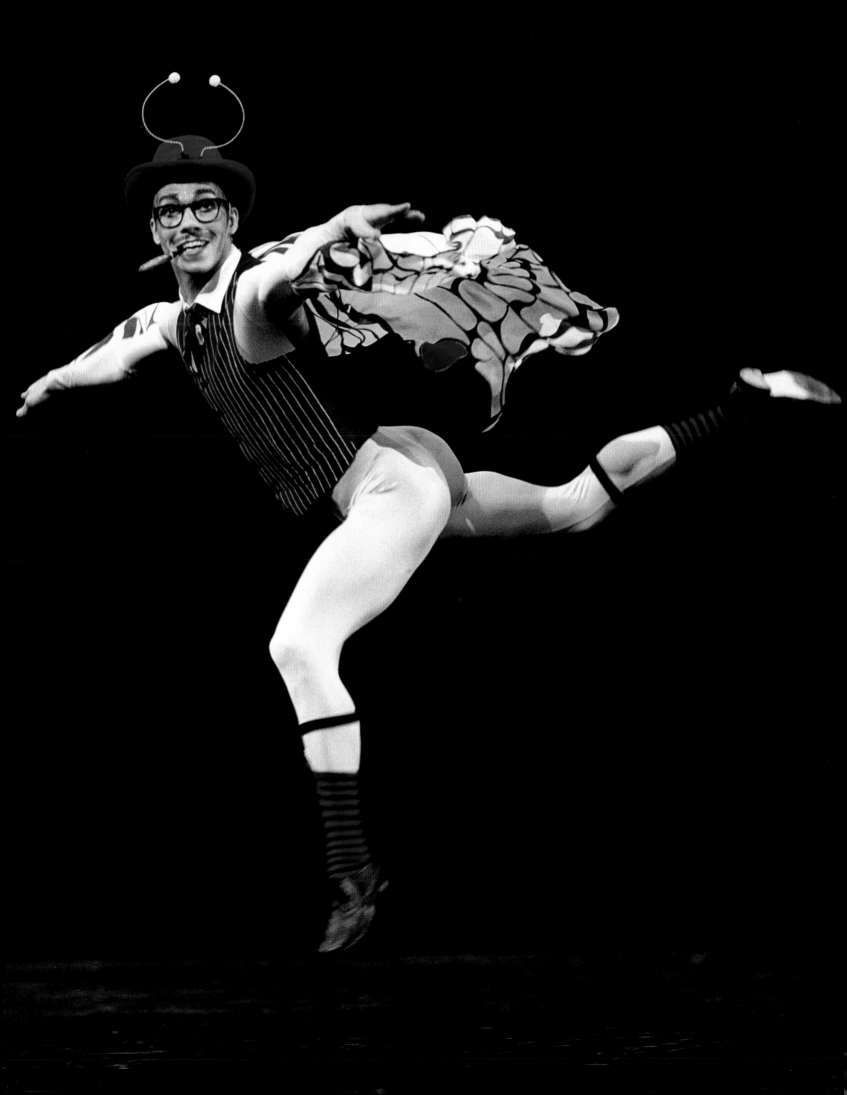

Previous pages, left: Victoria Hewitt, Maurice
Vodegel-Matzen *right:* Johan Kobborg

Right: Tom Sapsford, Nicola Tranah

Below: Luke Heydon, Sylvie Guillem

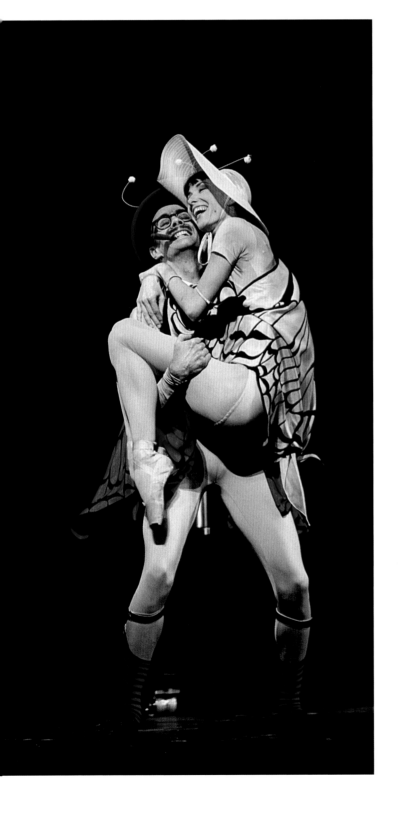

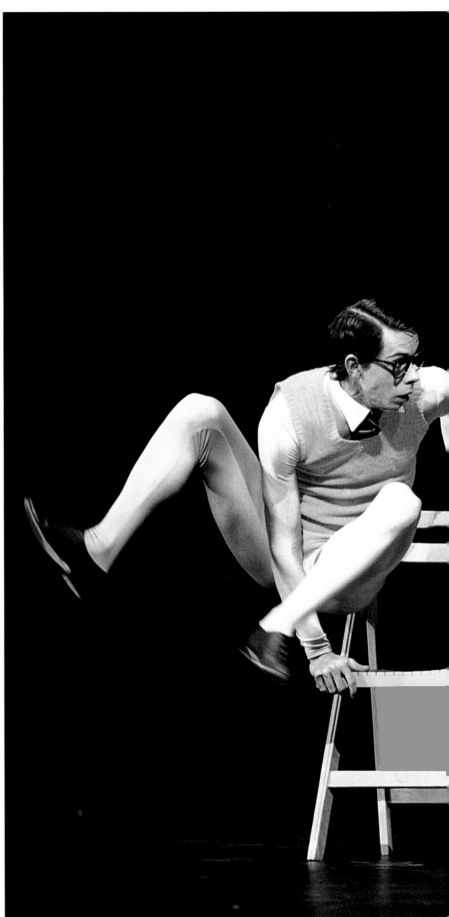

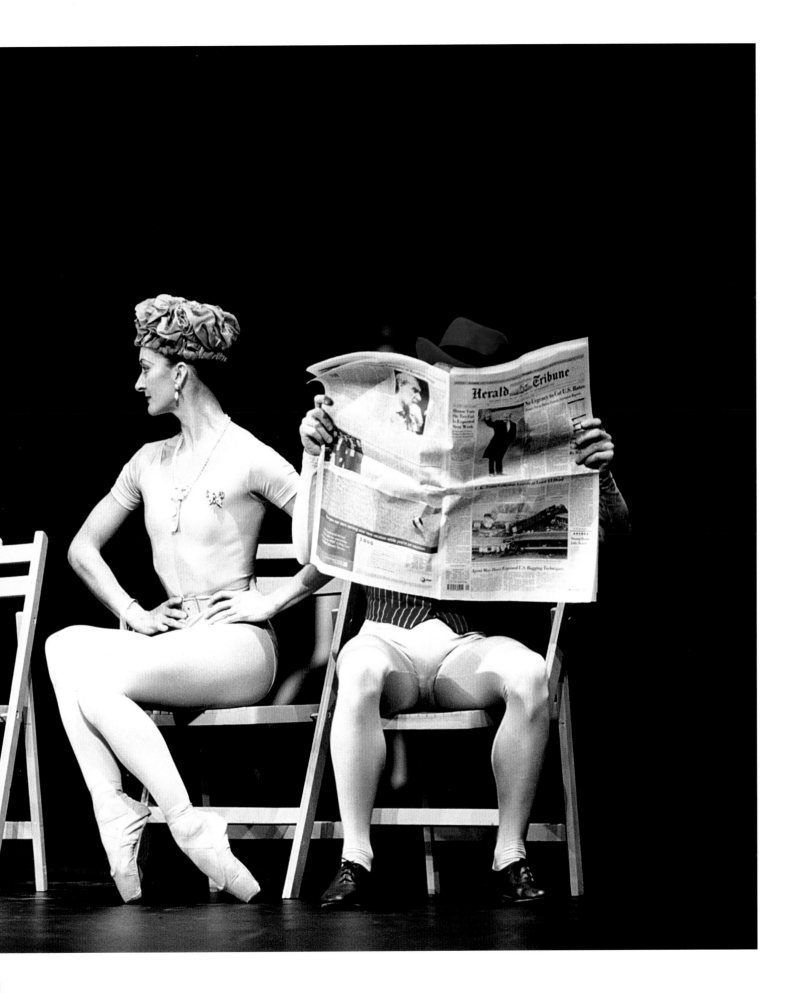

The Dream

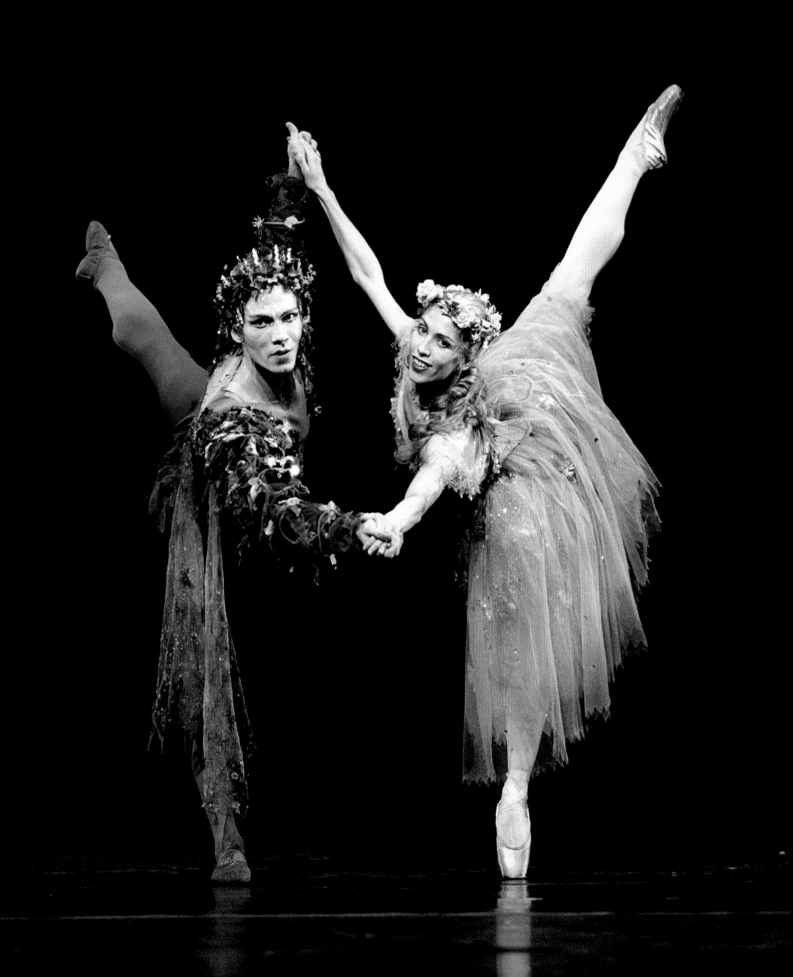

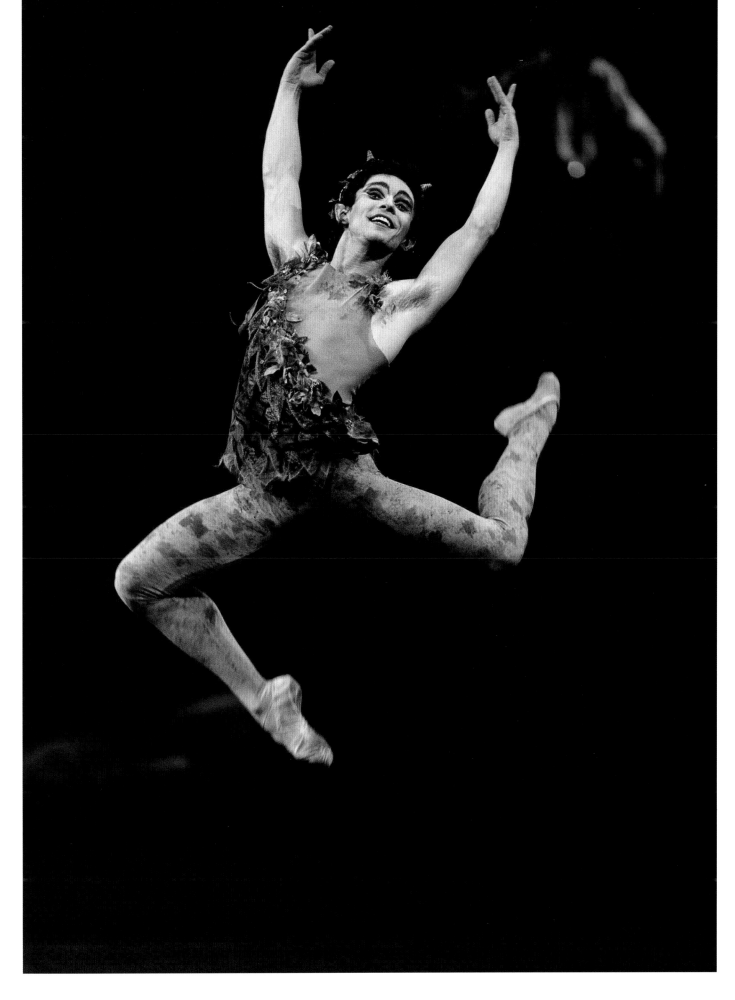

Above: Johan Kobborg, Leanne Benjamin

Right: Giacomo Ciriaci

127

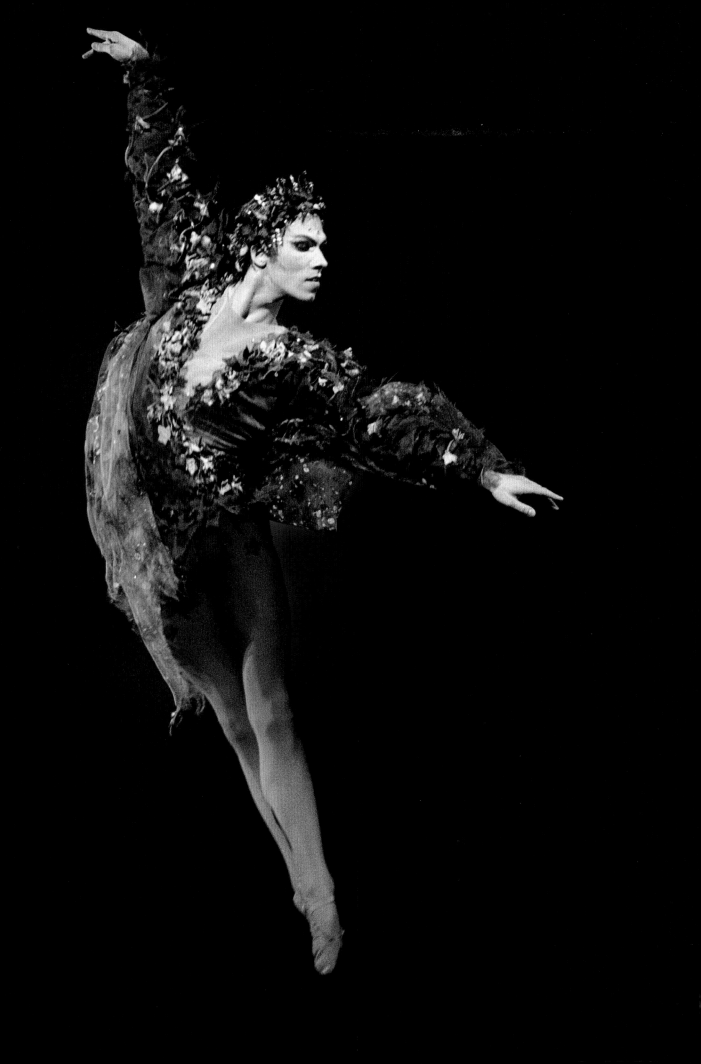

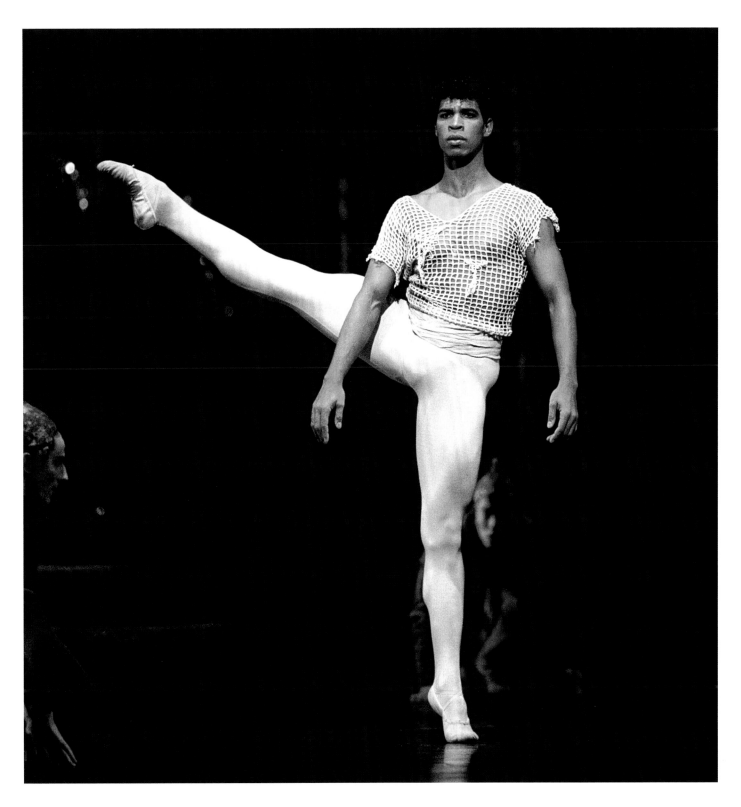

Above: Carlos Acosta

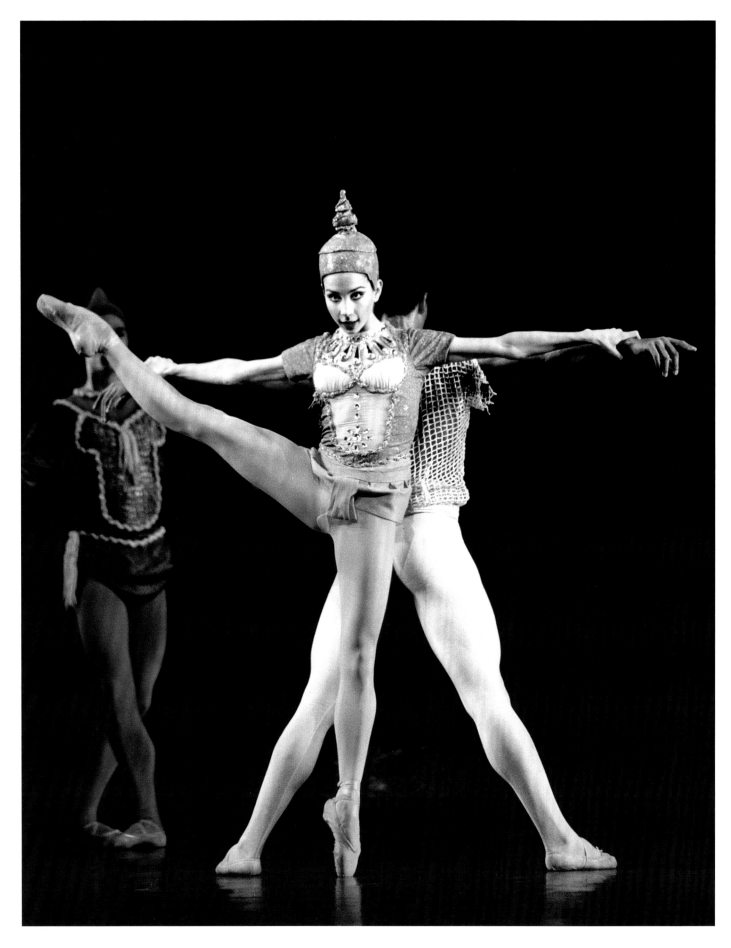

Above: Tamara Rojo

Right: Alina Cojocaru

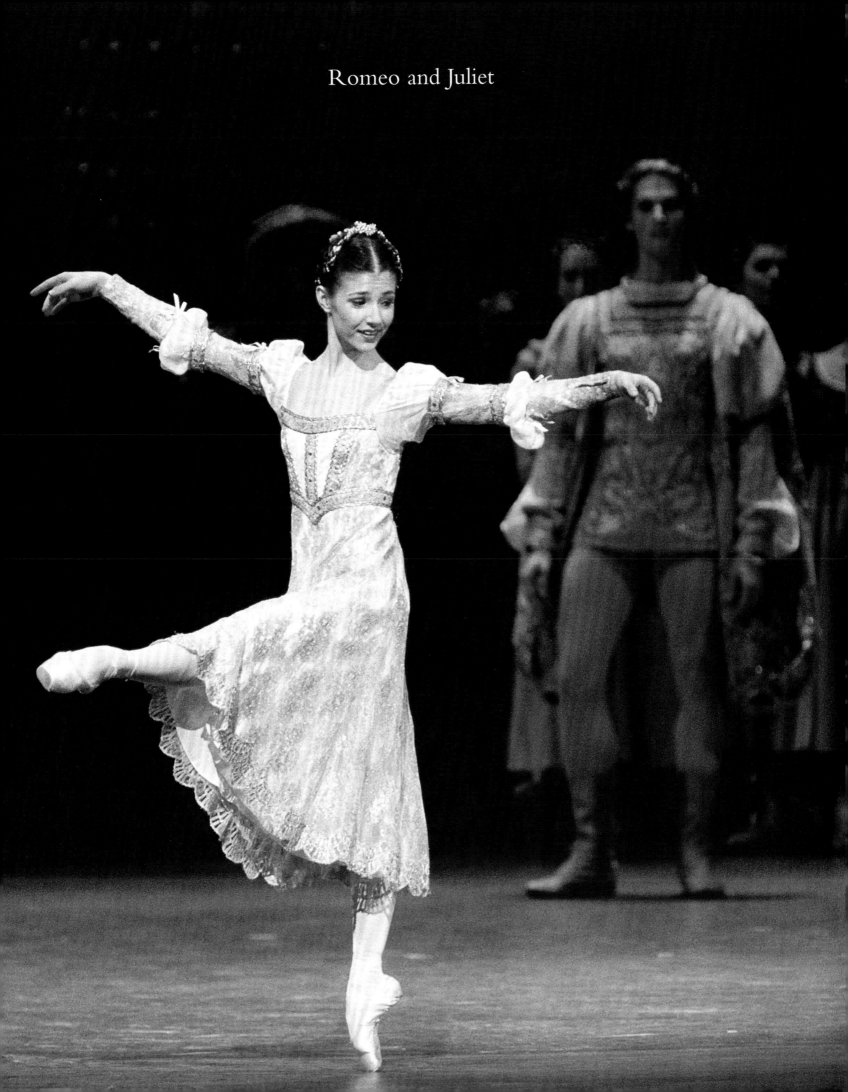

Romeo and Juliet

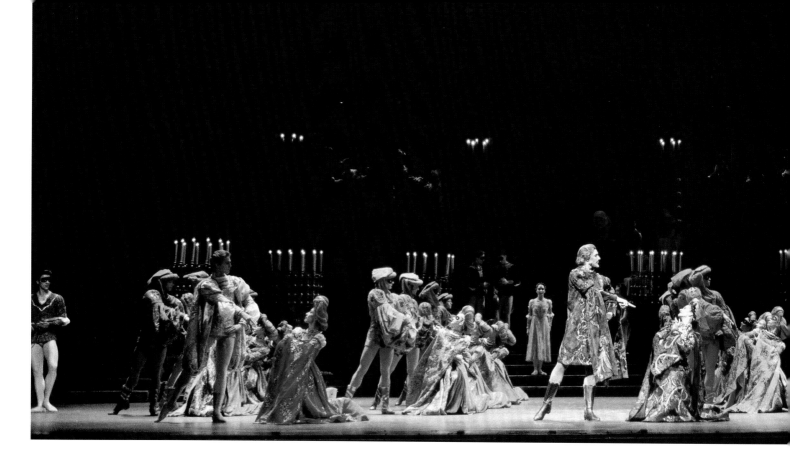

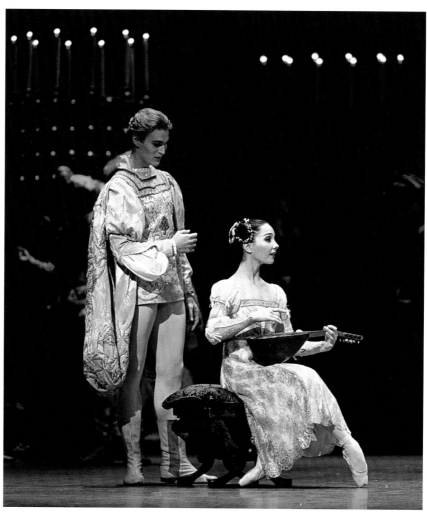

Right: Tamara Rojo, David Pickering

Opposite top: Massimo Murru,
Tamara Rojo

Opposite bottom: Johan Kobborg

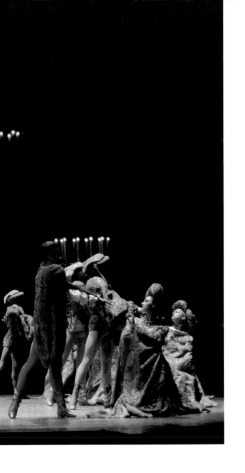

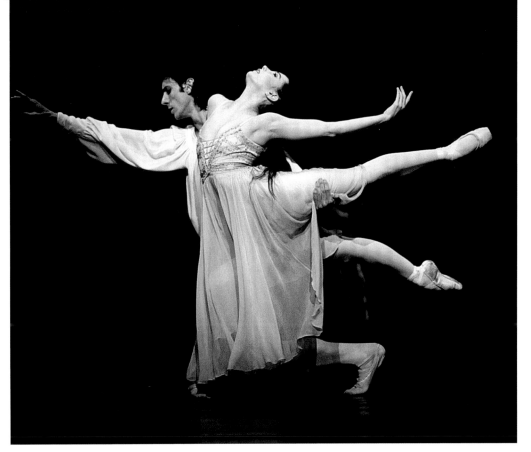

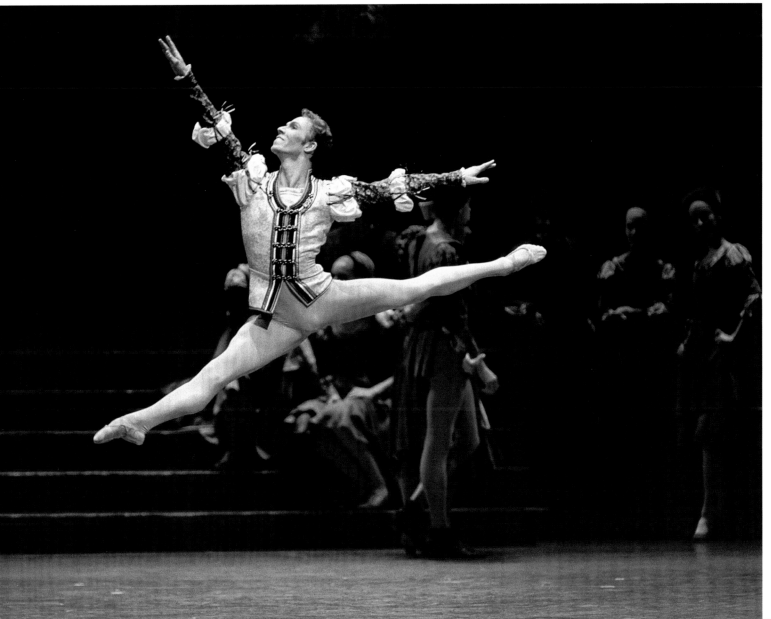

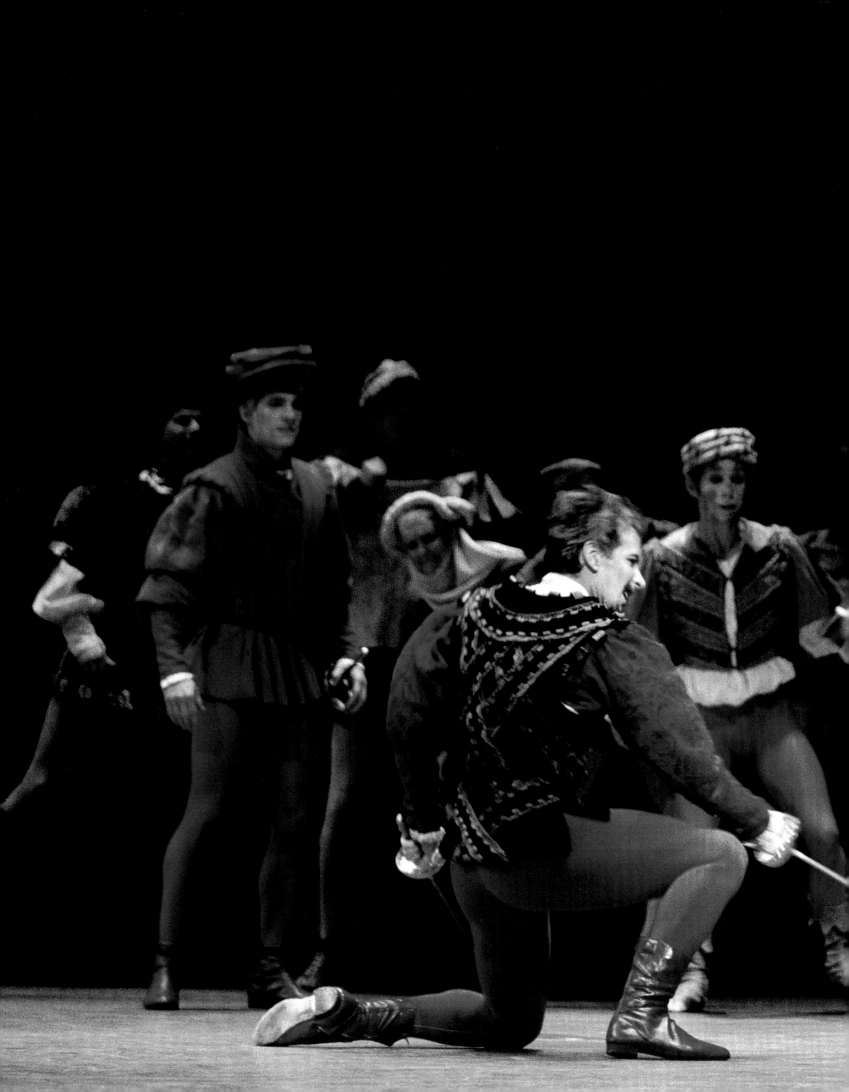

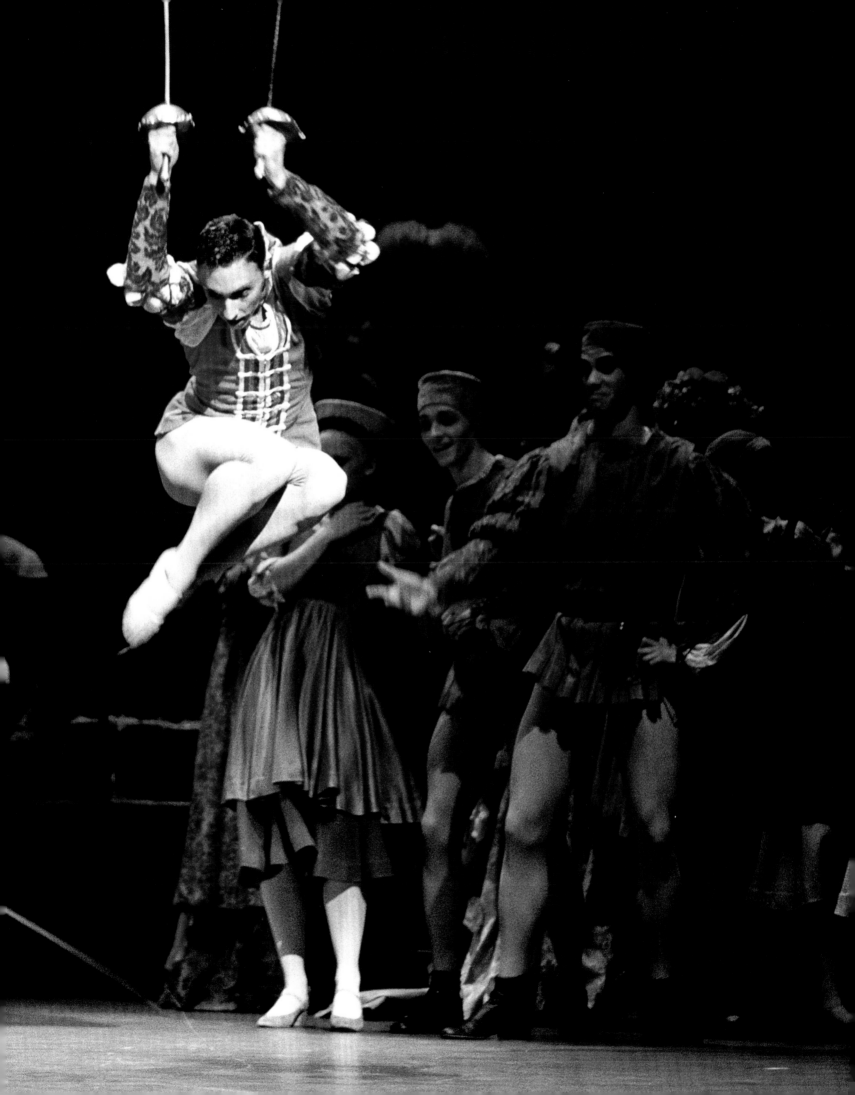

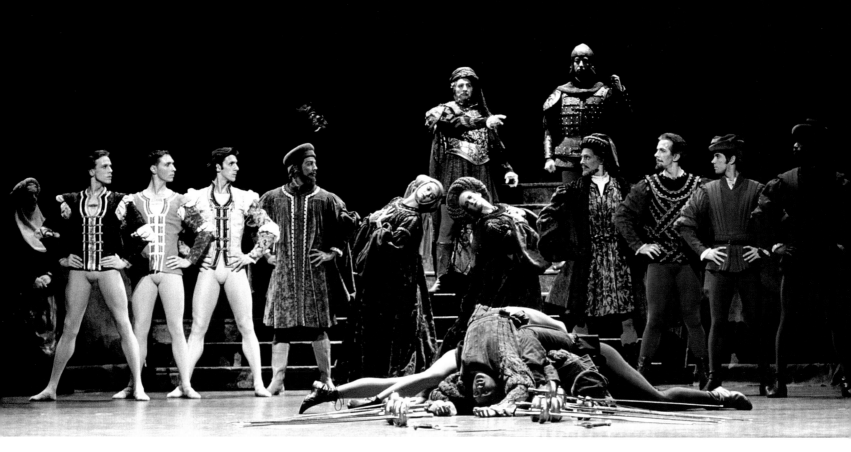

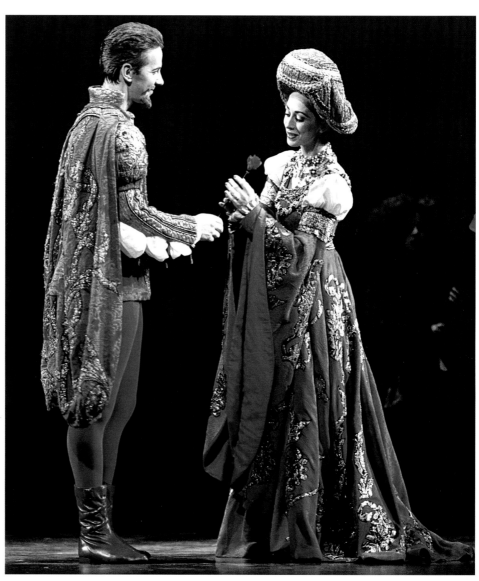

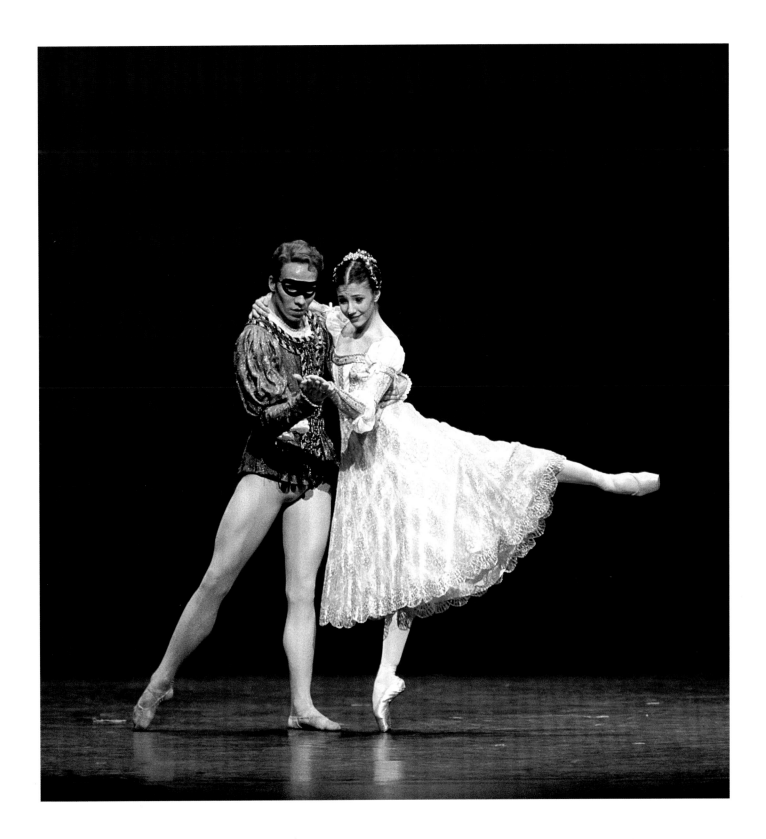

Jeux

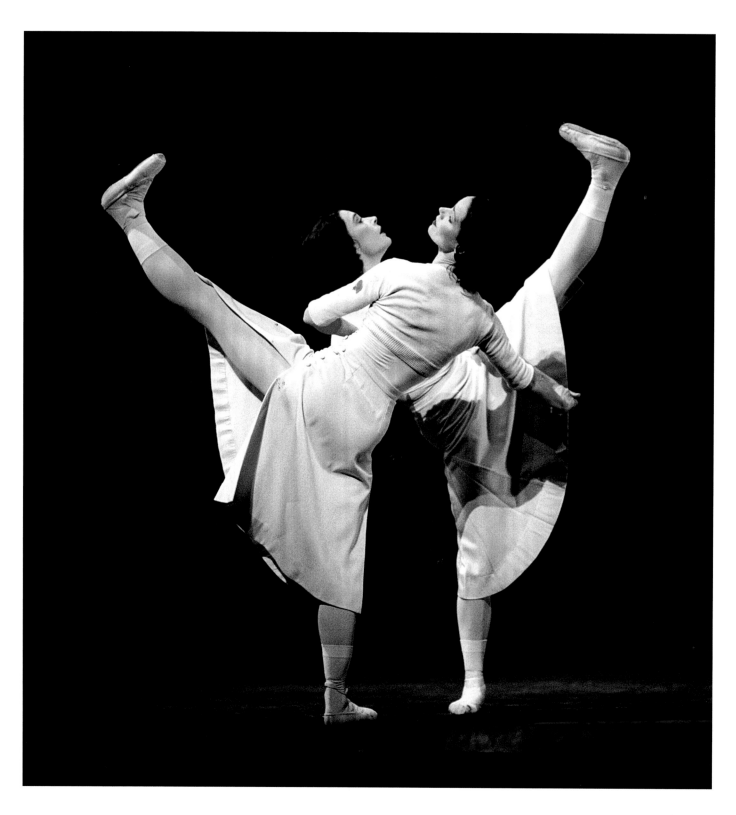

Above: Deborah Bull, Gillian Revie

Right: Bruce Sansom

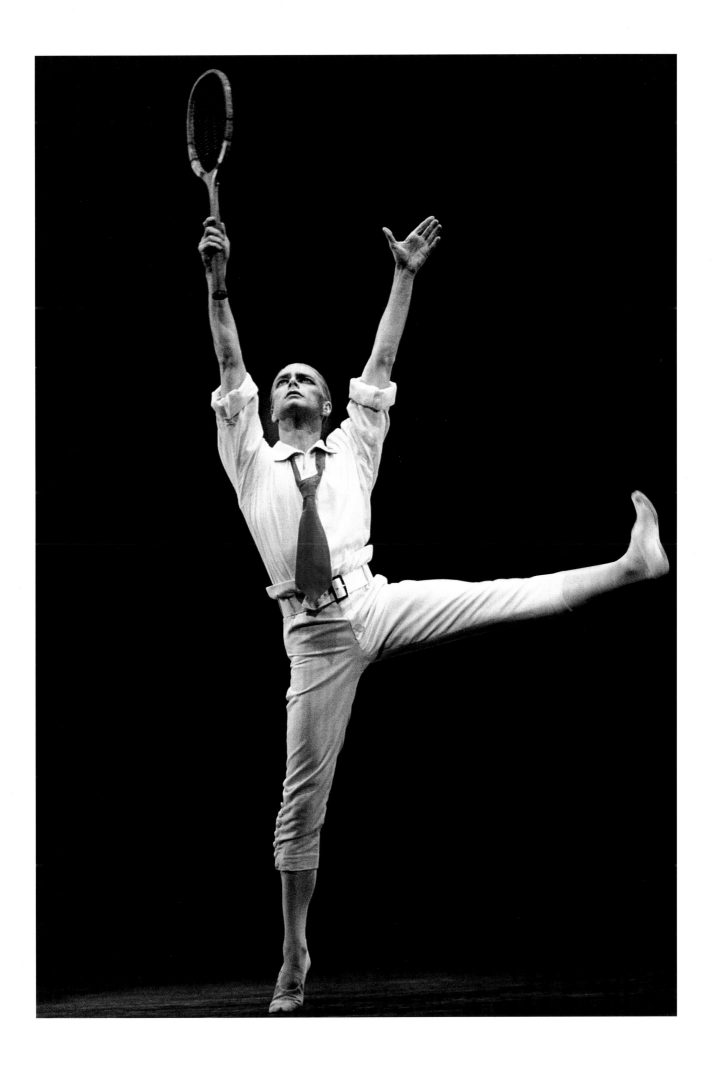

Tryst

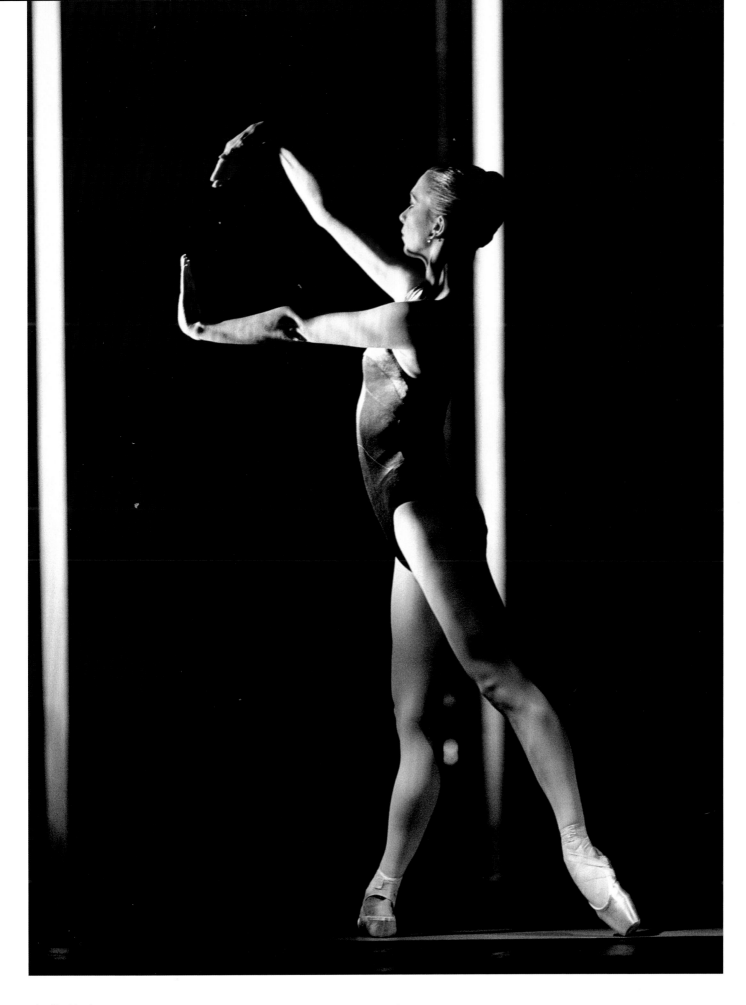

Above: Sian Murphy

Left: Darcey Bussell, Jonathan Cope

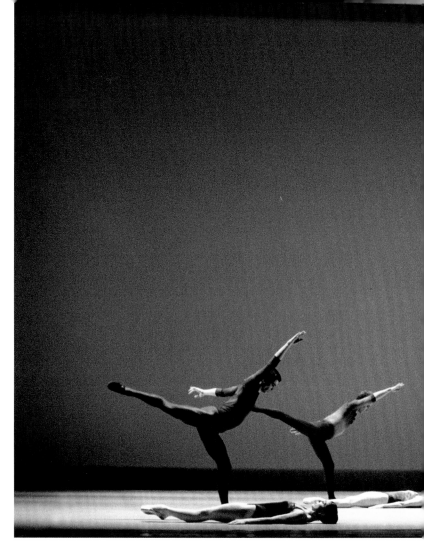

Below: Darcey Bussell, Jonathan Cope

Opposite bottom: Johannes Stepanek,
Jaimie Tapper

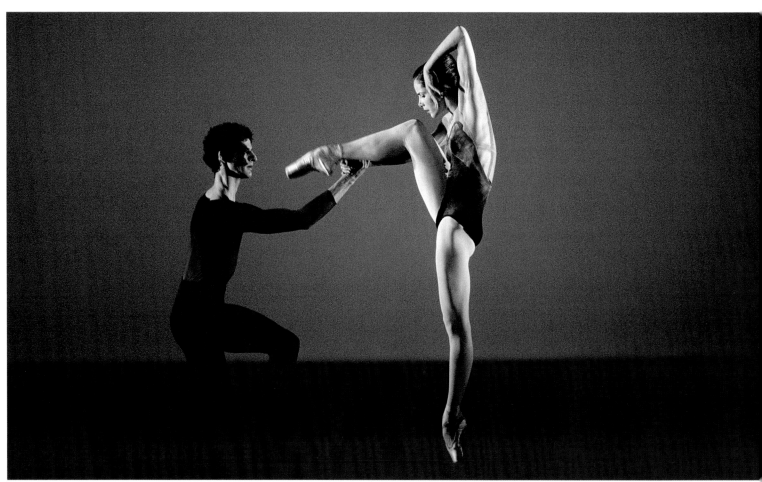

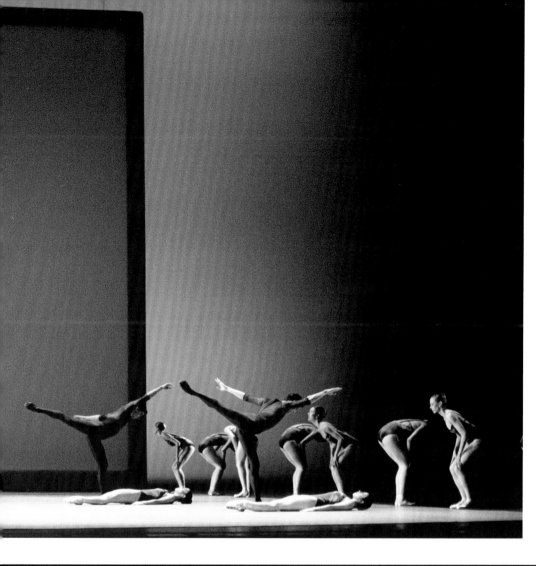

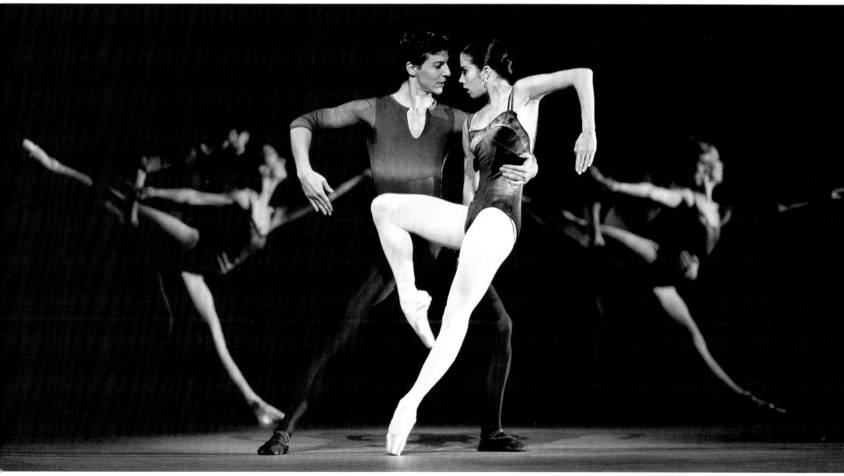

La Bayadére

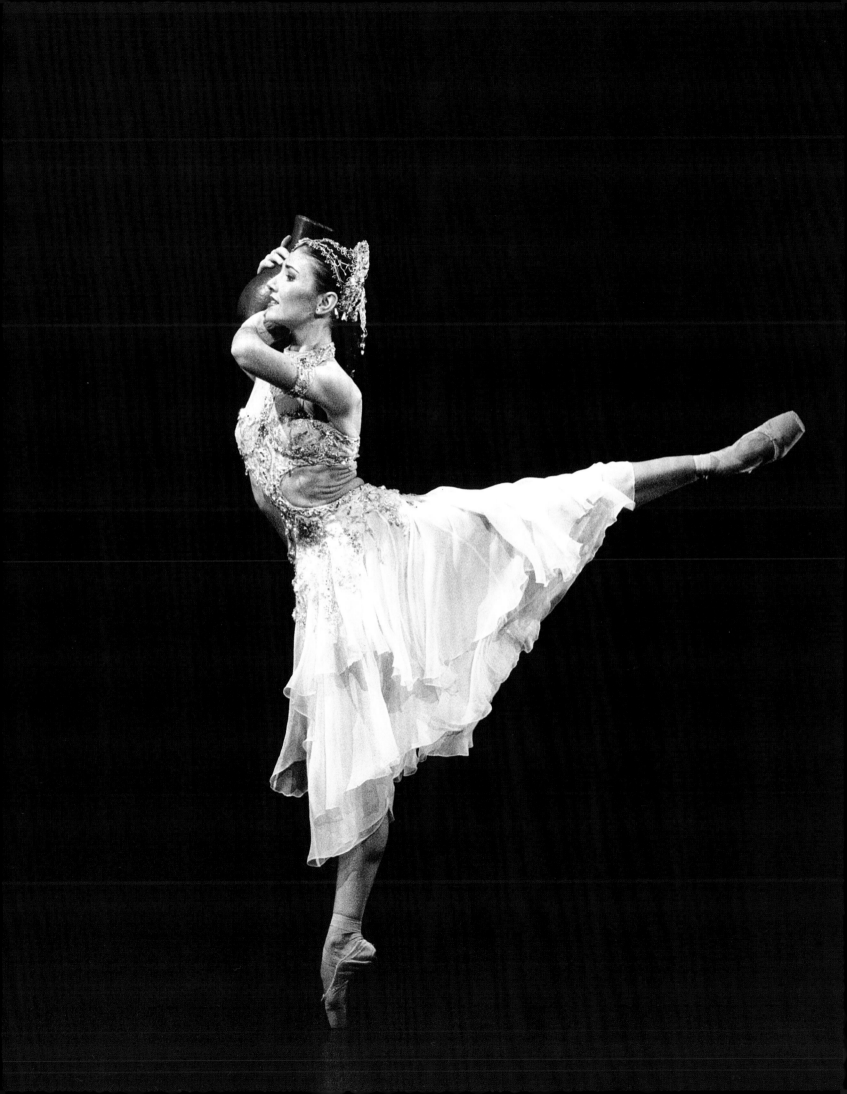

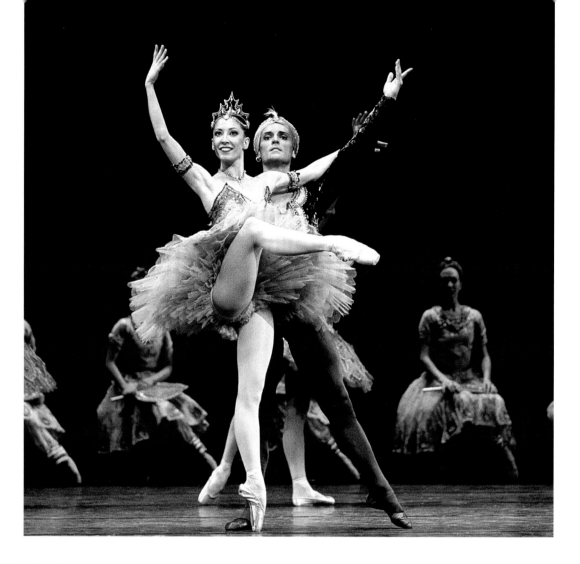

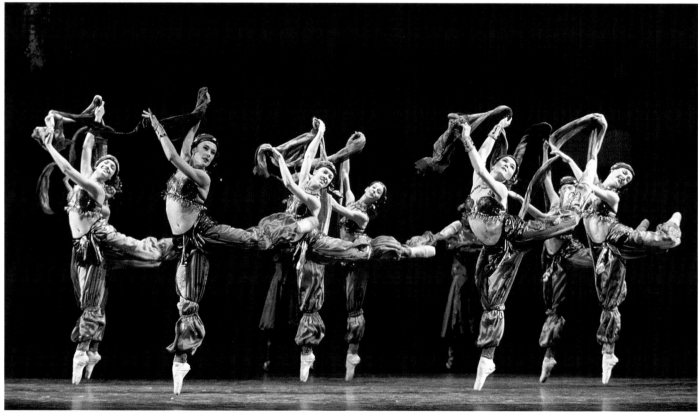

Previous pages, left: Darcey Bussell,
right: Alina Cojocaru

Opposite: Mara Galeazzi, Angel Corella

Below: Ricardo Cervera, Ashley Page,
Darcey Bussell

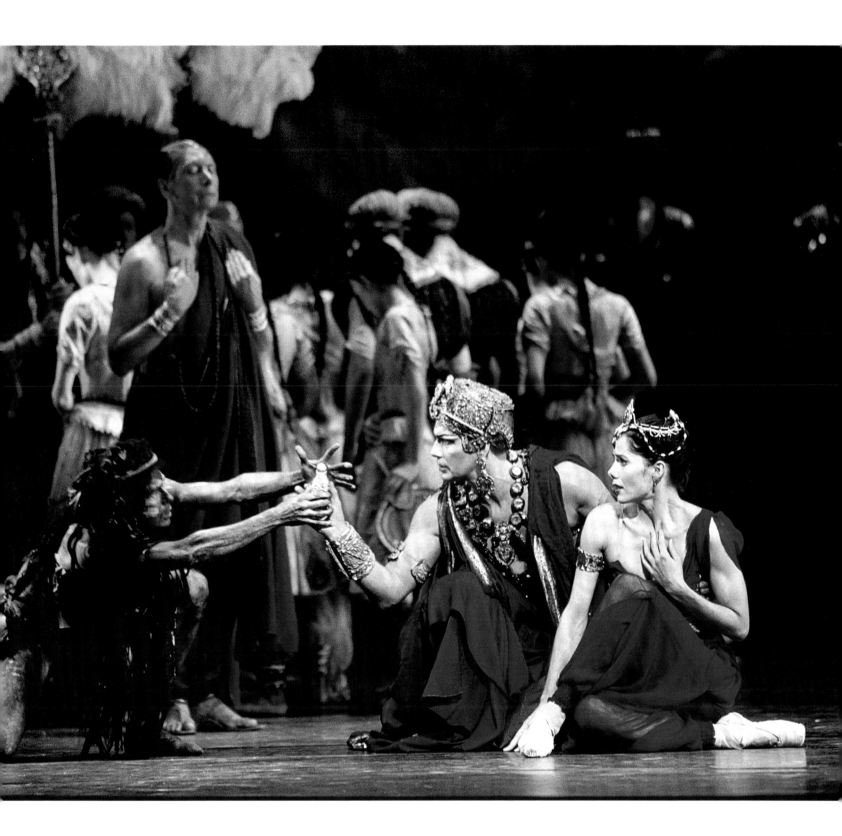

147

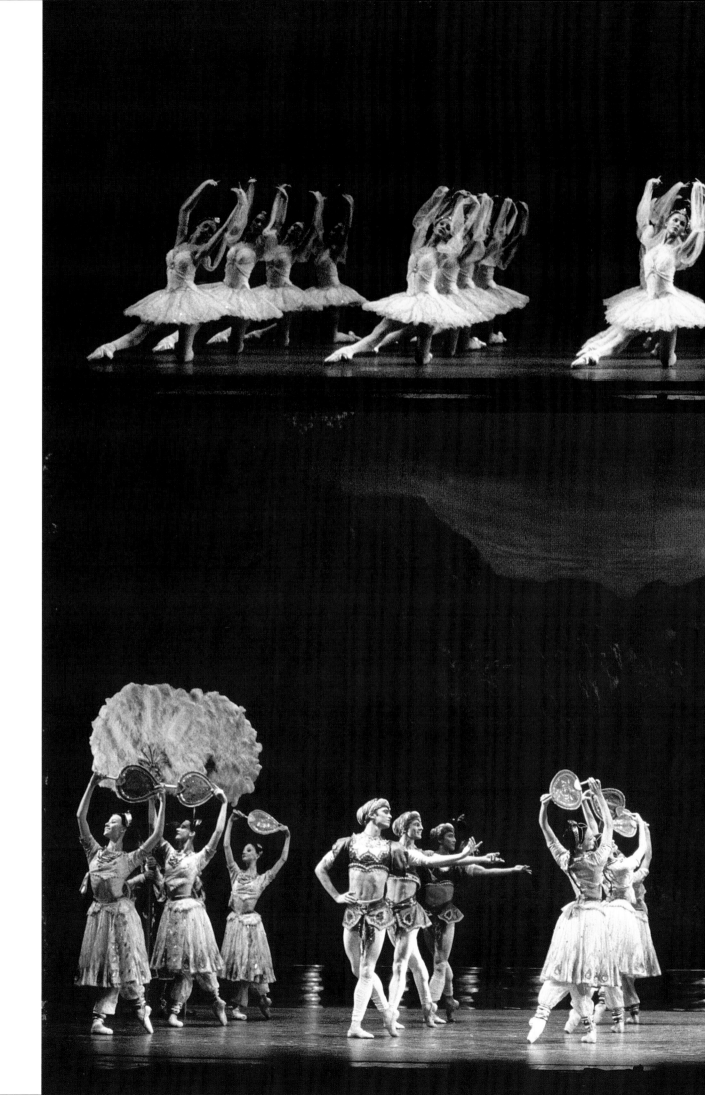

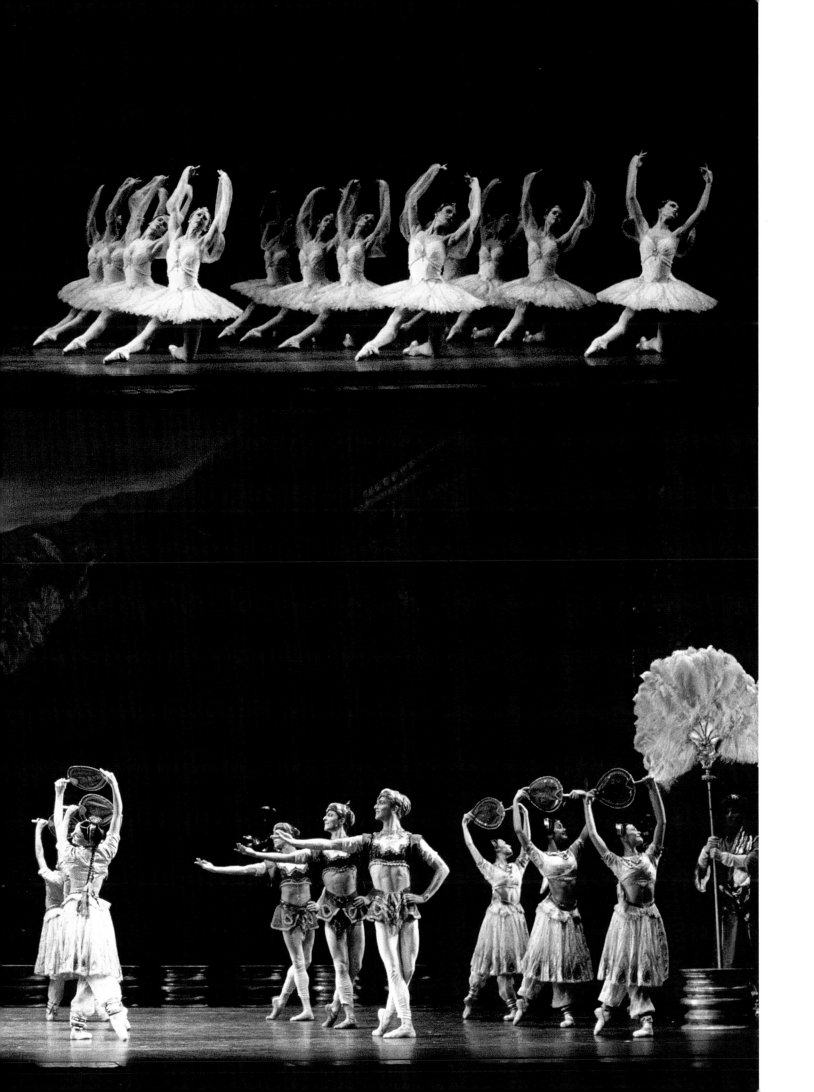

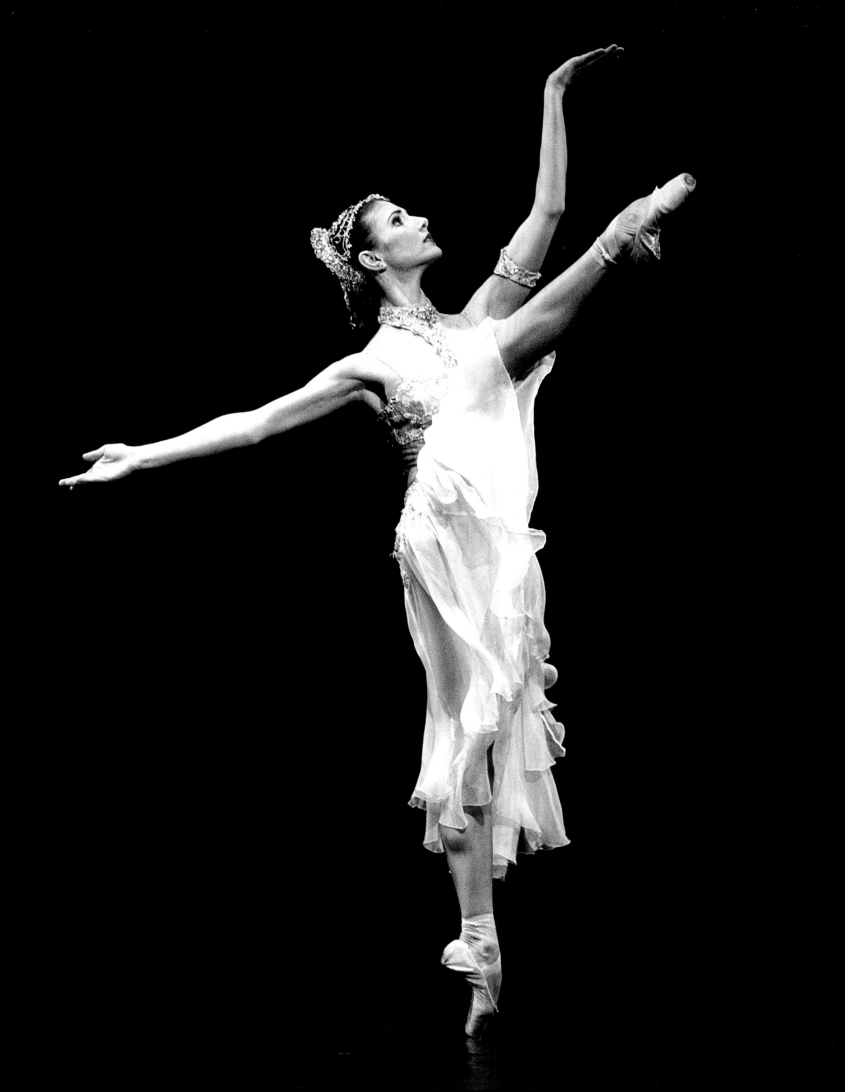

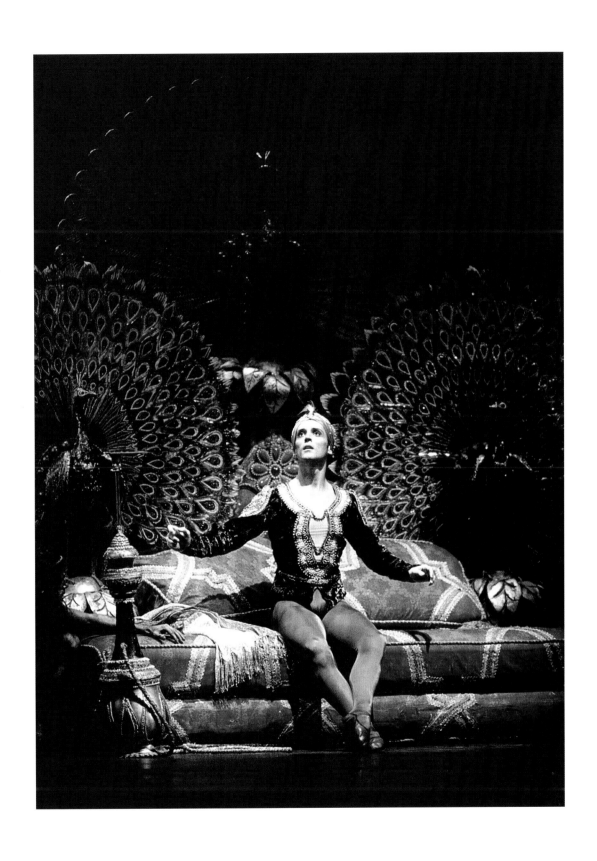

Above: Angel Corella

Left: Alina Cojocaru

Remanso

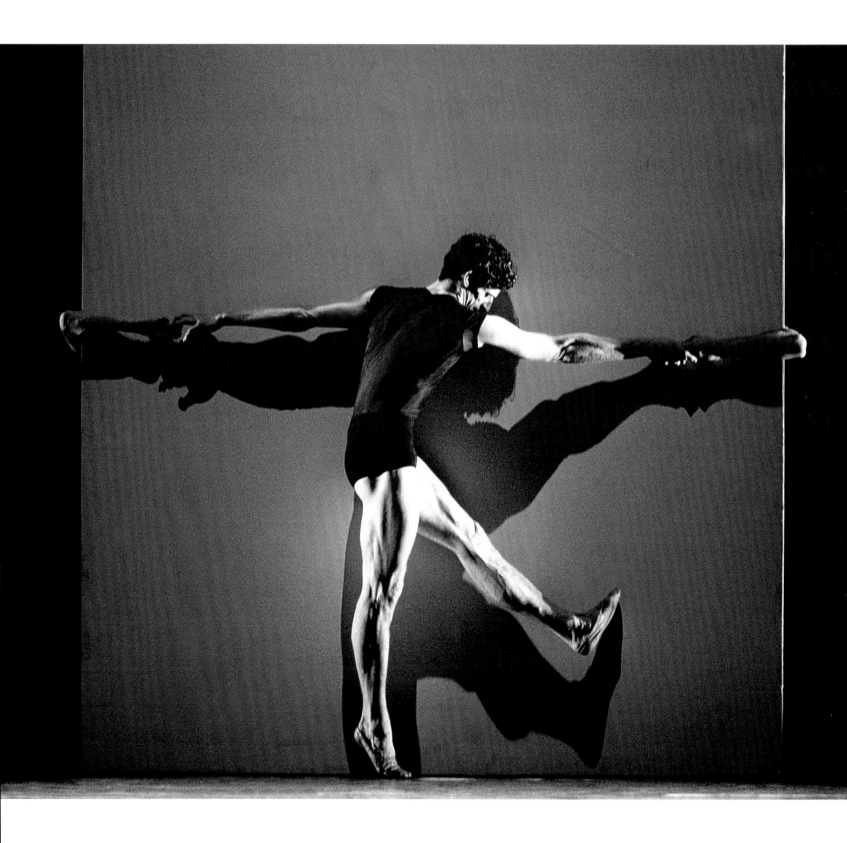

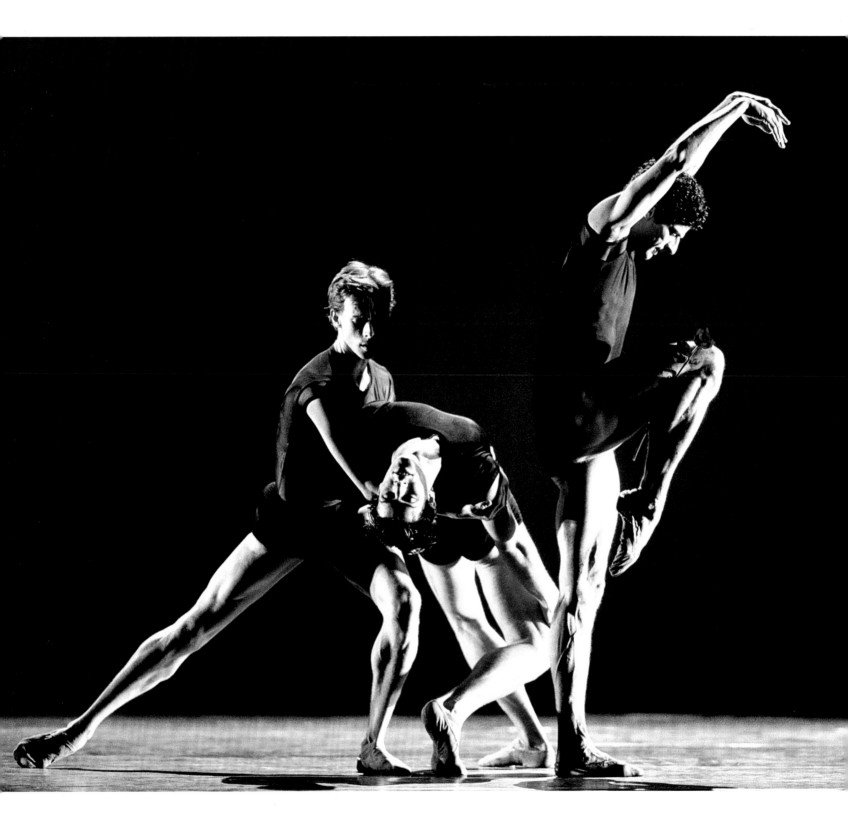

153

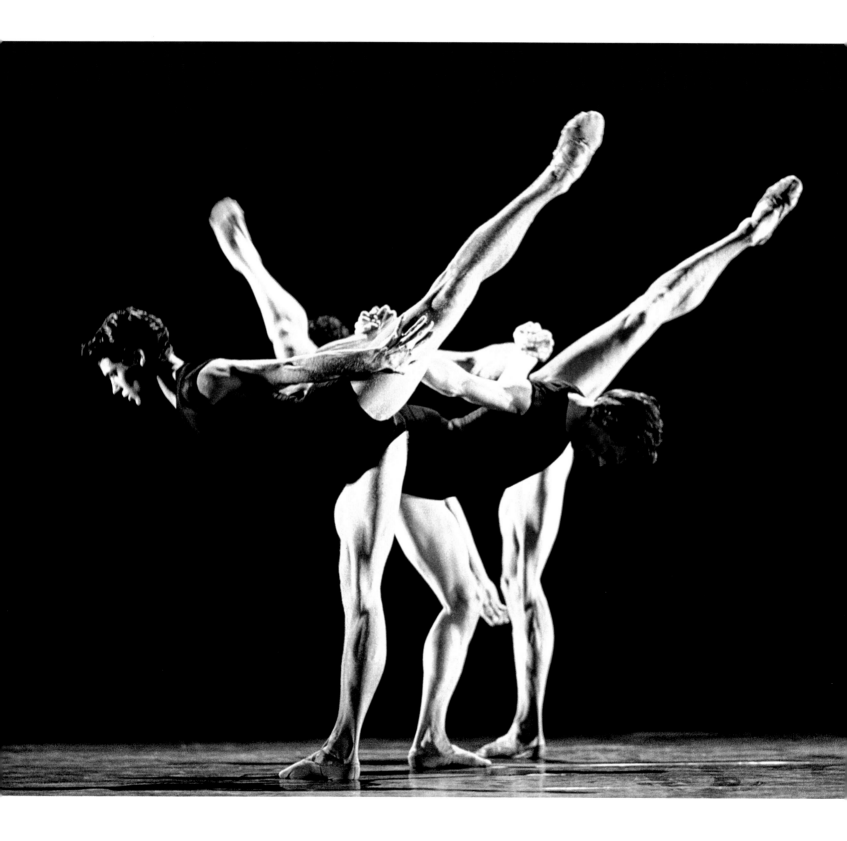

lle, Jonathan Cope,
son

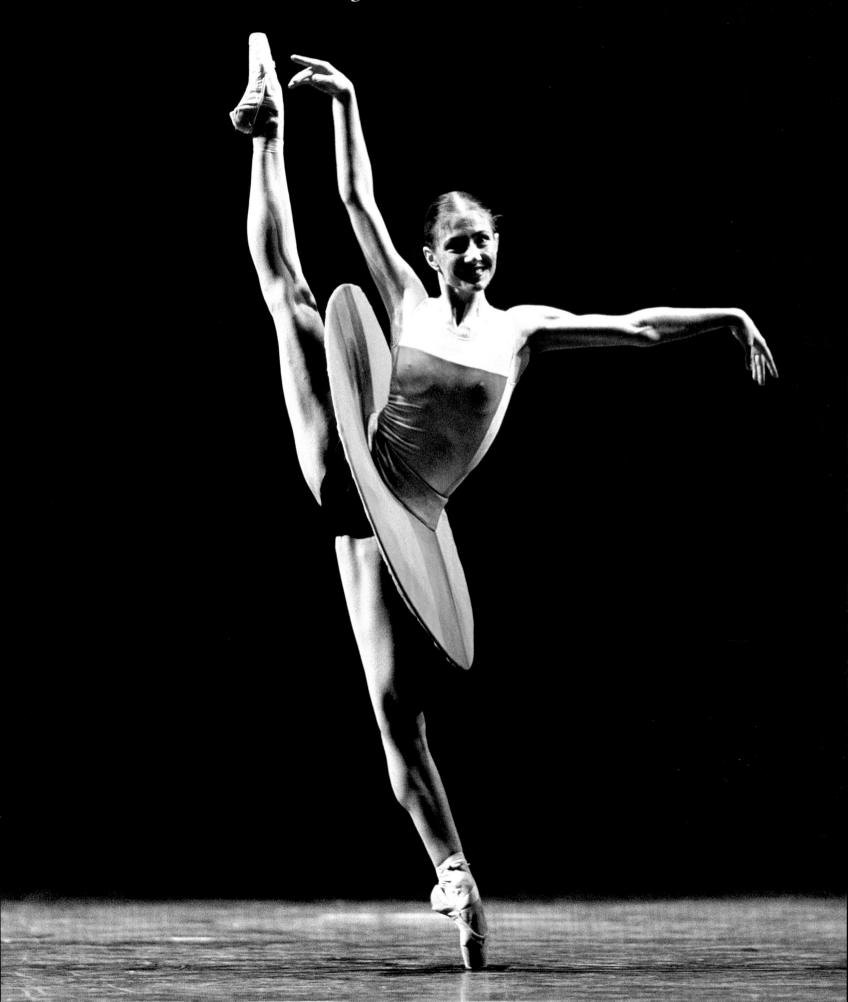

The Vertiginous Thrill of Exactitude

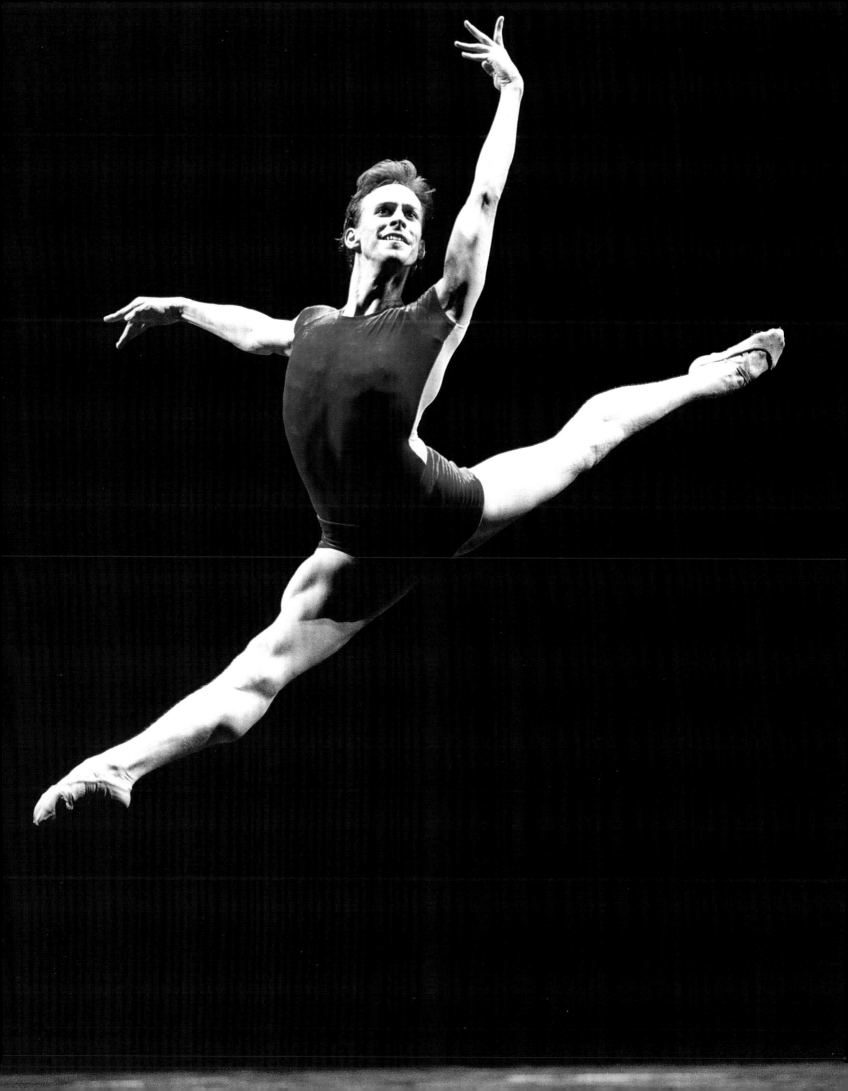

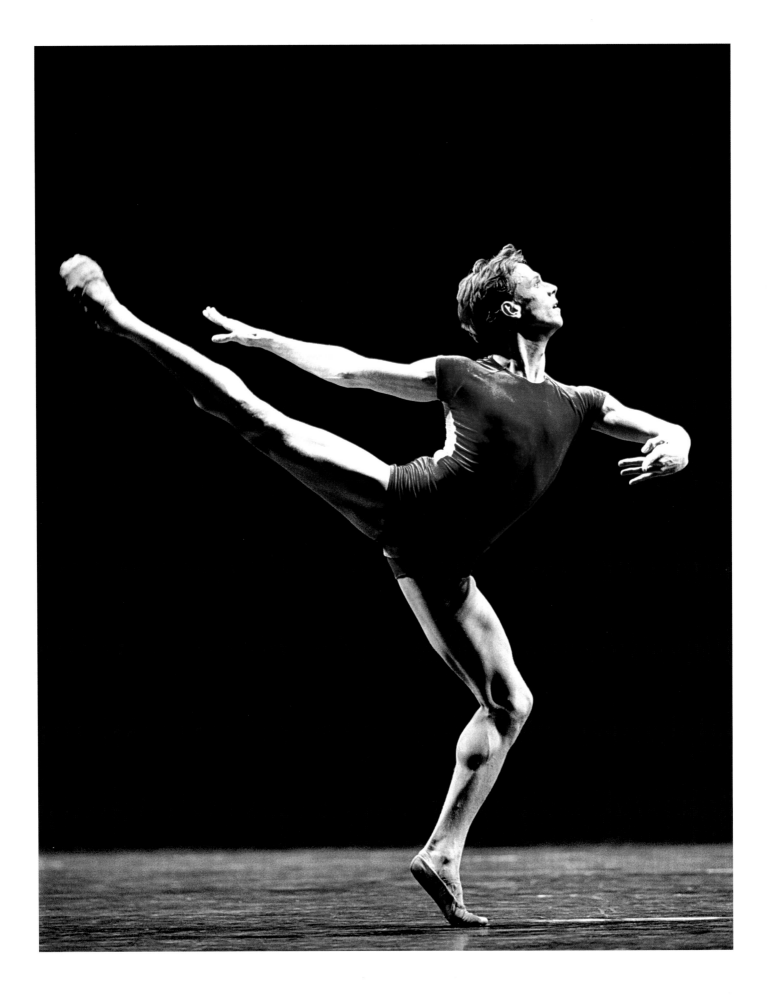

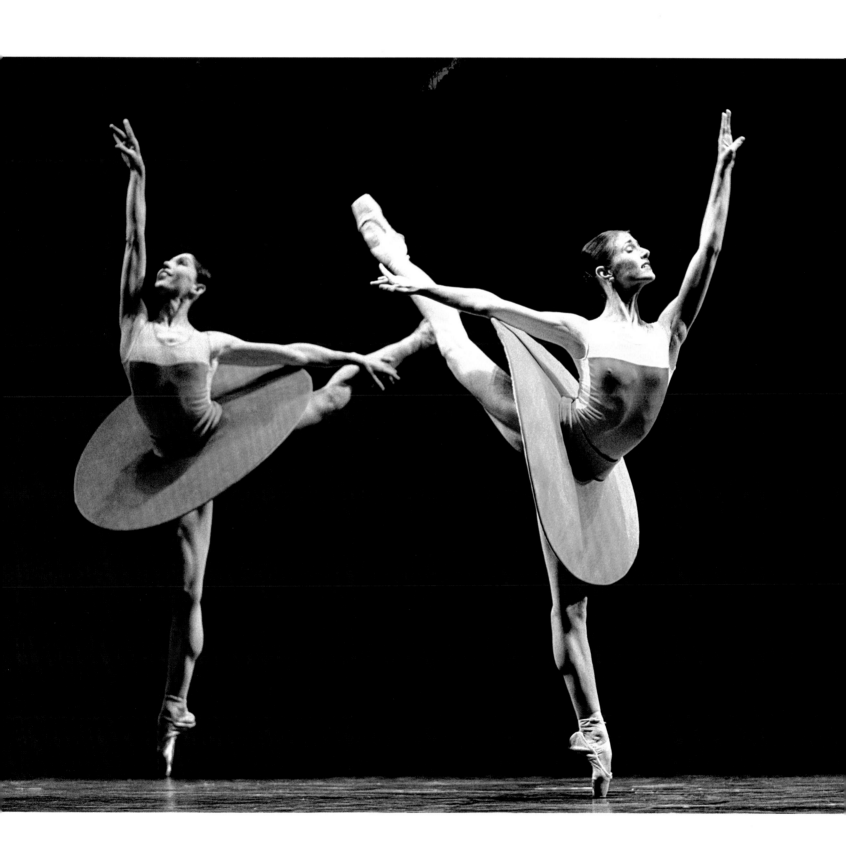

Carmen

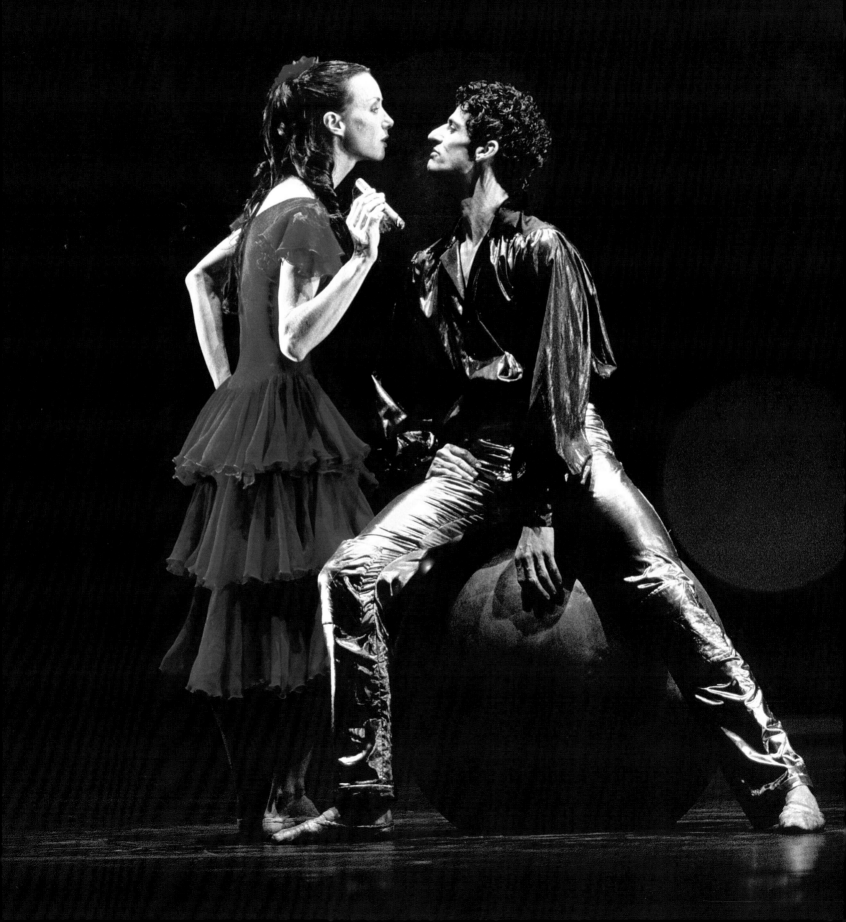

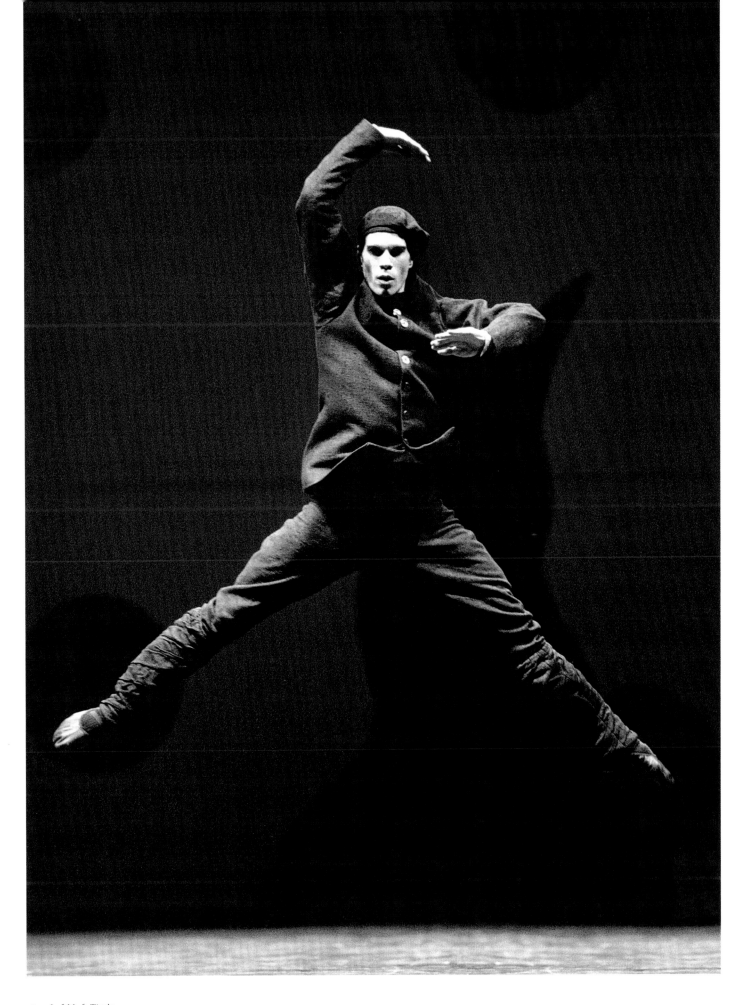

Above: José María Tirado

Left: Sylvie Guillem, Jonathan Cope

161

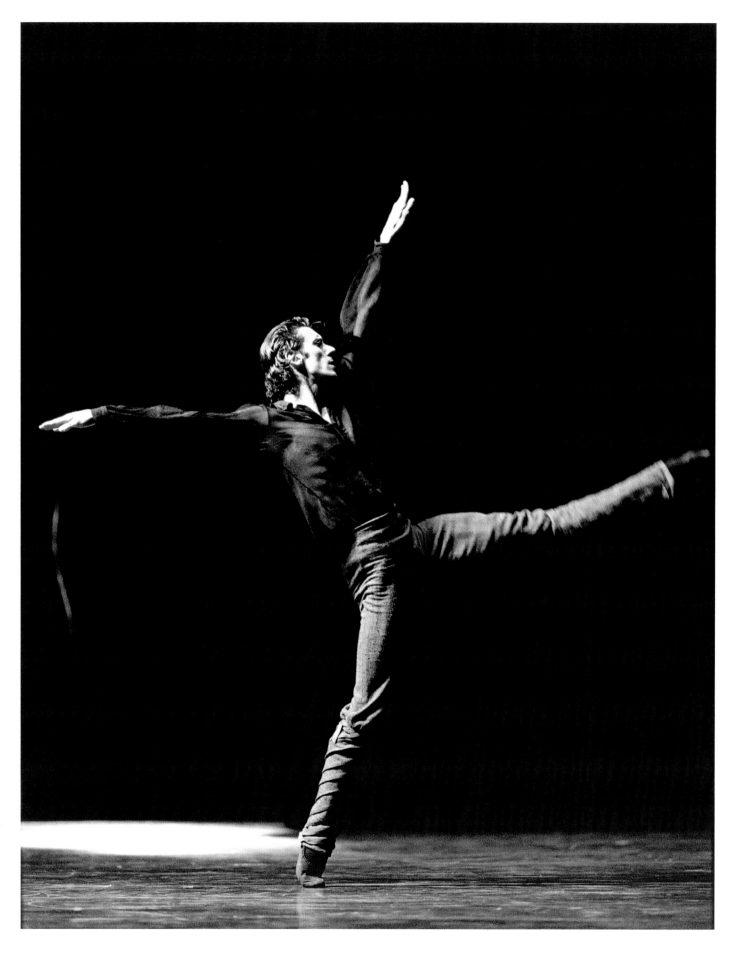

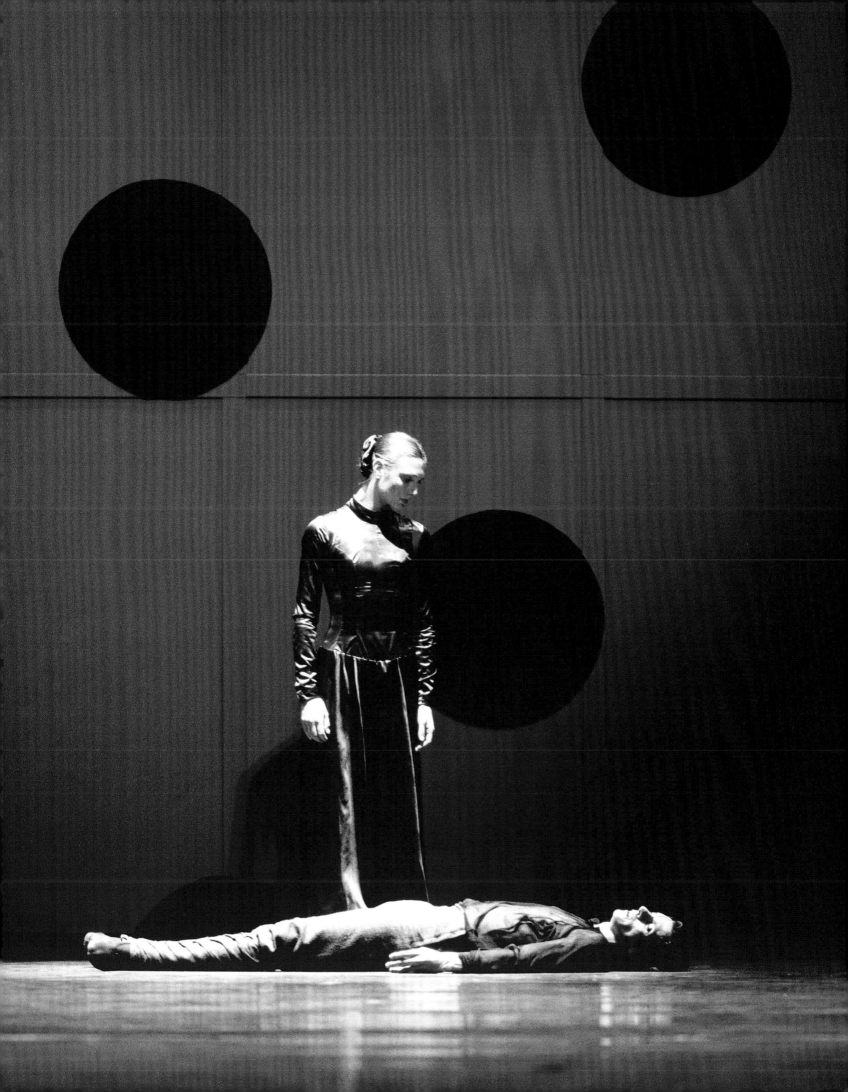

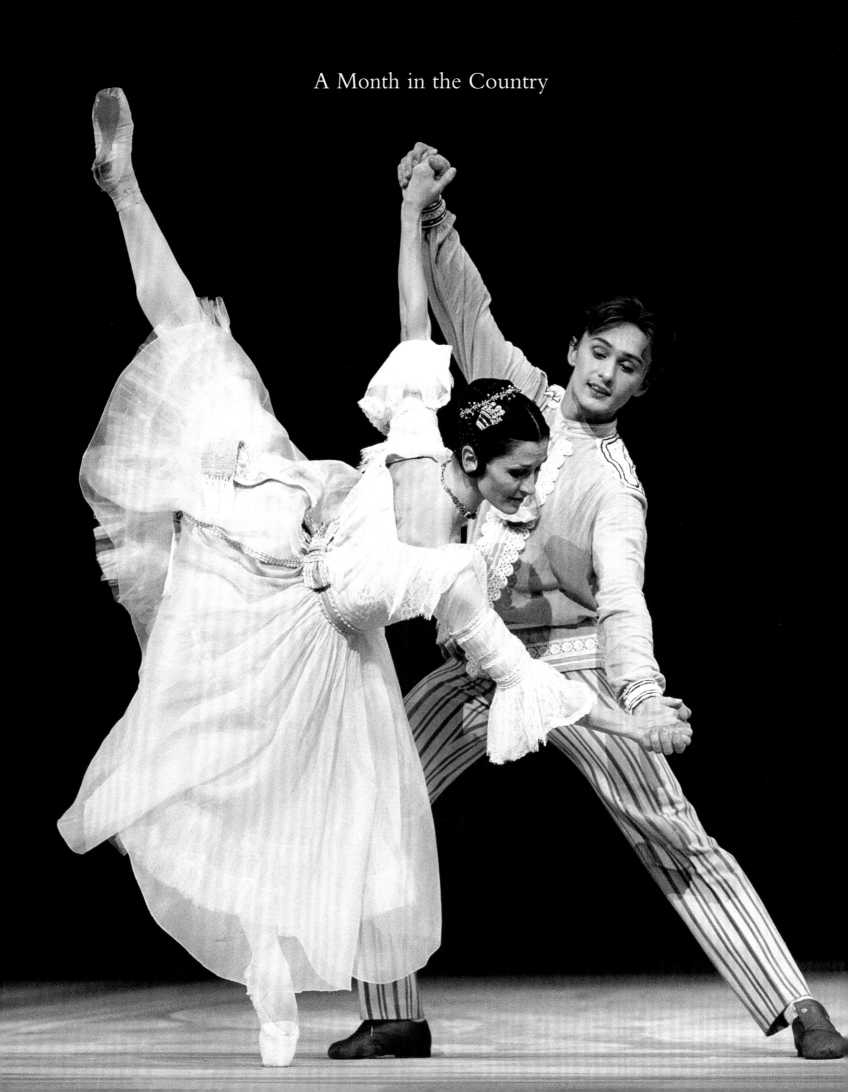

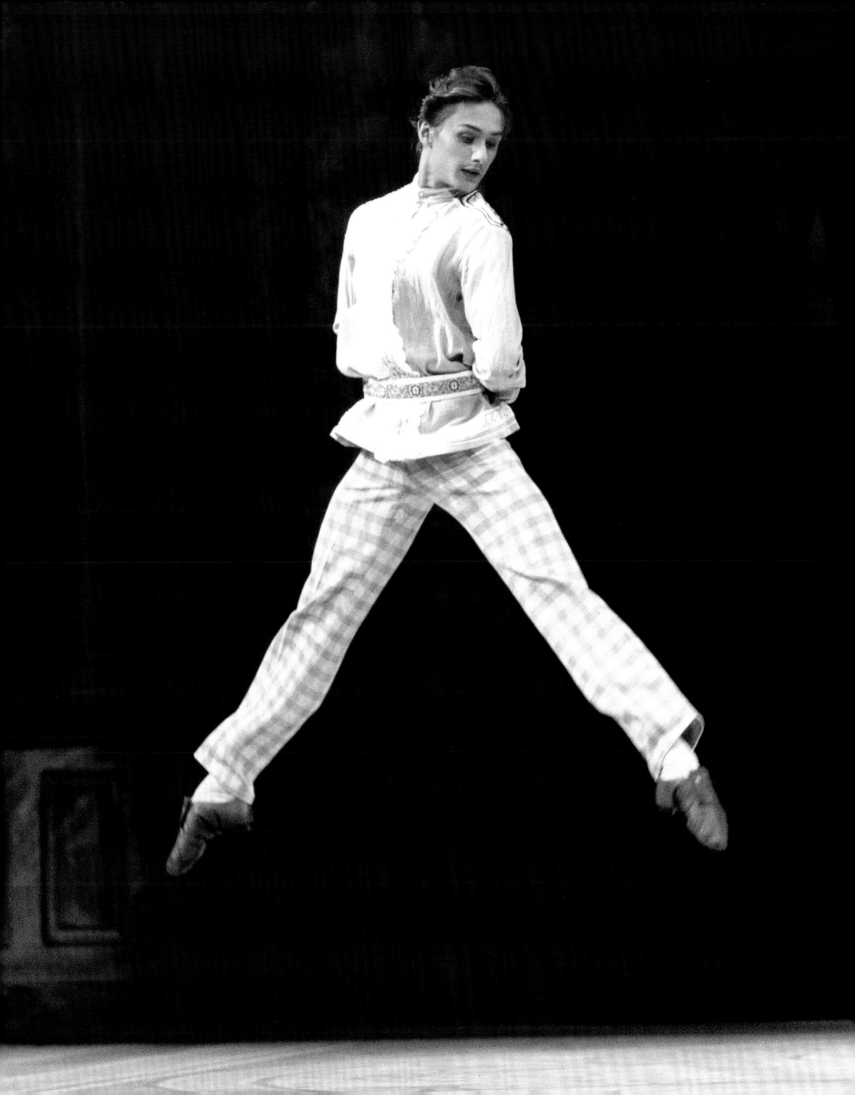

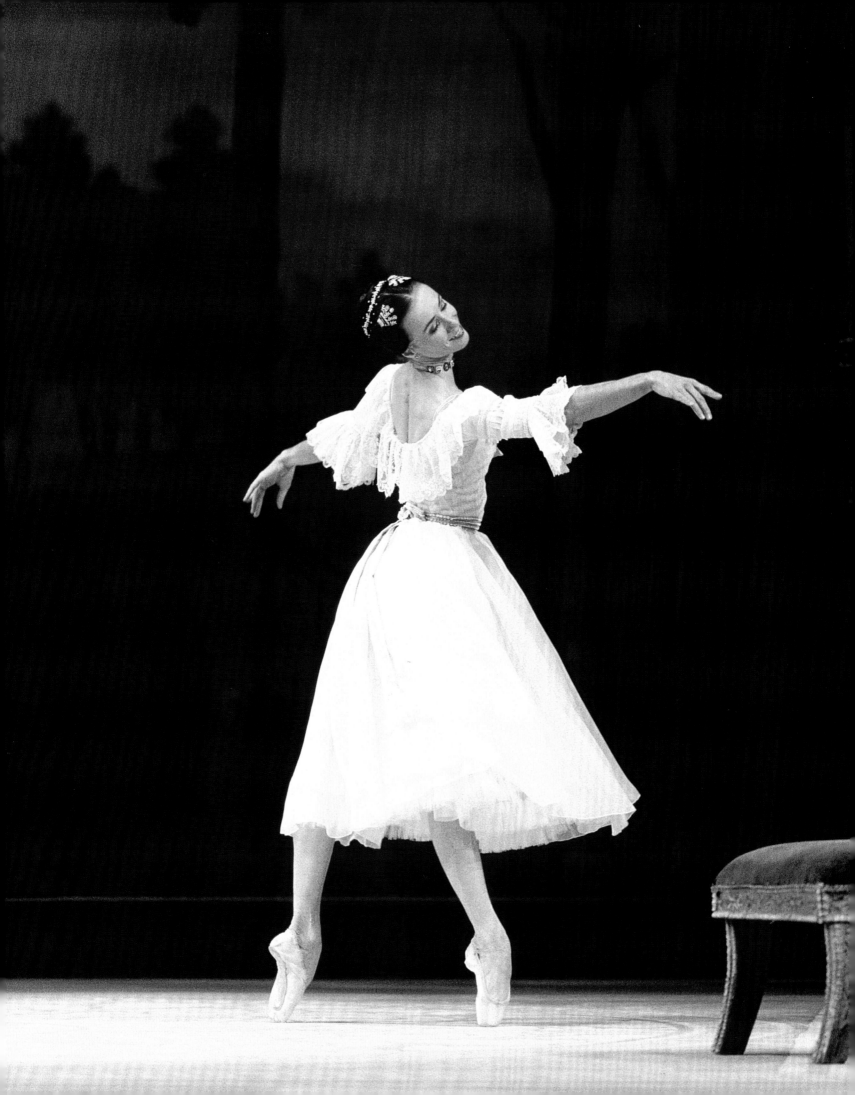

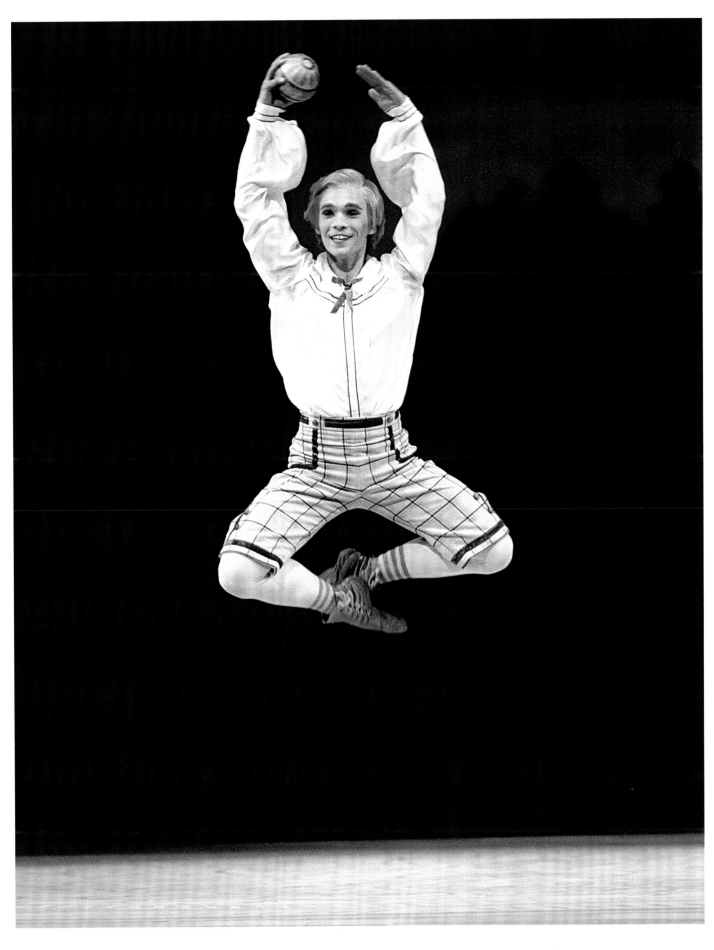

Above: Giacomo Ciriaci

Left: Sylvie Guillem

Previous pages, left: Muriel Valtat, Ivan Putrov,
right: Ivan Putrov

167

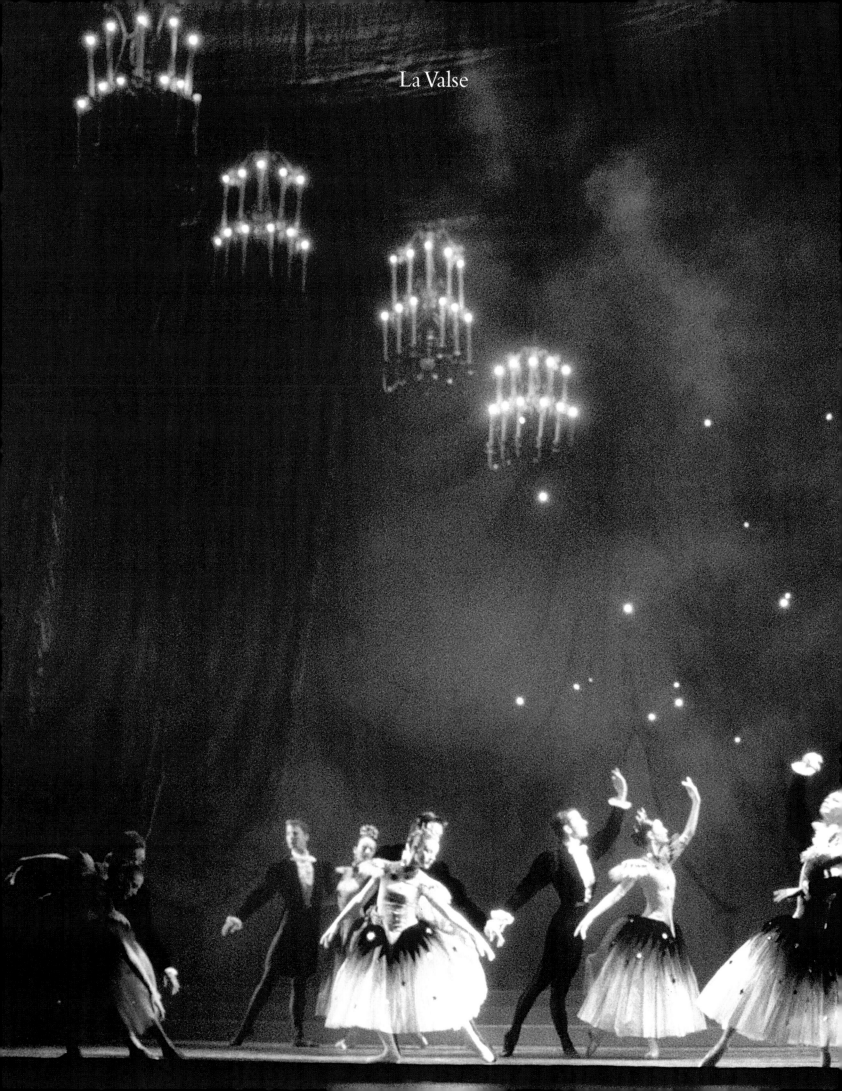

La Valse

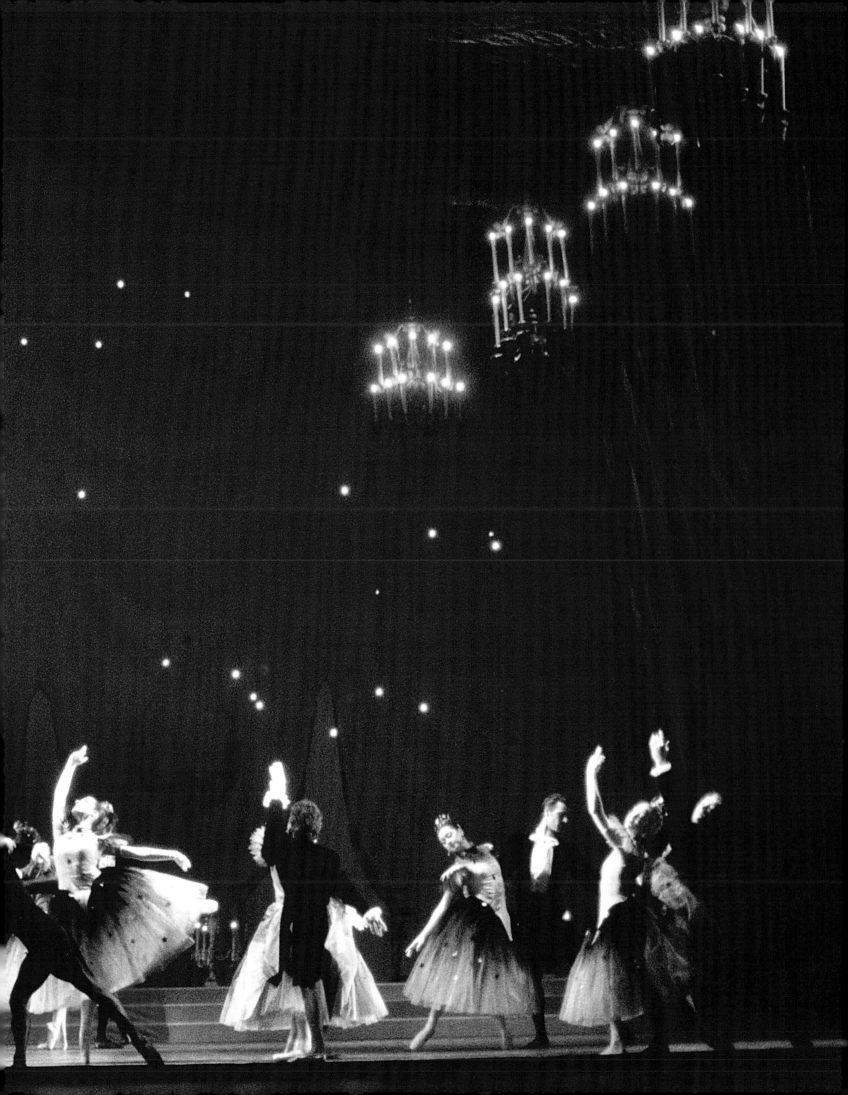

Don Quixote

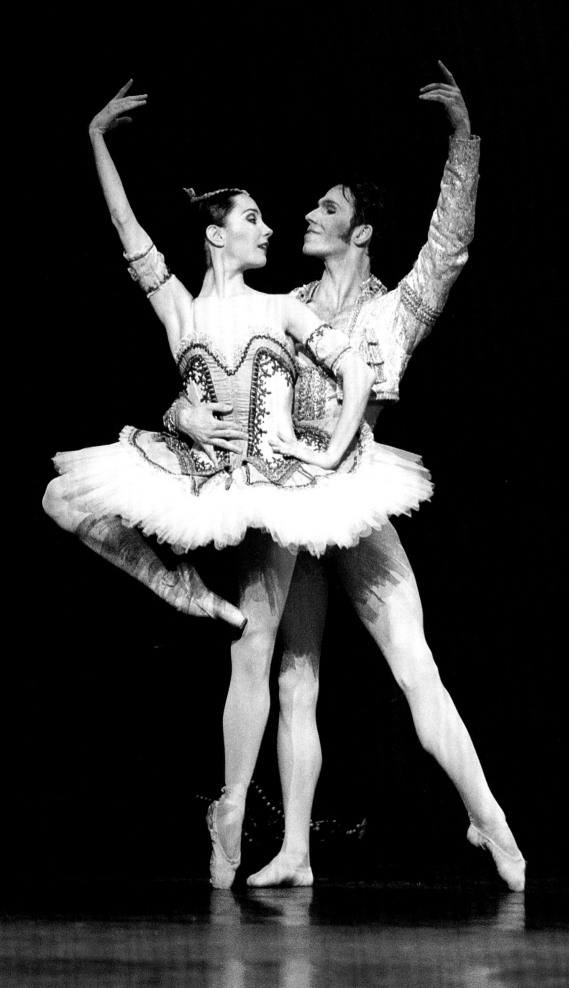

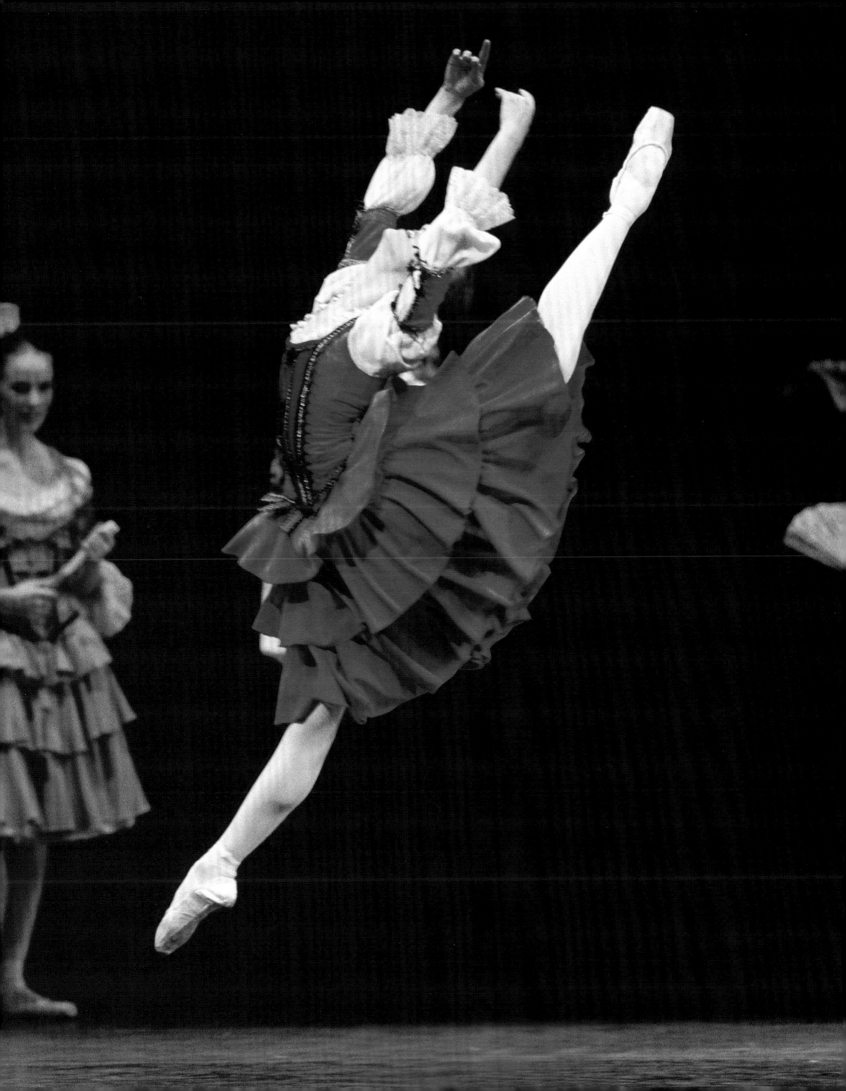

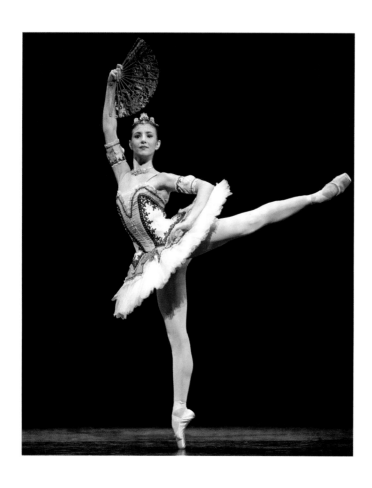

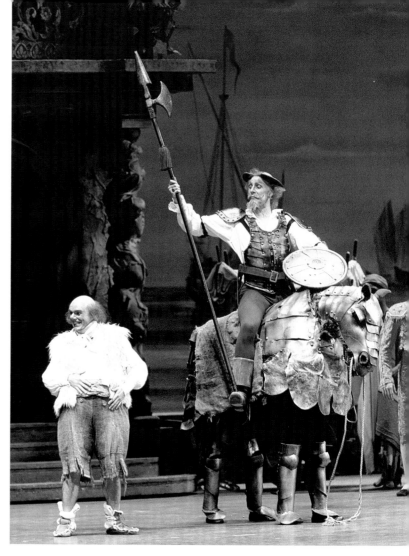

Above: Alina Cojocaru

Right: Alina Cojocaru, Ivan Putrov

Above right: Philip Mosley, Christopher Saunders,

Previous pages, left: Tamara Rojo, Johan Kobborg, *right:* Alina Cojocaru

Overleaf left: Johan Kobborg: *right;* William Tucket

Opposite: Nicola Tranah, David Pickering

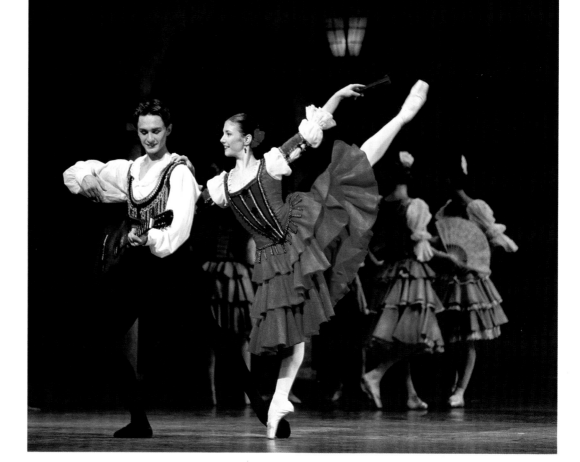

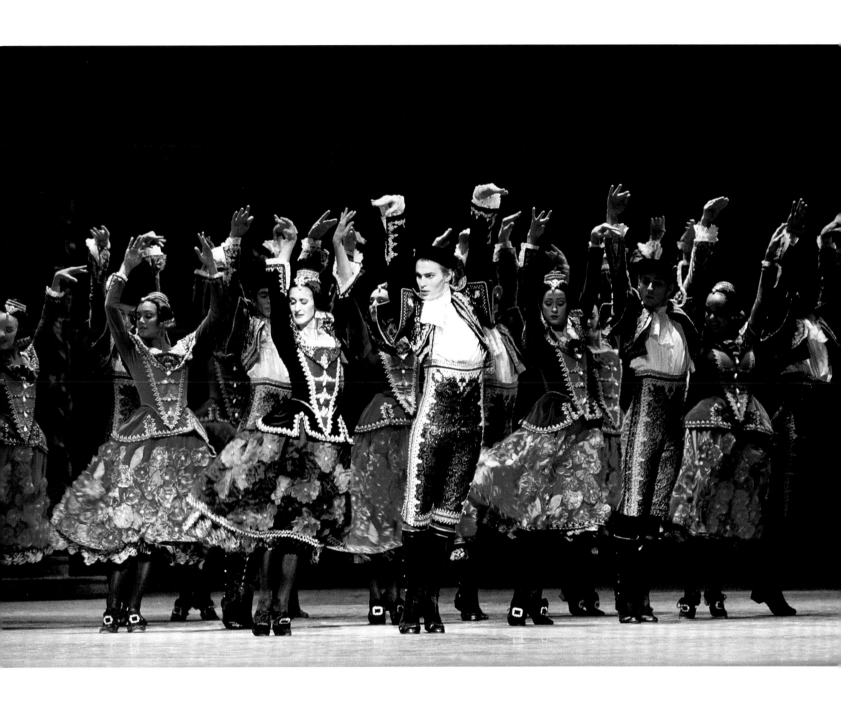

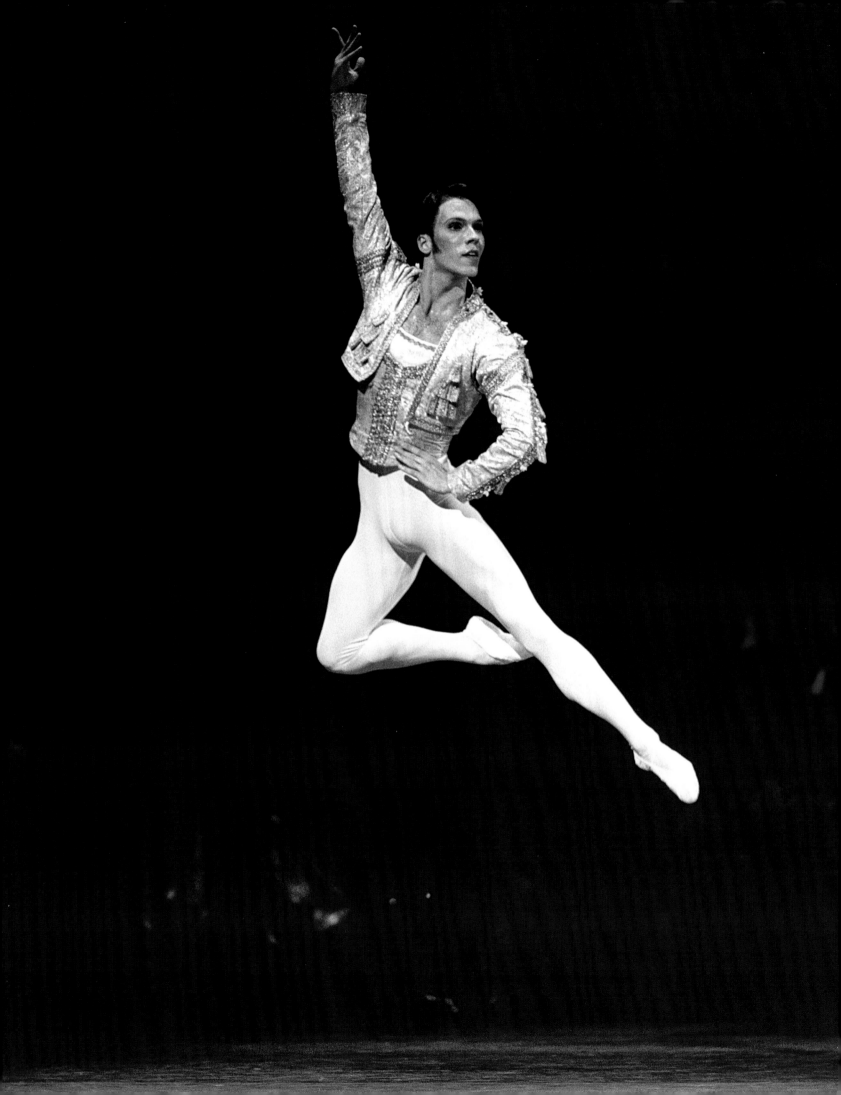

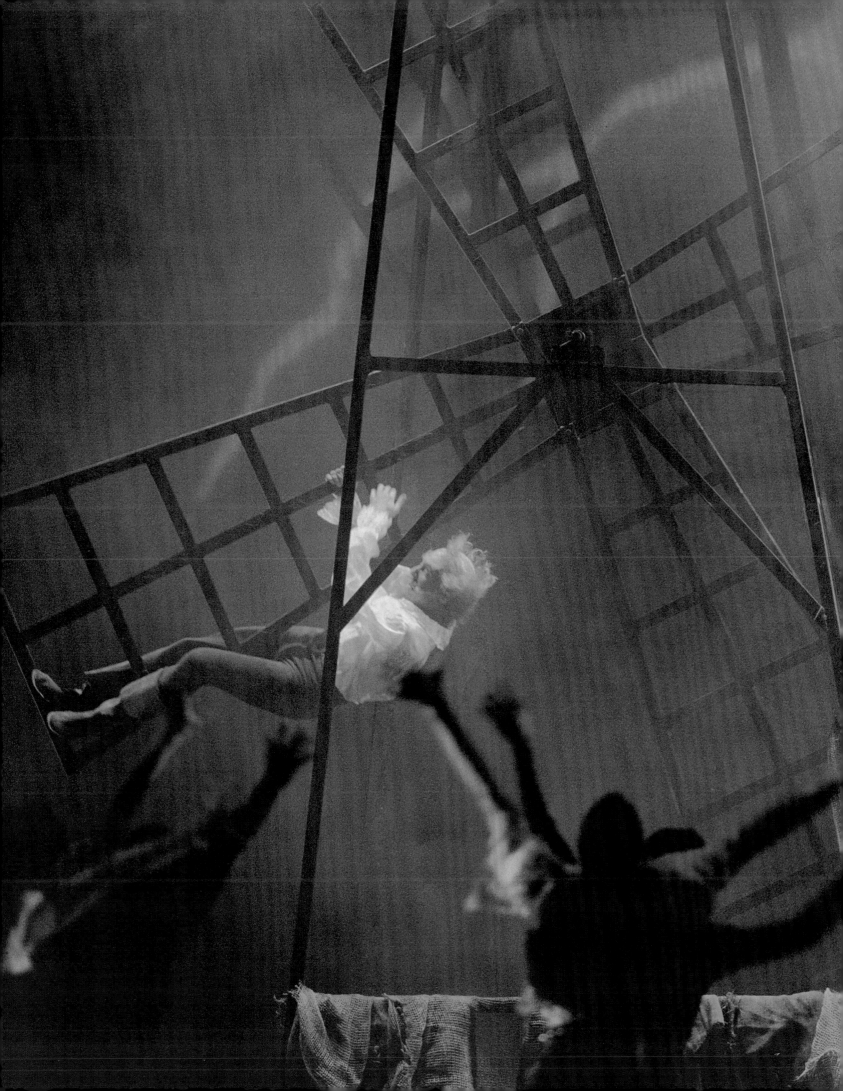

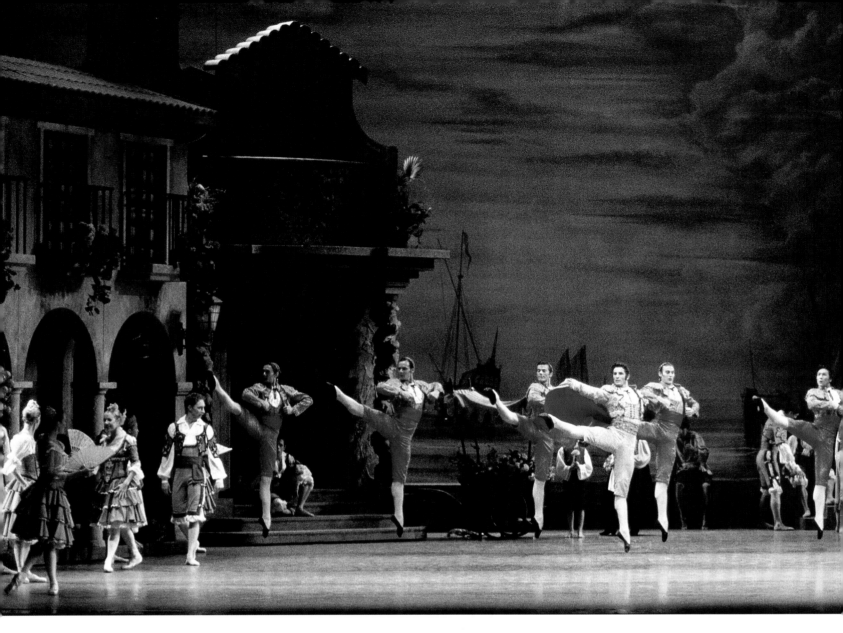

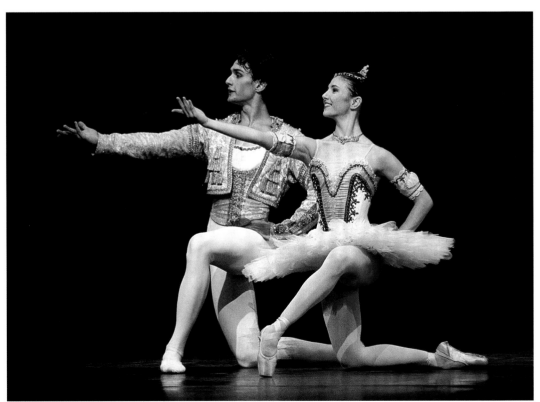

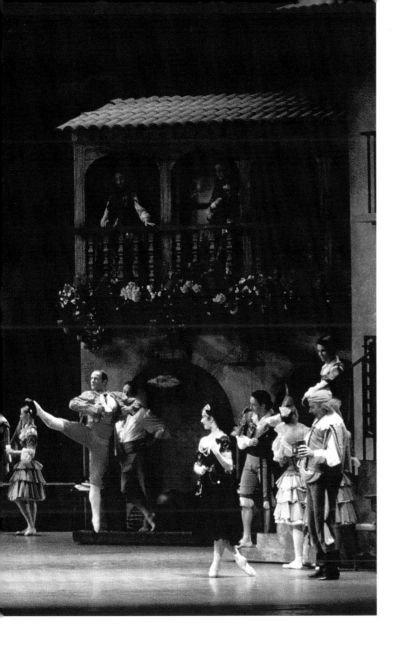

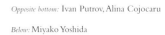

Opposite bottom: Ivan Putrov, Alina Cojocaru

Below: Miyako Yoshida

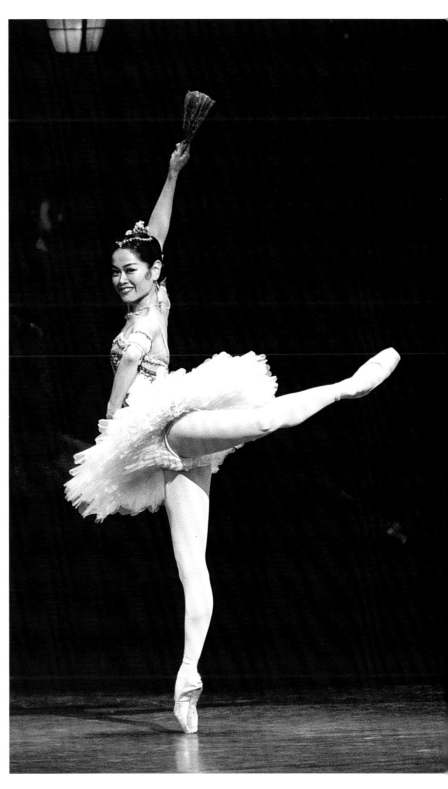

In the middle somewhat elevated

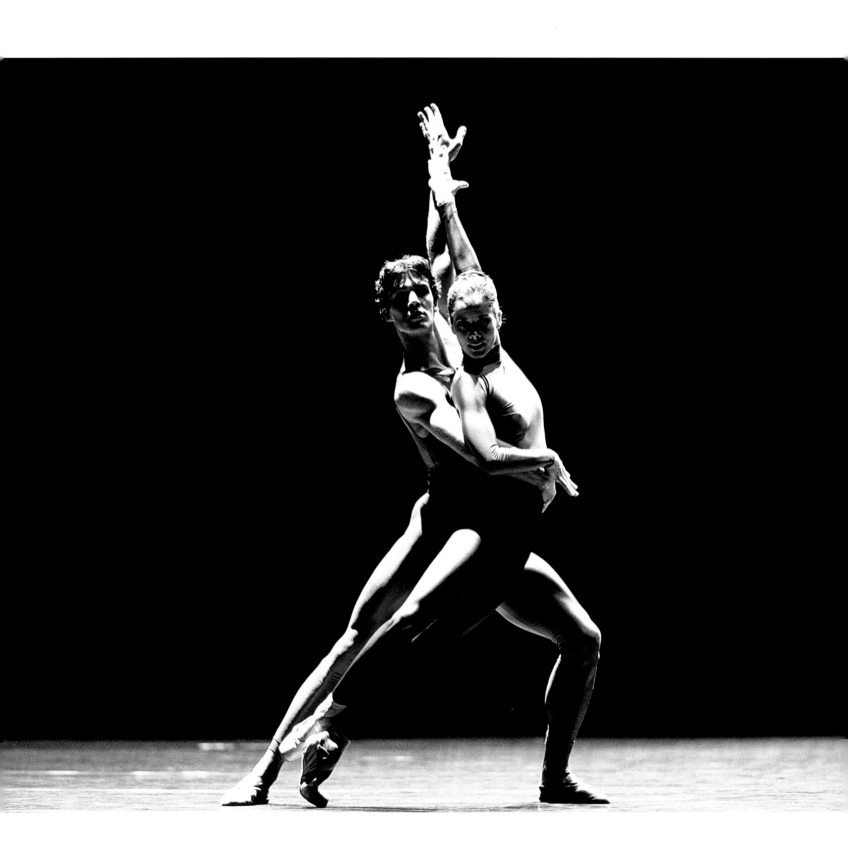

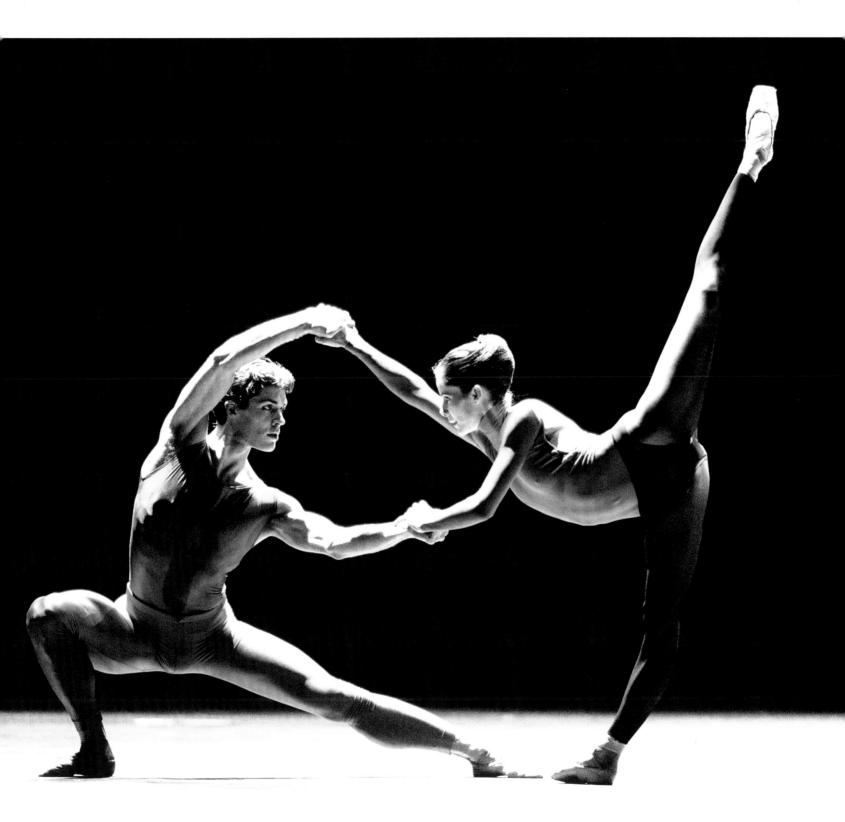

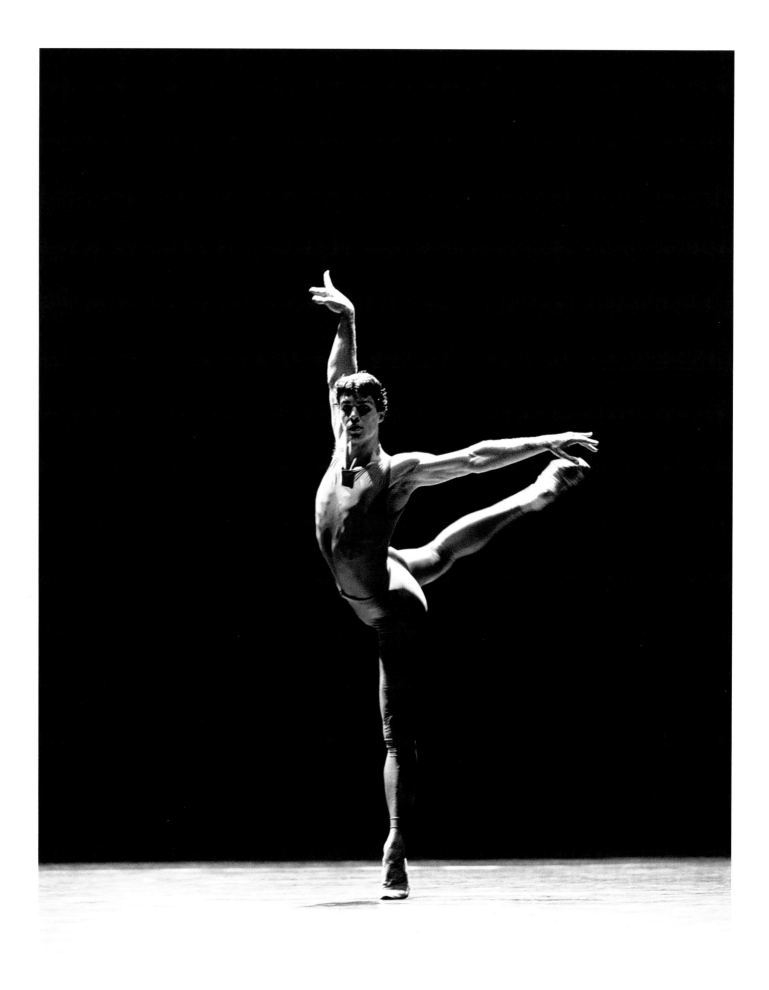

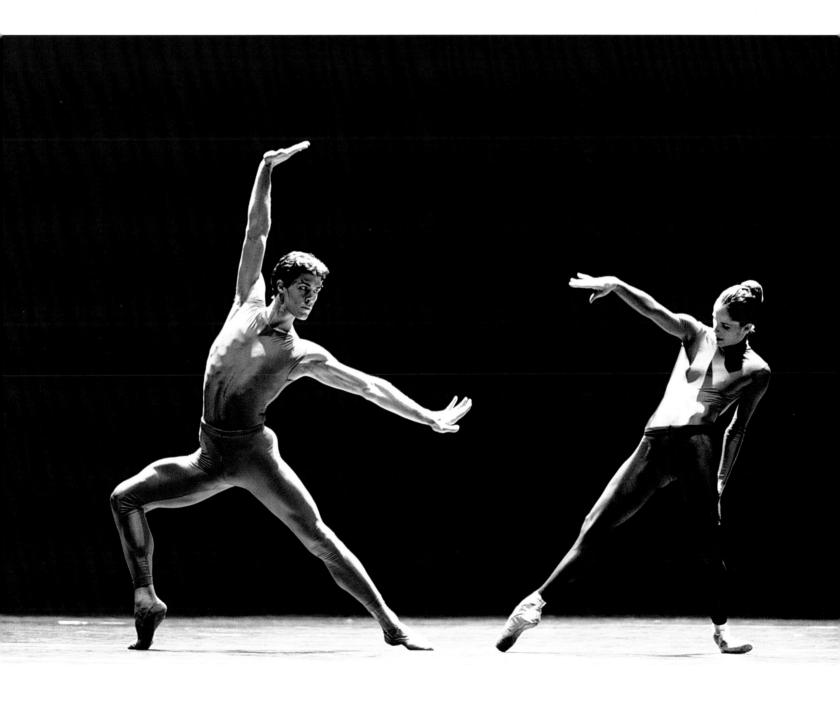

181

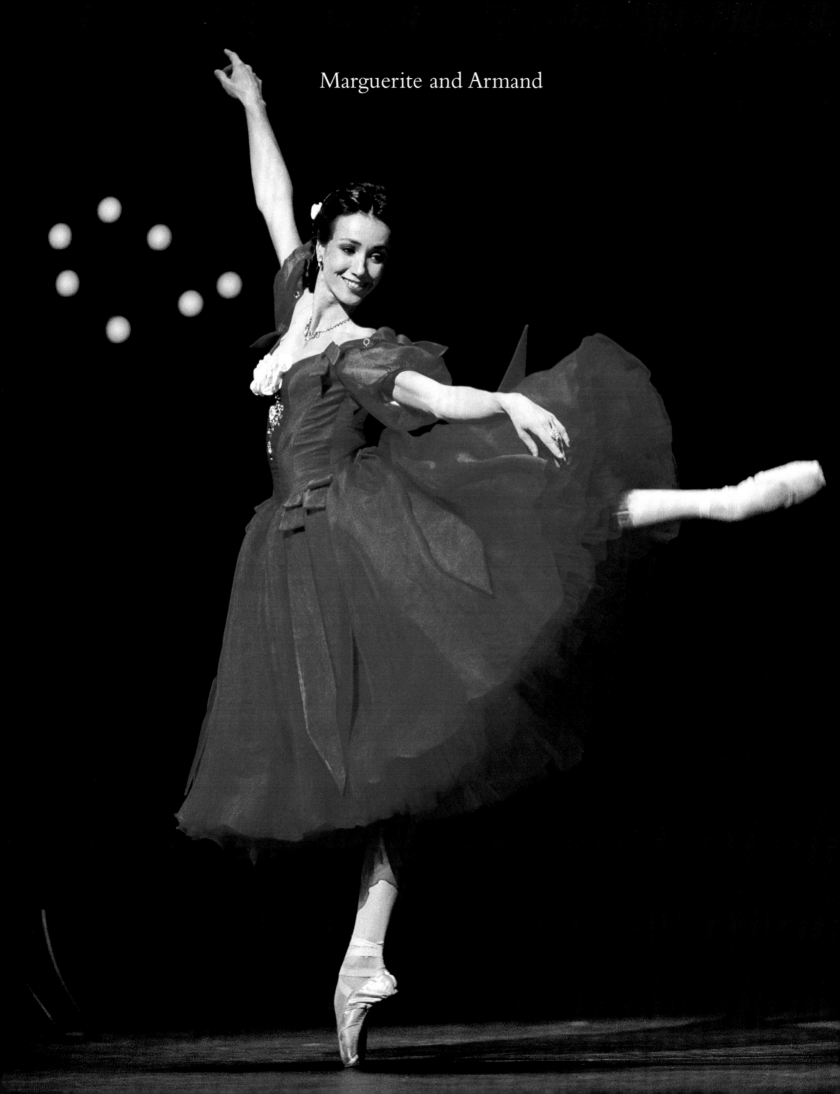

Marguerite and Armand

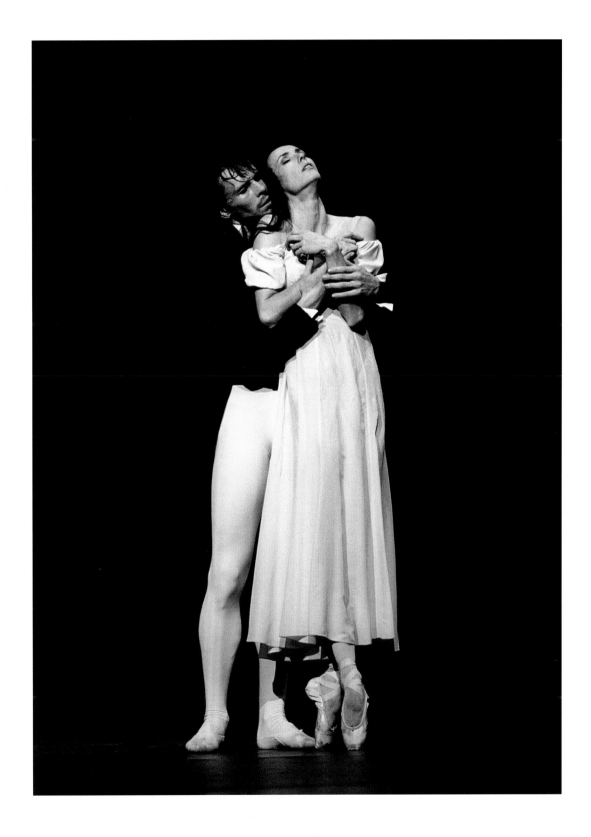

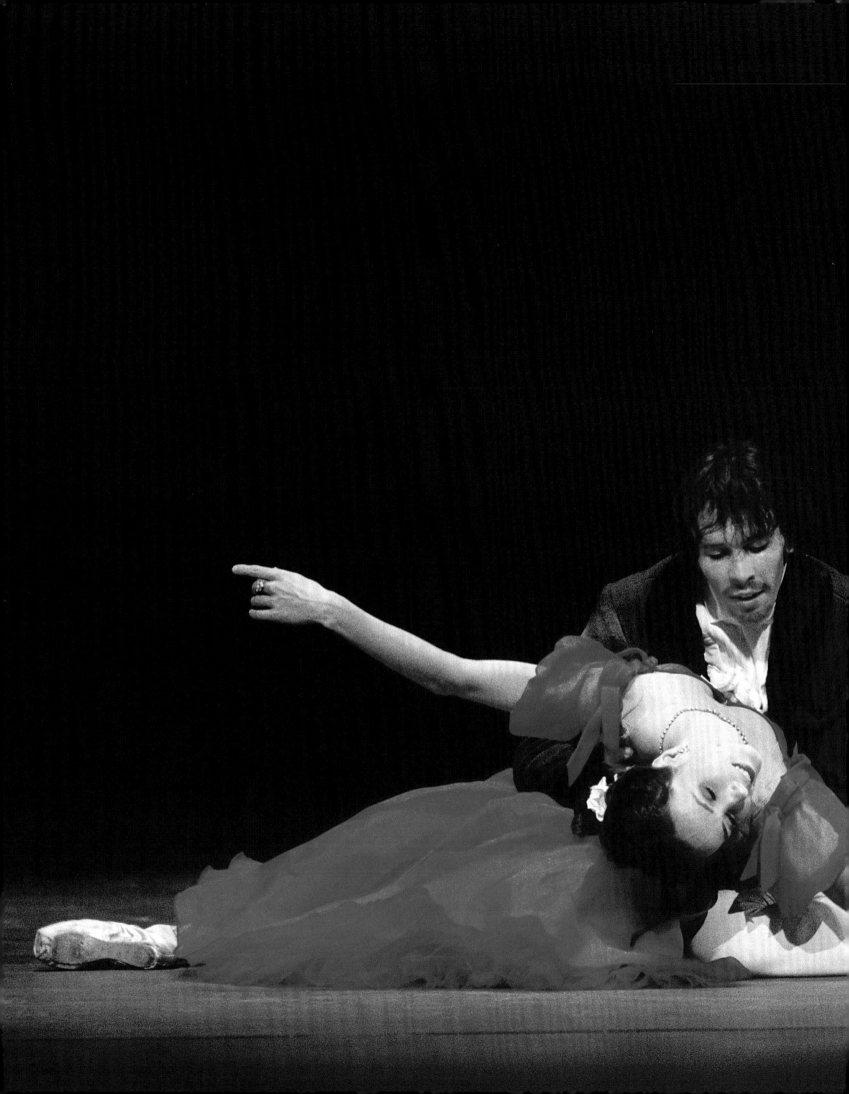

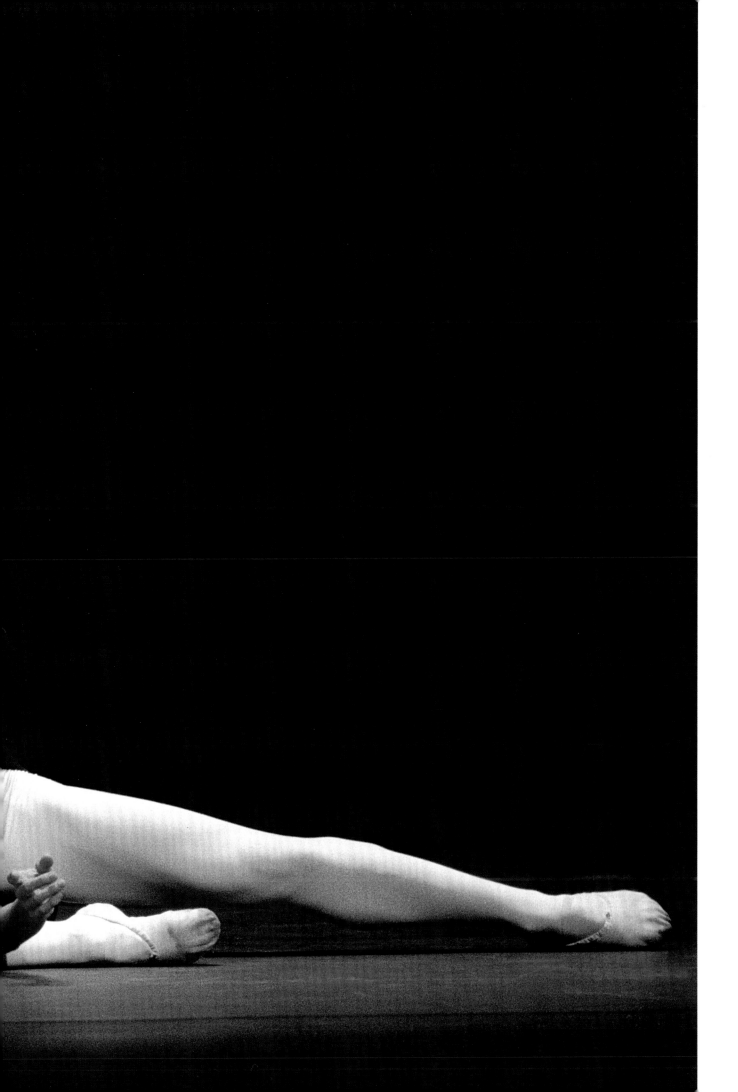

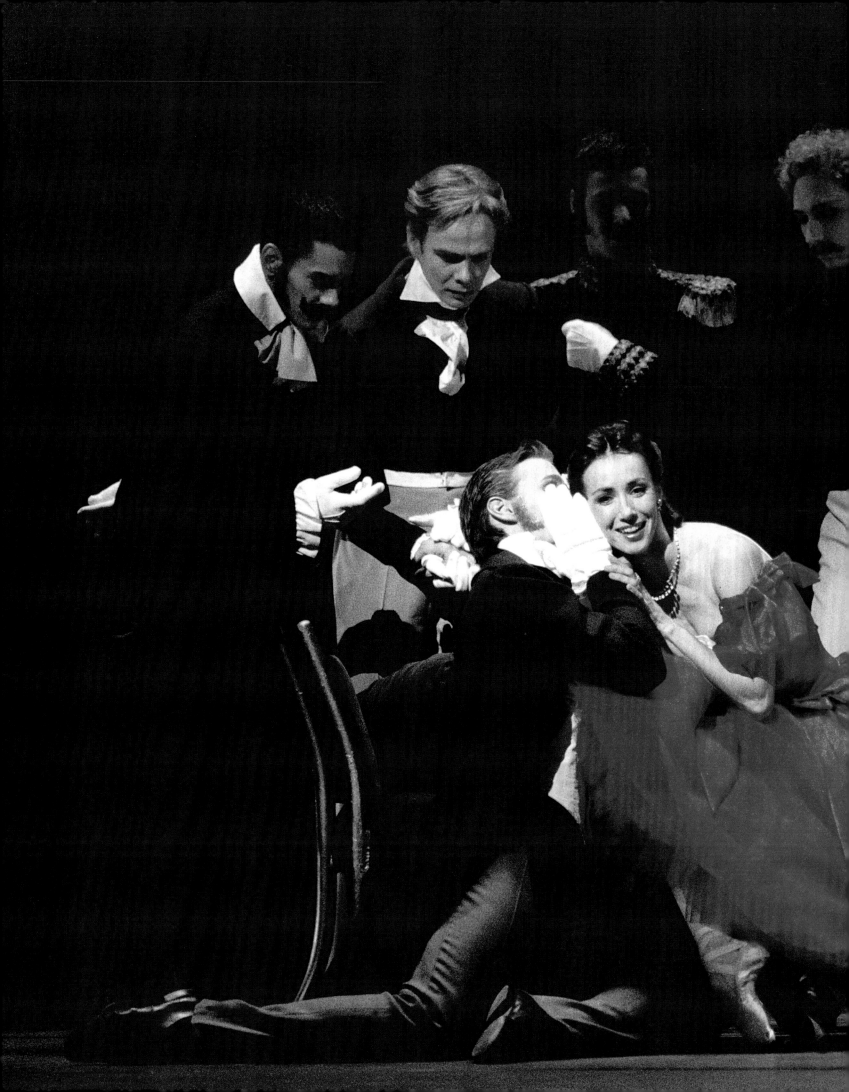

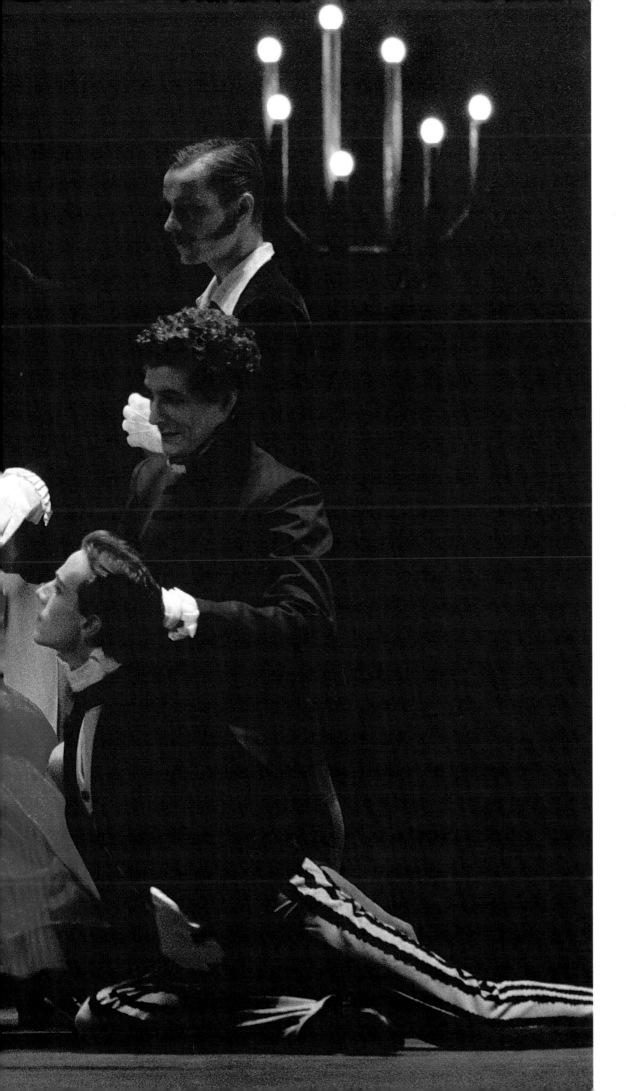

Left and previous pages:
Sylvie Guillem, Nicholas Le Riche

187

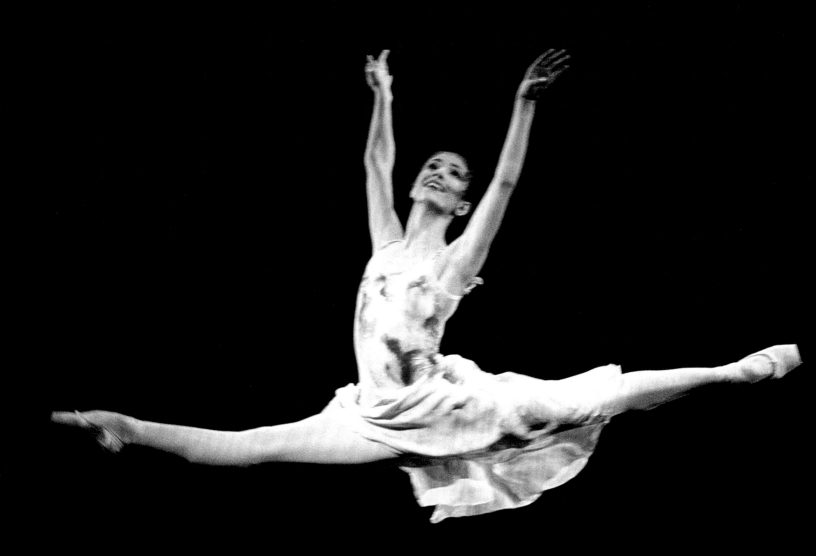

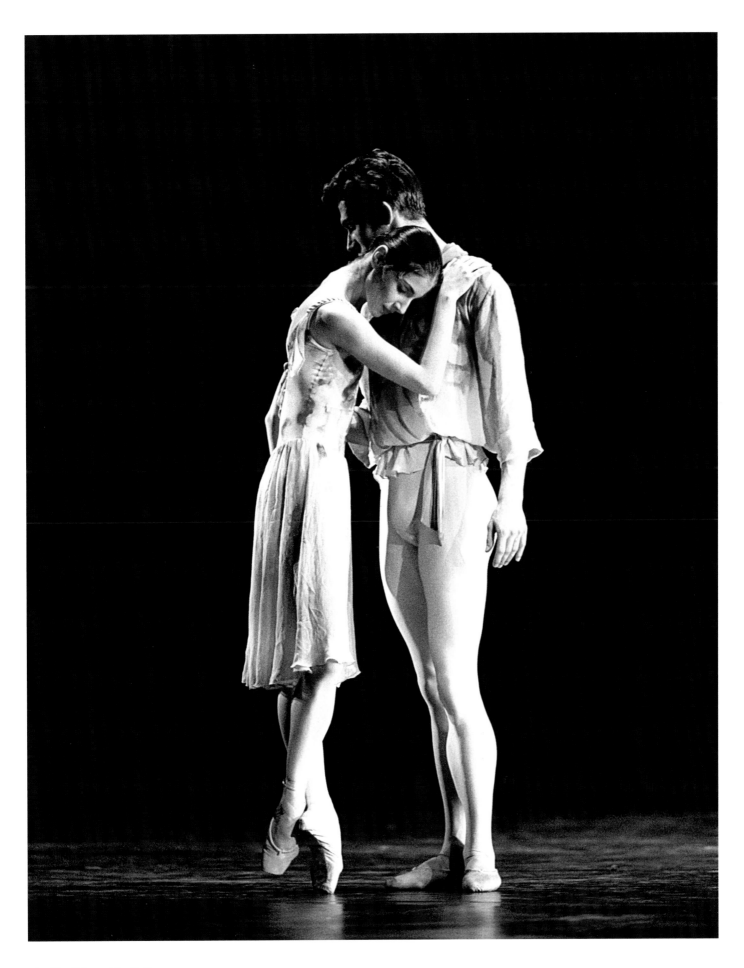

Above: Alina Cojocaru, Johan Kobborg

Left: Alina Cojocaru

Onegin

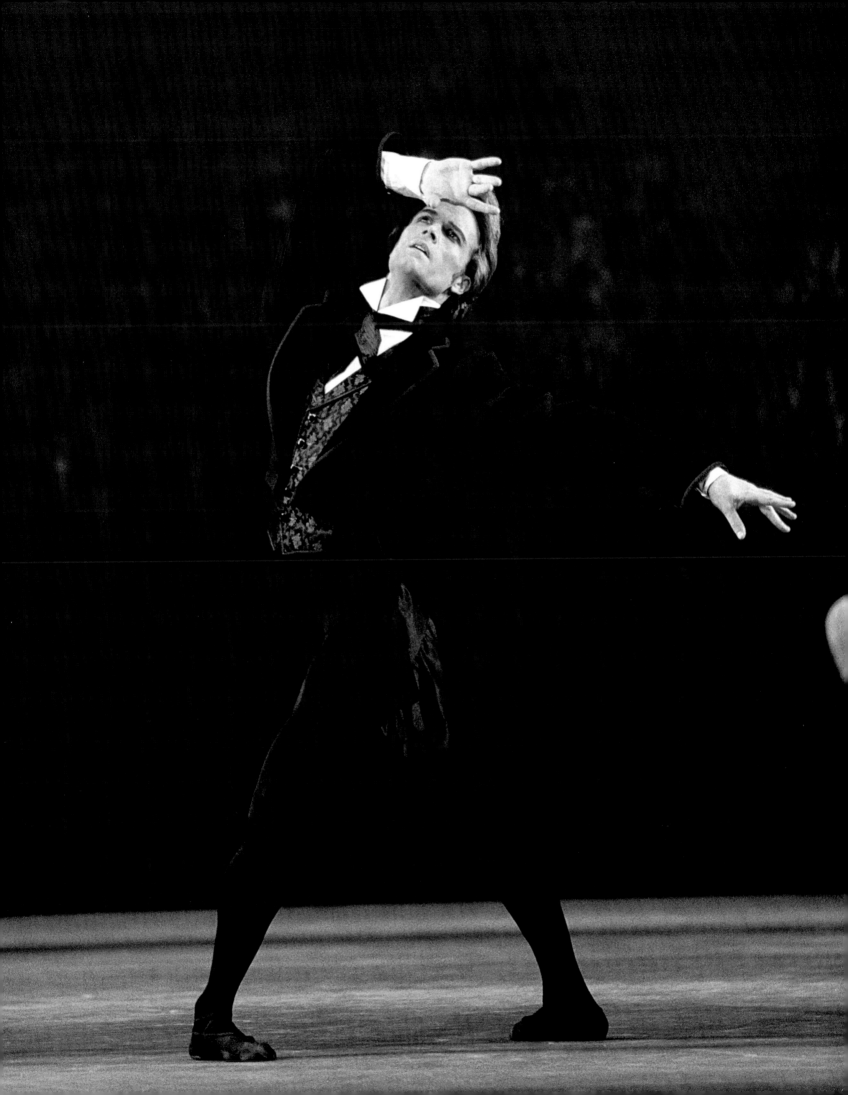

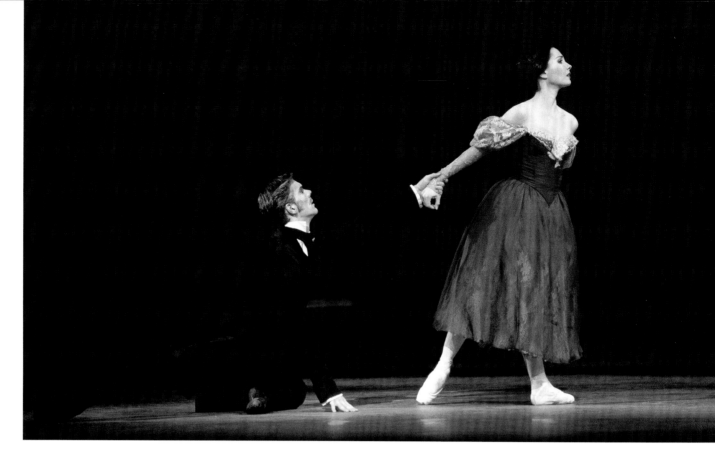

Above: Adam Cooper, Tamara Rojo

Right: Alina Cojocaru, Johan
Kobborg

Opposite top: Ivan Putrov

Opposite bottom: Adam Cooper
Tamara Rojo,

Previous pages, left: Bennet Gartside,
Alina Cojocaru, right: Robert Tewsley

192

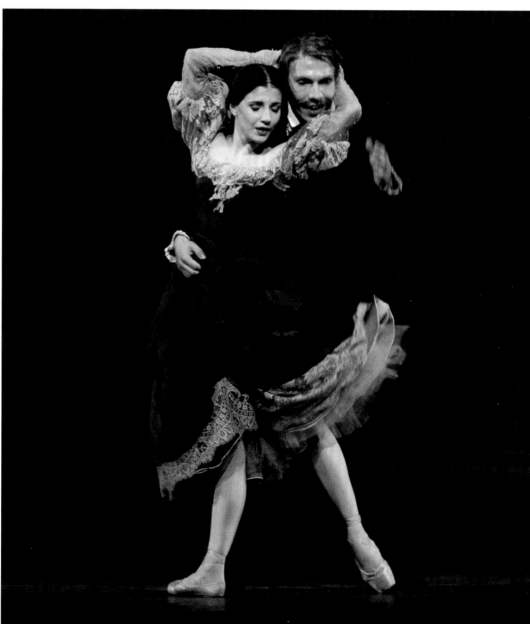

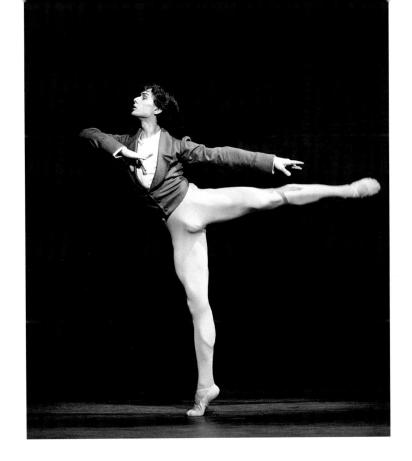

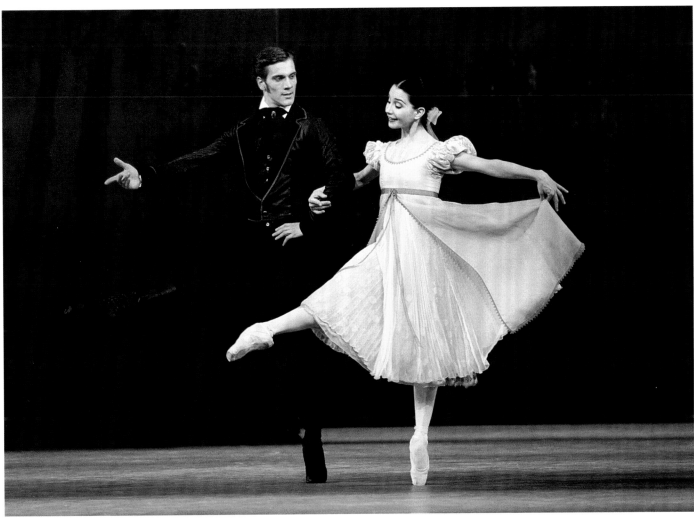

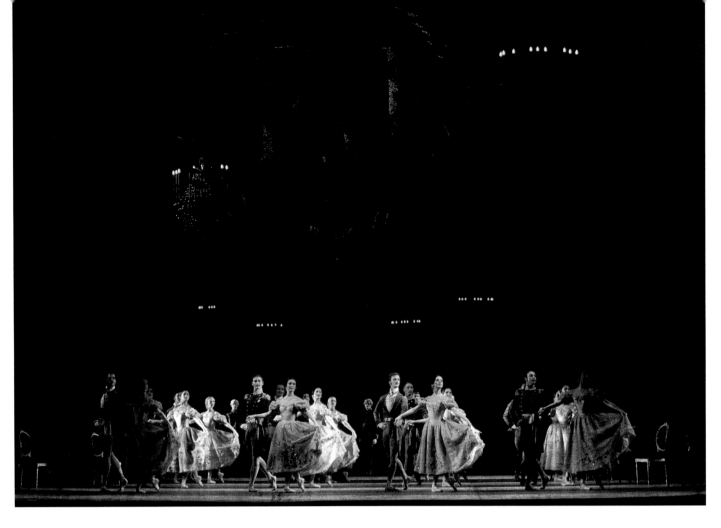

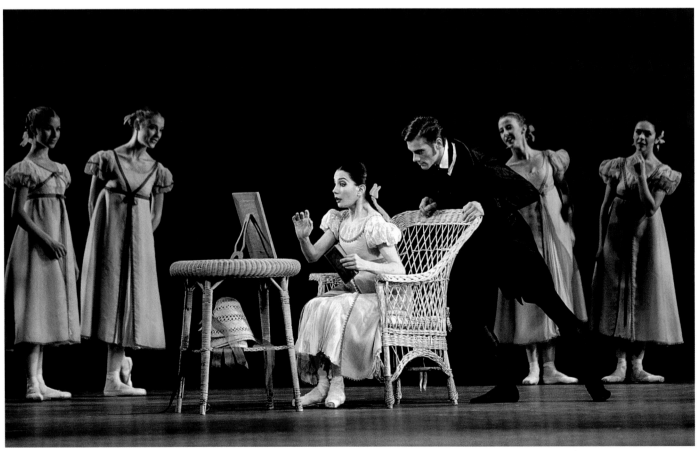

Top: Corps de ballet

Bottom: Tamara Rojo, Adam Cooper

Overleaf: Adam Cooper, Tamara Rojo

Right: Jane Burn, Ivan Putrov

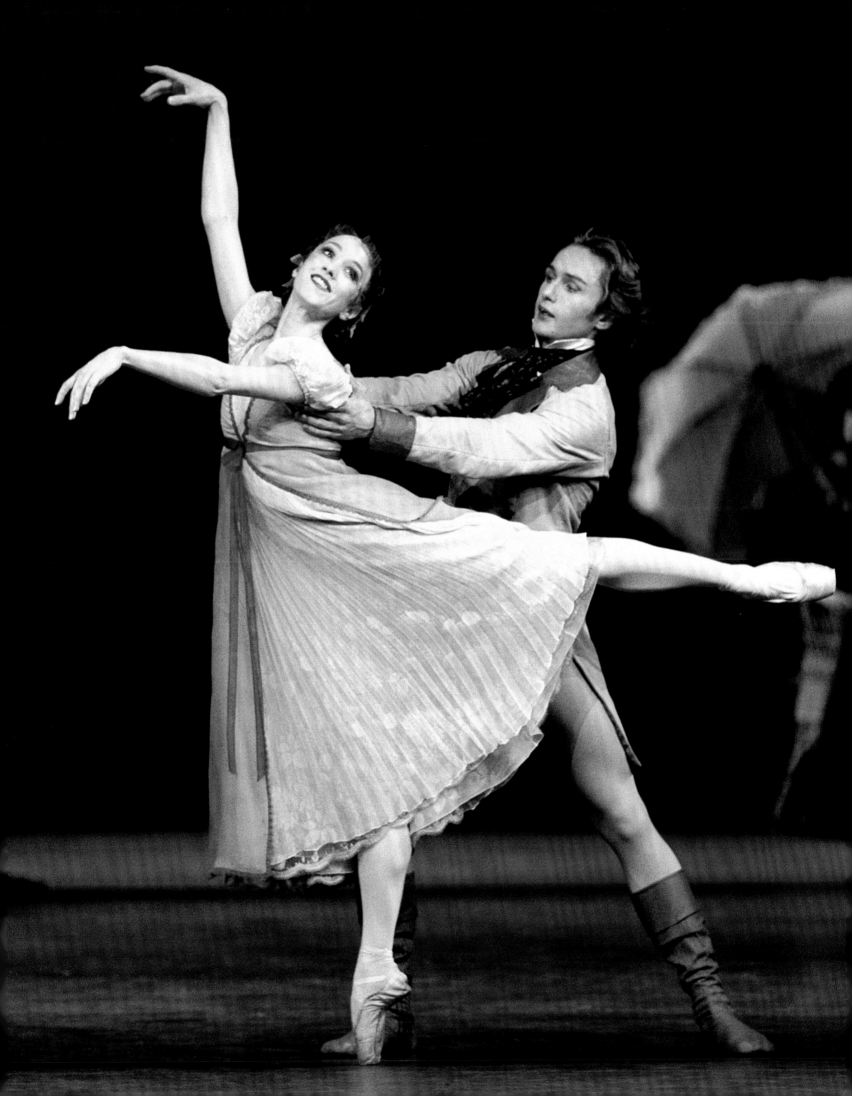

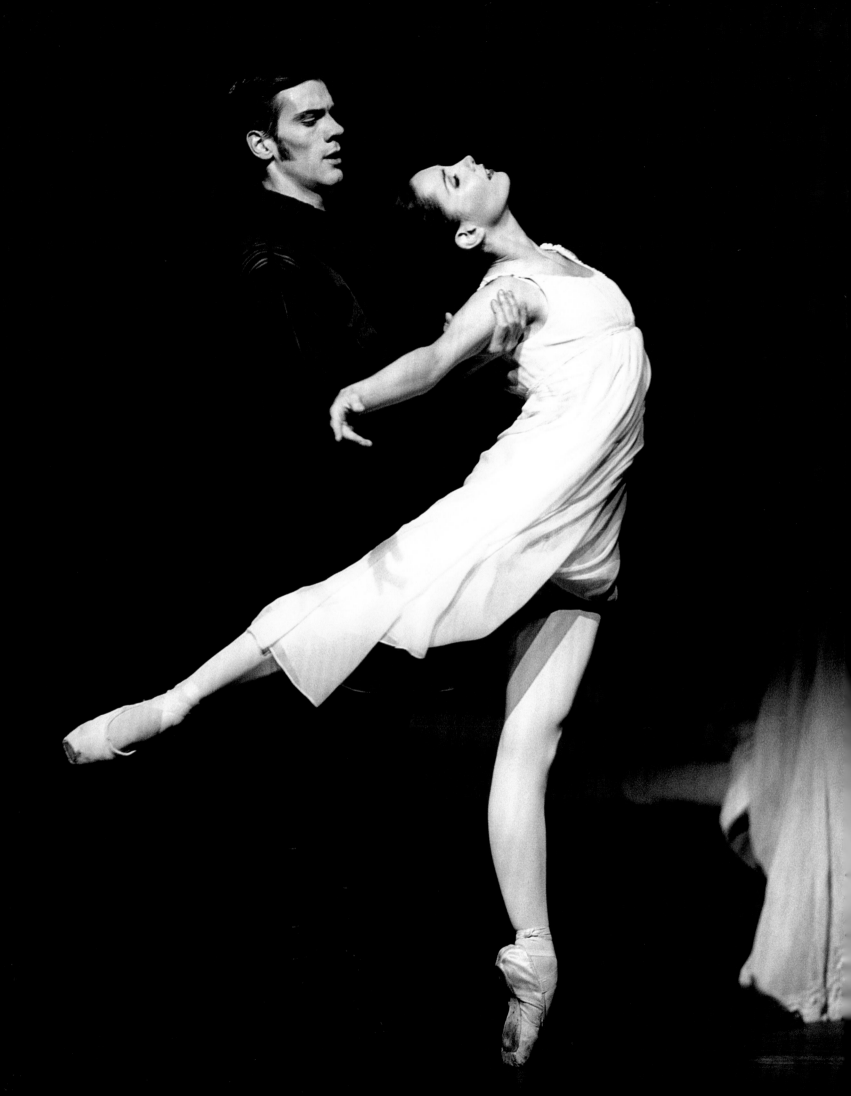

Por Vos Muero

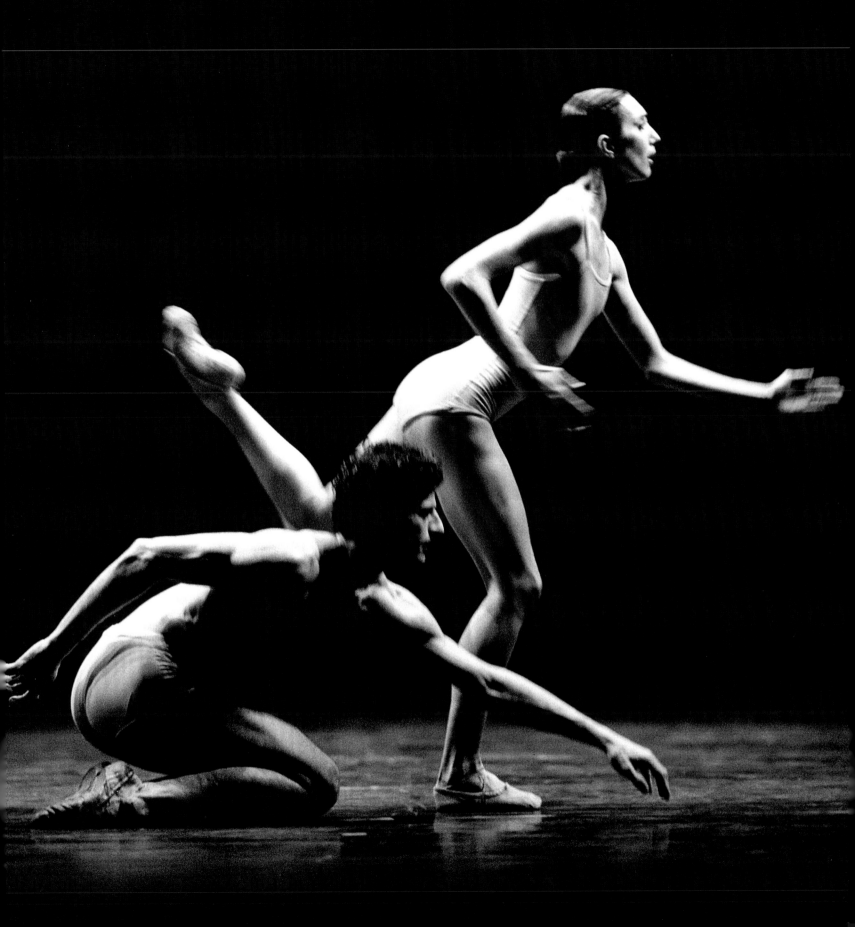

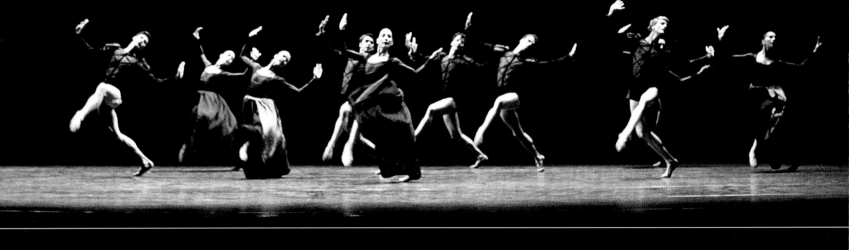

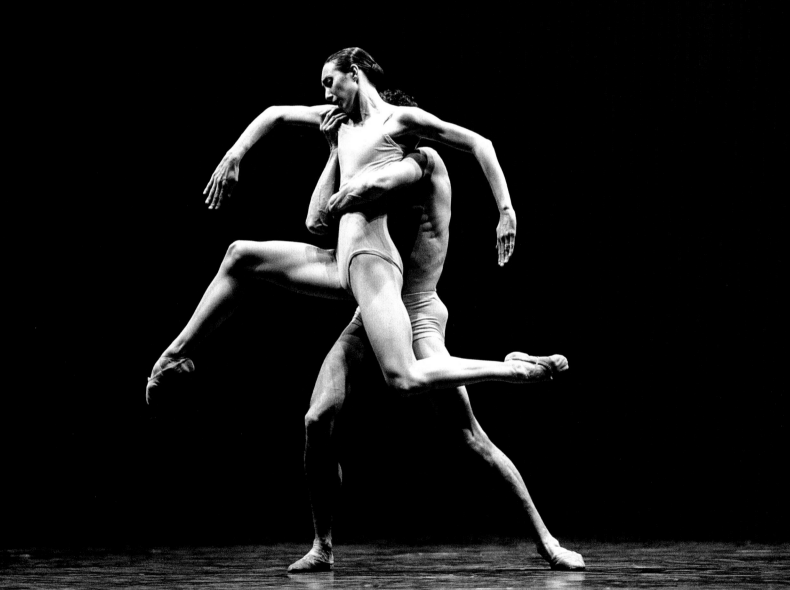

Above and previous page: Leira Ortueta,
Jonathan Cope

Notes of the Ballets

AGON *112*
Choreography: George Balanchine
Music: Igor Stravinsky
Lighting: John B Read

A MONTH IN THE COUNTRY *164*
Choreography: Frederick Ashton
Music: Frederick Chopin
Designs: Julia Trevelyan Oman
Lighting: William Bundy

A STRANGER'S TASTE *54*
Choreography: Siobhan Davies
Music: Tobias Hume/Sainte-Colombe/
Marin Marais/John Cage
Set design: David Buckland
Costume design: David Buckland/Sasha Keir
Lighting: Peter Mumford

BALLET IMPERIAL *18*
Choreography: George Balanchine
Music: Pyotr Ilyich Tchaikovsky
Designs: Eugene Berman

CINDERELLA *15*
Choreography: Frederick Ashton
Music: Sergey Prokofiev
Designs: David Walker

CARMEN *160*
Choreography: Mats Ek
Music: Georges Bizet/Rodion Shchedrin
Designs: Marie-Louise Ekman
Lighting: Göran Westrup

COPPÉLIA *70*
Choreography and production:
Ninette de Valois/after Lev Ivanov and
Enrico Cecchetti
Production restaged by Anthony Dowell with
Christopher Carr and Grant Coyle
Scenario: Charles Nuitter and Arthur Saint-
Léon/after E.T.A. Hoffmann's Der Sandmann
Music: Léo Delibes
Designs: Osbert Lancaster
Lighting: John B Read

DANCE VARIATIONS *115*
Choreography: Michael Corder
Music: Richard Rodney Bennett
Designs: Anthony Ward

DON QUIXOTE *170*
Choreography: Rudolf Nureyev, after
Marius Petipa
Music: Ludwig Minkus/arranged by John
Lanchbery/additional music: John Lanchbery
Set design: Anne Fraser

Costume design: Barry Kay
Lighting: John B Read

ELITE SYNCOPATIONS *15*
Choreography: Kenneth MacMillan
Music: Scott Joplin and others
Designs: Ian Spurling

FEARFUL SYMMETRIES *16*
Choreography: Ashley Page
Music: John Adams
Design: Antony McDonald

GISELLE *40*
Choreography: Marius Petipa/after Jean Coralli
and Jules Perrot.
Music: Adolphe Adam/revised by Joseph Horovitz
Scenario: Théophile Gautier/after
Heinrich Heine
Production: Peter Wright
Designs: John F Macfarlane
Original lighting: Jennifer Tipton/re-created by
Clare O'Donoghue

GLORIA *19*
Choreography: Kenneth MacMillan
Music: Francis Poulenc
Designs: Andy Klunder
Lighting: Bill Besant

HIDDEN VARIABLES *61*
Choreography: Ashley Page
Music: Colin Matthews
Designs: Antony McDonald
Lighting: Peter Mumford

IN THE MIDDLE, SOMEWHAT
ELEVATED *178*
Choreography and designs: William Forsythe
Music: Thom Willems
Original lighting execution: Olaf Winter
Sound design: Peter Tobiasch

JEUX *138*
Choreography: after Vaslav Nijinsky
Reconstructed and supervised by Kenneth Archer
Music: Claude Debussy
Designs: after Léon Bakst
Lighting supervised by: Millicent Hodson and
Kenneth Archer

LA BAYADÈRE *144*
Choreography: Natalia Makarova/after
Marius Petipa
Music: Ludwig Minkus/orchestrated by John
Lanchbery
Set design: Pier Luigi Samaritani
Costume design: Yolanda Sonnabend
Lighting: John B Read

LA FILLE MAL GARDÉE *95*
Choreography: Frederick Ashton
Music: Ferdinand Hérold/freely adapted and
arranged by John Lanchbery from the 1828
version.
Scenario: Jean Dauberval
Designs: Osbert Lancaster
Lighting: John B Read

L'APRÈS-MIDI D'UN FAUNE *37*
Choreography: Vaslav Nijinsky (revived from his
notation by Ann Hutchinson Guest/Claudia
Jeschke
Music: Claude Debussy
Designs: Léon Bakst

LA VALSE *168*
Choreography: Frederick Ashton
Music: Maurice Ravel
Designs: André Levasseur
Lighting: John B Read

LES BICHES *66*
Choreography: Bronislava Nijinska
Music: Francis Poulenc
Designs: Marie Laurencin

LES NOCES *100*
Choreography: Bronislava Nijinska
Music: Igor Stravinsky
Designs: Natalia Goncharova
Lighting: John B Read

LES RENDEZVOUS *48*
Choreography: Frederick Ashton
Music: Daniel-François-Esprit Auber/arranged
and orchestrated by Constant Lambert
Designs: Anthony Ward

LILAC GARDEN *75*
Choreography: Antony Tudor
Music: Ernest Chausson
Set design: Tom Lingwood
Costume design: Hugh Stevenson
Lighting: John B Read

MANON *56*
Choreography: Kenneth MacMillan
Music: Jules Massenet
Orchestration and arrangement: Leighton
Lucas/Hilda Gaunt
Designs: Nicholas Georgiadis
Lighting: John B Read

MARGUERITE AND ARMAND *182*
Choreography: Frederick Ashton
Music: Franz Liszt/orchestrated by Gordon Jacob
Designs: Cecil Beaton
Lighting: John B Read

MONOTONES II *85*
Choreography: Frederick Ashton
Music: Erik Satie
Designs: Frederick Ashton
Lighting: John Charlton

NAPOLI *13*
Music: Helsted and Paulli
Choreography: August Bournonville and Beck

ONDINE *116*
Choreography: Frederick Ashton
Music: Hans Werner Henze
Designs: Lila de Nobili
Lighting: John B Read

ONEGIN *190*
Choreography and libretto: John Cranko/after
Pushkin's Eugene Onegin
Music: Pyotr Ilyich Tchaikovsky/arranged and
orchestrated by Kurt-Heinz Stolze
Staged by Reid Anderson and Jane Bourne
Designs: Jürgen Rose
Lighting: Steen Bjarke
Copyright: Dieter Graefe

POR VOS MUERO *170*
Choreography: Nacho Duato
Music: 16th Century Spanish Music
Set design: Nacho Duato
Costume design: Nacho Duato and Ismael Aznar
Lighting: Nicolás Fischtel
Text: Garcilaso de la Vega

RAYMONDA Act III *13*
Choreography: Rudolf Nureyev after
Marius Petipa
Music: Alexander Glazunov
Designs: Barry Kay

REMANSO *152*
Choreography and designs: Nacho Duato
Music: Enrique Granados
Lighting: Brad Fields

ROMEO AND JULIET *131*
Choreography: Kenneth MacMillan
Music: Sergey Prokofiev
Costumes and new set designs:
Nicholas Georgiadis
Lighting: John B Read

SERENADE *28*
Choreography: George Balanchine
Music: Pyotr Ilyich Tchaikovsky
Staged by: Francia Russell
Costume design: Karinska
Lighting: after Jean Rosenthal

SHADOWPLAY *129*
Choreography: Antony Tudor
Music: Charles Koechlin
Designs: Michael Annals
Lighting: John B Read

SONG OF THE EARTH *88*
Choreography: Kenneth MacMillan
Music: Gustav Mahler
Designs: Nicholas Georgiadis
Lighting: John B Read

STEPTEXT *17*
Choreography: William Forsythe
Music: JS Bach
Design: Raymond Dragon Design Inc./
William Forsythe

SWAN LAKE *76*
Choreography: Marius Petipa/Lev Ivanov
Act I waltz: David Bintley
Music: Pyotr Ilyich Tchaikovsky
Designs: Yolanda Sonnabend
Lighting: John B Read

SYMPHONIC VARIATIONS *52*
Choreography: Frederick Ashton
Music: César Franck
Designs: Sophie Fedorovitch
Lighting: William Bundy

THE CONCERT *120*
Choreography: Jerome Robbins
Music: Frederick Chopin/orchestrated by
Clare Grundman
Frontcloths: Edward Gorey
Costume design: Irene Sharaff
Lighting: Jennifer Tipton

THE CRUCIBLE *65*
Choreography: William Tuckett
Music: Charles Ives
Designs: Ralph Steadman

THE DREAM *126*
Choreography and scenario: Frederick Ashton/
after Shakespeare's A Midsummer Night's Dream
Music: Felix Mendelssohn
Designs: David Walker
Lighting: John B Read

THE FIREBIRD *30*
Choreography: Mikhail Fokine
Choreographic reconstruction: Isabella Fokine/
Maris Liepa
Music: Igor Stravinsky
Set design: Alexander Golovin
Costume design: Alexander Golovin/Léon Bakst
Set and costume reconstruction: Anna Nezhnaya/
Anatole Neshny

THE GOOD HUMOURED LADIES *15*
Choreography: Léonide Massine
Music: Scarlatti arranged by Vicenzo Tommasini
Designs: Léon Bakst

THE LEAVES ARE FADING *188*
Choreography: Antony Tudor
Music: Antonin Dvorák
Staging: Aire Hynninnen
Sets: Ming Cho Lee
Costume design: Patricia Zippordt

THE NUTCRACKER *102*
Choreography: Peter Wright/after Lev Ivanov
Production and scenario: Peter Wright
Music: Pyotr Ilyich Tchaikovsky
Original scenario: Marius Petipa/after E.T.A.
Hoffman's Nuszknacker und Mausekönig
Designs: Julia Trevelyan Oman
Lighting: Mark Henderson
Production consultant: Roland John Wiley

THE PRINCE OF THE PAGODAS *18*
Choreography: Kenneth MacMillan
Music: Benjamin Britten
Scenario: Colin Thubron after John Cranko
Designs: Nicholas Georgiadis

THE SLEEPING BEAUTY *8*
Choreography: Marius Petipa
Music: Pyotr Ilyich Tchaikovsky
Designs: Oliver Messel

THE VERTIGINOUS THRILL OF
EXACTITUDE *156*
Choreography: William Forsythe
Music: Franz Schubert
Costume design: Stephen Galloway

THIS HOUSE WILL BURN *86*
Choreography: Ashley Page
Music: Orlando Gough
Set design: Stephen Chambers
Costume design: Jon Morrell

TRIAD *74*
Choreography: Kenneth MacMillan
Music: Sergey Prokofiev
Designs: Peter Unsworth
Lighting: John B Read

TRYST *140*
Choreography: Christopher Wheeldon
Music: James Macmillan
Designs: Jean Marc Puissant

Acknowledgement
from Bill Cooper

IN MEMORY OF Peter Darrel, Margaret Lawford and Katherine Wilkinson who were
instrumental in helping me make the transition from dancer to photographer.

Thanks to everyone at The Royal Ballet and ROH, also Su, Roberta, Helen, Alison,
Hazel, Liza, Amanda, Nada, Dancer's Career Development, Janine and Simon for their
help. But especially Sine, without whose enthusiasm and perseverance this book
would not have happened.